Everything the publishing industry wants you to know about **getting published**

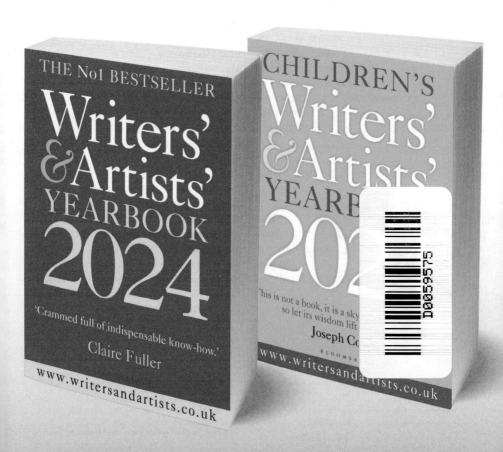

Out 20th July 2023

GRANTA

12 Addison Avenue, London W11 4QR | email: editorial@granta.com
To subscribe visit subscribe.granta.com, or call +44 (0)1371 851873

ISSUE 164: SUMMER 2023

This selection copyright © 2023 Granta Trust.

Granta (ISSN 173231 USPS 508) is published four times a year by Granta Trust, 12 Addison Avenue, London W11 4QR, United Kingdom.

Airfreight and mailing in the USA by agent named World Container Inc., 150–15, 183rd Street, Jamaica, NY 11413, USA.

Periodicals postage paid at Brooklyn, NY 11256.

Postmaster: Send address changes to *Granta*, Air Business Ltd., c/o World Container Inc., 150–15, 183RD Street, Jamaica, NY 11413, USA.

Subscription records are maintained at *Granta*, c/o ESco Business Services Ltd, Wethersfield, Essex, CM7 4AY.

Air Business Ltd is acting as our mailing agent.

Granta is printed and bound in Italy by Legoprint. This magazine is printed on paper that fulfils the criteria for 'Paper for permanent document' according to ISO 9706 and the American Library Standard ANSI/NIZO Z39.48-1992 and has been certified by the Forest Stewardship Council (FSC). *Granta* is indexed in the American Humanities Index.

ISBN 978-1-909-889-57-6

MIX
Paper | Supporting responsible forestry
FSC
FSC® C023419

CONTENTS

6 Introduction
 Sigrid Rausing

11 Reports from the Front:
 Winter 2023
 Peter Englund, tr. Sigrid Rausing

35 Family Meal
 Bryan Washington

43 Cairo Song
 Wiam El-Tamami

61 Plainsong
 Suzie Howell, with an
 introduction by A.K. Blakemore

75 The Index of Porosity
 Adam Mars-Jones

85 One Day It Will all
 Make Sense
 Tabitha Lasley

95 Animal Rescue
 Martha Sprackland

97 A Report on Music
 in Ukraine
 Ed Vulliamy

120 Journal Excerpts 1997–1999
 Lydia Davis

127 Once a Dancer
 Diana Evans

136 We're Not Really Strangers
 Sama Beydoun

155 Soundscapes of Phnom Penh
 Anjan Sundaram

167 The Tide
 Adèle Rosenfeld,
 tr. Jeffrey Zuckerman

179 The Soundscape of War
 Ada Wordsworth

184 Great North Wood
 James Berrington

203 Endurance
 Maartje Scheltens

215 Things That Dream
 Brian Dillon

222 Strange Beach and
 More Night
 Oluwaseun Olayiwola

227 A Life Where Nothing
 Happens
 Mazen Maarouf, tr. Mazen
 Maarouf and Laura Susijn

233 TonyInterruptor
 Nicola Barker

251 Mute Tree
 Y-Dang Troeung

262 Notes on contributors

Introduction

The title of this issue – Last Notes – has a dual meaning, alluding to soundscapes and music, our theme, and also to the fact that this is the last issue of *Granta* I will edit. Thomas Meaney, our new editor, has now taken over from me – his first issue (on Germany and German writing) will be out this autumn.

I came to the magazine in 2005 and took over the editorship in 2013. Reflecting on those years, I am struck by the momentous changes in perceptions of writing and publishing. We have had the Black Lives Matter movement, Me Too, and the Trumpian Fake News debates, all of which touch on the question of truth and of representation – who gets to write about whom? – and therefore on editorial considerations. Much else changed, too. A literary magazine relies on trading arrangements, and Brexit has made for some delays and difficulties. Covid, too, was a challenge, but it coincided with advances in technology enabling working from home, which changed our work practice.

This has also been an era of brutal war. In Possession, our 2015 summer issue, we published 'After Maidan' a long piece by Oliver Bullough on Ukraine. He describes arguing with a Russian on a bus somewhere near the border. What was the West doing supporting Ukrainian fascists, the man wanted to know. 'If the Ukrainian government is fascist, why is the prime minister a Jew?' Oliver asked. The answer was obvious, at least to the man on that bus: 'Of course he's a Jew, they're all Jews.' We know by now that in the distorted post-Soviet codes of Putin's Russia 'fascist' is the term for any invented enemy of the state, and that 'Jew', at least to Russian ultra-nationalists, at times can mean more or less the same thing.

Later the same year I commissioned another piece on Ukraine, 'Propagandalands' by Peter Pomerantsev (winter 2016). Peter travelled to the Donbas where Russian separatists battled Ukrainian activists in the long-standing conflict. Again and again, he heard

the phrase *No one hears the Donbas*, expressing the local sense of alienation and disaffection. The people of Donbas, many of them Russian speakers, felt marginalised, and were receptive to Russian propaganda. Much of it made no sense, strings of evocative words dating from the Second World War and the Soviet past, but that, Pomerantsev wrote, '. . . almost seemed to be the point: break down critical thinking with absurdities and false logic, then open people up emotionally with images of suffering and trauma before promising them glory.'

Three of the pieces in this issue are set in Ukraine. Peter Englund, the Swedish historian, travels to the front. Ed Vulliamy investigates music in Ukraine, and Ada Wordsworth writes about the silence in the villages where she works restoring war-damaged houses, after the cacophony of sirens in Kharkiv.

The reports of fatalities and the gradual destruction of Ukrainian buildings and infrastructure are relentless. The war is creating a zone of destruction reaching from Chernobyl to the Donbas, some of the most fought-over land in European history. Some Westerners tend to seek fault in their own actions or inaction after the fall of the Soviet Union. The West, they argue, manifested the hubris of victory, while the Russians felt humiliated by the destitution and dysfunctionality of their state. I travelled regularly in the post-Soviet space, and that is not what it felt like to me. To the contrary, I saw alliances made between a variety of people – they were not all Russian – and Western liberals and academics. I saw universities and institutions founded or strengthened, and archives opened up. Like-minded people in the post-Soviet space started all kinds of new initiatives, creating ethnographic museums, collecting evidence on Stalinist atrocities, making orphanages more humane, formulating disability rights, measuring toxic pollution and environmental damage. Perhaps it is that vision that has been lost in those countries – that the work of thousands of activists has a genuine effect. Britain has a long tradition of honouring the voluntary sector, but in Russia many of the people trying to make things better were silenced by the oligarchs and the kleptocratic and repressive state.

Rather than focus on Western hubris or inertia, I think it's more interesting to think of the current moment in Russia as a neo-Stalinist

revival – a brutal, repressive and expansionist regime forming political alliances (as Stalin did) with conservative Orthodox religious leaders and extreme nationalists, targeting human rights activists, feminists and gay and trans people. Propaganda, disinformation, staged political events and TV news shows conducted with a certain slick and vacuous knowingness, set the tone. Rehabilitating Stalin, inside and outside Russia is on the agenda. The only thing missing is socialism itself – it's hard to get a sense for what Putin's party actually stands for other than a 'glorious' Russia.

In *Life and Fate*, Vasily Grossman noted the loss of diversity on the streets of Leningrad after Stalin's purges. A certain type – high cheek bones and blue eyes set wide apart – now predominated. The description fits Putin perfectly: his people may have been among those who genuinely mourned Stalin's death, the hundreds of thousands of people gathering in streets and squares all over the Soviet Union. Perhaps that is what Putin represents, or purports to represent: a grandiose and nostalgic return to order, to autocracy and to Russian supremacy, the 'older brother' among 'fraternal' nations.

In the village in post-Soviet Estonia where I carried out fieldwork in the early 1990s, the summer months brought visitors from Sweden, many of them former child refugees from the war. There was an economic imbalance between visitors and locals, yes, but often a very real sense of kinship was re-kindled, too. In Estonia, the people who in the late 1980s and early 1990s were engaged in liberating and reimagining the nation – in the early days this was sometimes syncretically referred to as 'building capitalism' – by and large inherited the state. In Russia, the alliance between the oligarchs and the kleptocratic state crushed or obscured the liberals (and many of the oligarchs, too).

I bought some Soviet coffee-table books at that time, including one about Soviet Ukraine. It had this to say about the 'great fraternal friendship' between Russia and Ukraine:

> In 1913 Lenin wrote: 'Given united action by the Great
> Russian and Ukrainian proletarians, a free Ukraine *is*

possible; without such unity, it is out of the question.' History proved the correctness of Lenin's great prophecy. His words about the unity of the Russian and Ukrainian peoples are inscribed on his monument in Kiev, the capital of the Soviet Ukraine. It was thanks to the common struggle of the Russian and Ukrainian workers, of the two fraternal peoples, that a free Ukraine indeed became possible. Free for all times . . .

In this issue, Anjan Sundaram describes the deafening building bonanza in Phnom Penh in 2017 (much of it financed with Chinese investments) that took place alongside the suppression of democracy and the political exultation of 'harmony', embodied in shiny new buildings with bland international names like 'Sky Villa' and 'The Peak'. But culture is not just a manifestation of economic conditions: when lunch hour struck and the workers downed tools, you could hear the wooden clatter of street chess and admiring cries from spectators and opponents reacting to unexpected moves. And this in Cambodia, where only a few decades earlier most of the educated class was destroyed by the Khmer Rouge, one of the most brutal left-wing movements in history.

The writer Madeleine Thien drew my attention to the last book written by her friend Y-Dang Troeung, formerly a child refugee from Cambodia. Troeung passed away before publication of *Landbridge,* a moving exploration of the violence of the Khmer Rouge and American mass bombing in the region, interlaced with letters to her child. Our excerpt is taken from the end of the book.

What comes after a dictatorship such as the murderous reign of the Khmer Rouge? At best, justice and restitution, but also thoughtful reflections from the aftermath. Memorialising (when it's not hijacked by the state) is an essential part of the democratising project. The words are dull, but they mean something like freedom. Waking up without fear. Trusting the state, the police, the army. Talking about, and writing about, what happened, and how and why; where the graves are, who died, and who gave the orders.

W iam El-Tamami writes about the soundscape of Cairo, another city of hardening repression, rampant inflation and a building boom. Her text is concerned with loss of hope – hope in the nation, the city, and her own body – the three intertwine and are made one in this poignant description of repression and polarisation.

'*Al-thawra ontha* [the revolution is female]', people chanted on the marches in Beirut, playing on the gendered noun. Sama Beydoun's photographs document Beirut nightlife at a time when the city felt pregnant with freedom and demonstrators passed each other notes with slogans that avoided sexist, slut-shaming or homophobic language.

B eing the editor of *Granta* has been a hard position to give up, but it's time for new thoughts and directions, new editorial discussions, and new taste. Literary magazines tend to come and go, reliant as they are on donations or patrons. To secure *Granta*'s future we have transferred its ownership to a charitable trust, and I would like to thank the British Council for the grant they have already given. I hope that in the months and years to come, when we begin our fundraising activities, we will find support among British institutions and individual donors. If you were to ask me why literary magazines are important, I would say that they are performance spaces for new writers, a place to experiment with voice, to engage with the editing process, to meet other writers and to gain readers and recognition. Without that space, which is both playful and profound, some nebulous quality in the culture dies. ■

Sigrid Rausing

PAUL HANSEN

REPORTS FROM THE FRONT: WINTER 2023

Peter Englund

TRANSLATED FROM THE SWEDISH BY SIGRID RAUSING

1

There is something about the destruction which soon makes it feel uninteresting. Maybe because ruins by and large are similar, or maybe because without the people who once lived in them they are transformed into – literally – lifeless shells that all tell the same story. Even the landscape, Donetsk, seems to lose its meaning as we move through it: eternal curtains of trees; huge fields of dead, black sunflowers; identical (to the point of confusion) mountains of slag. Soon the monotony takes on a particular quality: in almost all villages, however badly damaged they may be (a column of white smoke from a chimney in the chill of the morning may be the only sign of life), you often catch sight of, first, an elderly woman wrapped in bundles of clothing, pushing a cart across a frozen dirt road, and, second, a couple of stray dogs skulking about in the ruins. It's like standing in front of a cheap animation, the same images repeated over and over. But in a week or a month or three that same dying village can suddenly become important enough for people to die defending it.

The front line around Bakhmut is still more or less static, but hard battles are fought here. 'But' may be the wrong word, incidentally. The front line is static precisely because the battles are so violent, the Ukrainian defence so stubborn. The Russians attack again and again, most of them Wagnerites, mercenaries sometimes recruited from the prisons of Russia. 'We call the people of the first wave donkeys,' a Ukrainian soldier tells us. 'They are completely green – no bulletproof vests, loaded with ammunition. The second and third wave pick up the ammunition. Then there's the fourth and fifth wave. They are more experienced. And so it goes, wave after wave. The tenth or eleventh wave will take the house.'

The territorial gains are incomprehensibly minute if you count the cost in human life. The dead pile up (literally). The wounded who are not rescued freeze to death at night. A battle for a building can go on for days; a battle over a staircase can last for hours.

'There are so many of them that we grow tired of killing.'

The front is closer now. There are fewer civilians on the village streets, and more soldiers in the Ukrainian army's light brown uniform, with its digital camouflage pattern. The stretches between the roadblocks are shorter, the checks more thorough; there are ever more rusting wrecks by the side of the road. (In a ditch, a single tank turret, the object soldiers call a 'lollipop', because that's what it looks like when the target explodes and the turret whirls up into the air.) Bridges over the icy rivers have long since been destroyed. We slow down; the road descends to a pontoon bridge, shaded by leaning concrete slabs.

The traffic now is almost exclusively military, vehicles of various kinds, most of them originally civilian, marked with white crosses. We are closer still. (Over there, an abandoned trench line filled with the detritus of war: bullet casings, empty cigarette packs, plastic bottles, Russian army supply boxes, parts of uniforms. Something – maybe a black balaclava? – hangs from a tree. Some fallen tree trunks look like a game of pick-up-sticks.)

We are there. Almost there. The frosty village street is empty. Any vehicles are either hidden or parked under a roof. (A recent wreck of a lorry shows us why.) We hear voices but see no one – the soldiers are hiding in one of the buildings that still has a roof. An armoured personnel carrier rattles by at great speed; the soldiers, in full combat gear, are crowded on top. One of them makes the shaka sign and smiles. Then they're gone. What is termed *the front* is – emptiness. Visually speaking. It is, instead, a landscape made of sound: under your feet a carpet of noise, all around you a wall of cacophony, above you a sky of thunder.

They watch the sky anxiously as they work. It's blue. But not summer blue or azure or clear blue – the sky is a cold blue, a metallic, cold blue. The only cloud you see is haze from missiles detonated over the Russian line. And earlier: a puff of white smoke with a wavy tail. A guided robot of some kind shot down another airborne entity of some kind, perhaps a Russian drone.

The men watch for these drones. They can see far on a day like this. Russian kamikaze drones target heavy equipment. And the Ukrainian equipment is undeniably heavy, and old – this howitzer is almost a museum object, inherited from the Soviet era, but it will have to do. The men haul it into position, watching the sky. They are in a hurry. The first shell is loaded. Someone has written a message on it: 'From Igor for Dmytrivka'. It's fired. At this proximity the sound and pressure waves are simultaneous. A yellow cloud of dust whirls up.

The field is flat, the horizon so distant as to feel eternal.

This is a war of artillery, an unexpected return to the shape of the First World War – and the Second – fought, not least, on this ground. These are the bloodlands, layer upon layer of battlefields and forgotten mass graves. 'Artillery is the god of war,' Stalin said, or may have said. The Soviet army used that tactic, and the Russian one after it. All resistance was to be annihilated by shells, hammered into the ground.

The Ukrainian army medic confirms the tactic: 'I can't give you exact figures, but about 90 per cent of all wounds are from explosives. The most common injuries are from the blast, and the pressure waves – burst eardrums, but often lungs are damaged too, and the inner organs, the guts. We give first aid to the wounded, stabilise them, then we drive them to the military hospital in town. Some of the badly wounded are transported all the way to Kharkiv. We see all kinds of injuries, terrible injuries.'

A question: Do you get used to it? Answer: 'Most people get used to it in two weeks, maybe a month. After that it's routine, a job to do. You learn not to engage emotionally. But sure, you can still feel it if you get someone to hospital and a few hours later he's gone. We all feel it, and suffer from it, but to varying degrees and in different ways.' The medic climbs back into his German military ambulance, engine running, red crosses painted out ('The Russians target ambulances').

A vast amount of ammunition is fired. During the great summer offensive of 2022, the Russian army fired some 50,000 shells a day; the Ukrainians some 7,000. (By comparison, the US produce around 15,000 a year.) By autumn, the Russian volume of fire decreased noticeably to about half the previous amount, a temporary reprieve. Both sides run out of ammunition from time to time, and (at least as important) the barrels of many Ukrainian artillery pieces are simply starting to wear out.

A rtillery war is seldom described. It lacks dramatic quality: it's monotonous. The protagonist can do little other than hide in a hole, hoping for luck. The antagonist is an invisible, untouchable force, far away. There is no combat, no one to outsmart, simply a collision between human beings and explosives. And explosives win, whenever they touch human beings. The end is not pretty. A grenade splinter as light as a gram can kill, almost without trace; a splinter of two grams can cut off a hand. A grenade exploding nearby can decapitate, shear off arms and legs, cut a person in two, turn a body inside out, transform it into a mix of guts and limbs, an empty sac of blackened skin, cut it into tiny pieces (the catalogue of obscenities

ends here), turn it into vapour, make it disappear without trace.

Question: What do you do then? The military doctor who is the head of the medical station explains: 'Sometimes we don't even have a finger or a pair of legs to test for DNA. Then it's a question for the courts. If the circumstances are known, and the person is gone, the court can declare death with a year's delay from the day it happened. That's routine. The ordinary deaths are worse. Like at New Year. That was particularly bad. It's my task to document, to write death certificates, but also to photograph the bodies. Many of them were so young. Can you imagine sending a dead eighteen-year-old home, and only a part of the body is in the coffin?'

'The two most important tools in this war,' someone says, 'are the drone and the spade.' The drone to see what's happening, the spade to dig a hideout. Digging the trenches was quick in this place – the trench is deep and narrow, as it should be. The men dug and hacked through a metre of fertile black soil to the light-grey Donbas clay underneath. Parts of the wall are secured with tree trunks and the ammunition is kept in a separate place, behind an earth blind. A thin layer of brush makes a roof, filtering the January sun. What took time, the group leader tells me, was the bunker. Two weeks.

A covered side tunnel leads to the bunker. The door is a coarse grey blanket. Behind it, down a few steps cut into the clay soil, is a room. The low ceiling is made of thick tree trunks, the floor is covered in canvas; the walls are clad in silver thermal blankets.

The air is stale, but it's unexpectedly warm. There is a single lamp by the entrance, powered by a petrol generator which also provides electricity for chargers. On the right, a few planks on an ammo box makes a kitchen: sliced bread, teabags, instant coffee, a half-eaten orange, a white mug with the words YOU MAKE MY HEART SING. (The word 'sing' is crossed out, replaced by 'beat'.) On the floor some foam camping mats, sleeping bags and backpacks. Clothing, uniforms and carrier bags hang from nails on the walls. There's a pair of green Crocs on the floor.

The place is in immaculate order. That's true above ground, too. All rubbish is carefully collected, even cigarette ends, which are thrown into a bright-green Russian ammunition tin. The space has to be immaculate, otherwise six grown men couldn't coexist in nine square metres underground.

Question: What is the worst thing about living in a bunker? Vasyl, thirty-five, used to work for a flooring company, and is married with two children: 'It isn't too bad. You get used to it. How long it takes depends on the person.' Serhij, forty-eight, is a building engineer, divorced with an adult daughter: 'Hygiene can be an issue, keeping clean. Rats and mice are a problem.' Slava, fifty-one, previously unemployed, is unmarried: 'It's not frightening, but it's harder at my age. The young ones support me.'

They have lived in this bunker for two months now. Earlier they were further south, on the Kherson front. These men have been fighting since the beginning of the war. Just one of them has had leave in the last two months. But they seem curiously unbothered. 'We have to do this. We must defend ourselves.' Dirty grey smoke rises from the horizon near Bakhmut as we speak.

The spades are piled by the side of the trench. The drone is up. The platoon commander, Robin, is twenty-four, a professional soldier with a girlfriend in Odesa. He bends over his iPhone in the trench, following the live feed from the drone. The phone is propped against a box; an ordinary tablet beside it is running the program that calculates the heavy mortar's firing range. The drone is a civilian DJI Mavic 3. The battered old mortar, on the other hand, dates from the Soviet era.

They fire. Slava runs, carrying a bomb from the blind through the trench to the launcher. He holds the sixteen-kilogram object in front of him as you might hold a wet child. Robin wipes some dirt from the iPhone. The target is hard to hit. It's a group of Wagnerites who have dug themselves into a slope, near a ruined house. Robin speaks to the drone pilot, watches the bombs explode in real time, corrects the aim, corrects again, fires. It's a hit.

In one way, this sounds abstract, in another it's all too real. On the high-res images captured by the drone you see what the bombs actually do. People collapse, crawl across the ground, writhe in pain. A dying man beats his left arm repeatedly into the crumpled ground. Seen on an iPhone it looks like a bizarre TikTok clip.

There are rumours about a great Russian offensive starting soon (someone calls it 'the big show') with regular troops, fresh brigades, new equipment – or at least only semi-aged. The Wagnerites are finished, some say literally so. It's hard to get anyone to say much more. There is no excitement in the air, maybe because the men are used to living in a world of rumour, uncertainty and silence. Maybe because they have been fighting for so long, fighting even as the Russians arrived with their best troops, their latest tanks. Robin: 'There is no war without loss, and this is far from over. But give us the tools and we'll finish it.'

A slow, hesitant morning comes to life. The day is warming up. Someone puts out some sausage and water in a tin for the ginger cat. Medics crowd the farmyard, smoking. The atmosphere is one of nervous expectation. It's over now, yesterday's empty hours on the foam mats in the small house, windows covered and repaired, rooms heated by a wood-fired stove. It's an unavoidable cliché: war is mainly waiting. Everyone waits for something or other; for orders or news or transport or for some imagined thing; waiting, at times without knowing why or what for; waiting impatiently or with boredom, with anxiety or without much reflection.

Yesterday the medics played with their phones or slept. But today something is happening at the zero line – the Ukrainian term for the front line. Something big. Everyone can hear it. I repeat: the landscape of war is an acoustic landscape. And sometimes sound is the only reliable information, the only one that does not underrepresent reality. The normal background noise of thunder and boom has tightened. We hear the drawn-out sound of a rocket salvo landing – WOMP WOMP WOMP WOMP WOMP WOMP – and so on. (Imagine forty

such womps, one after the other, with a second or so in between: a deep, unpleasant sound you feel as much in your stomach as you do in your ears. It can make even seasoned veterans fall silent in the middle of a conversation, and turn their heads towards the sound as though out of respect.)

Soon it's clear that tanks are involved, too. (The noise of tank fire is easily identifiable: BOOM–VOOM. The discharge is followed almost instantly by the sound of the hit.) Then the ripping sound of machine guns and automatic cannons rise through the clear and chilly air, indicating that the infantry has left the trenches and are moving through no man's land.

This is the front west of Kreminna, a little town in the Luhansk region which the Ukrainians have been trying to recapture since late autumn, and which the Russians have defended energetically. The men talk about 'the forest' – no place names are mentioned – but everyone seems to understand anyway. Today the Ukrainians are attacking, again.

Military vehicles tear back and forth along the dusty village road. A drone is shot down from the blue leaving only a grey-white puff, soon dispersed by the wind. Someone says it's not good to have so many vehicles parked close together. It draws the attention of the Russian drone pilots. But judging by the noise, all ambulances will be needed today: the military-green Dutch one, the boxy Danish one, the Norwegian one, so new it hasn't been repainted yet, SYGETRANSPORT still written on its side, and the all-terrain vehicle bought with private donations from Sweden. Walkie-talkies jump to life; shrill voices pour out.

The first transport of the day, a dusty black Nissan Warrior, stops in front of us. Three wounded men are assisted out: glassy eyes, grimaces, a bloody, swollen hand. But they can all walk to the waiting Norwegian ambulance. Next transport: a badly wounded man. The same glassy eyes, a bandaged head, a torn and bloodstained uniform. The alarm is sounded for three more casualties, then one more. The

cat circles around broken glass and cigarette ends, sits down to lick her paws in the sun. The explosions seem not to concern her. It's only when two jets pass over the roof, shooting rockets shaking the ground, that she is suddenly gone. The edge of the road is covered with the litter of earlier days: identity tape, bloody surgical gloves, an army hat with a hole in it, a camo glove on top of a crumpled golden trauma blanket.

Tinny radio voices announce ever more wounded soldiers. Now ten are coming, no, twelve, no, fifteen. A report comes in: a group of medics from another unit have hit a mine. In the forest. Shouts, questions – silence. No, no fatalities. Only light wounds. The thunder and bangs in all registers reach a crescendo. The Russians are counter-attacking, and the mood darkens.

The medics line up by the road, pull on fresh surgical gloves. Many injured men are coming. How many? 'A lot.' First a dark green all-terrain ambulance streaks past in a cloud of dust, then brakes, followed by a sand-coloured armoured personnel carrier stopping abruptly with a squeak. An unconscious man is carried away. A group of wounded men are helped out of the armoured vehicle and into waiting ambulances, which depart one by one.

A half-naked young man with dark hair and a short beard is left on the grass by the side of the road. His skin is pale, almost alabaster. On the right side of his chest you can see five or six tiny, jagged entry wounds. Grenade splinter. A female medic in camouflage and a protective vest finds a black body bag in the ambulance and unfolds it with a practised flick of the wrist. Her hair, put up, is coming loose. Her face is smeared with red – as it would be after giving a bleeding soldier mouth-to-mouth resuscitation.

One of the medics takes the feet of the dead man, two others take the arms. The body is manoeuvred into the sack. The medic closes the zip, crying quietly. The others have just lifted it up when an older soldier – short and sturdy with grey in his beard – runs up. He gesticulates, begs. After a short hesitation the men lower the bag to

the ground. The medic zips it open and the fallen man's face emerges in sharp profile, paler still against the black plastic – a pietà image. There is nothing frightening about the dead: they are just silent and pale and very still. All their pain and anxiety have been transferred to the living.

The older soldier kneels, touches the face of the dead man. 'Vadym, Vadym!' A group gathers. 'My brother, don't die!' The medic kneels, speaks with him quietly, puts her arm around his shoulders. 'Vadym, my brother!' Two others help the man to his feet, gently lead him away. He has blood on his face, his features have somehow dissolved, his eyes are staring, unseeing. The body bag is carried away. When all the wounded have been driven off one of the medics brings out a bucket of hot water. They scrub out the ambulance. Red water runs down the road, staining the frozen sand. The medic has stopped crying. Her face is clean, her expression is resolute and she has rearranged her hair.

2

What might you call that experience of jarring contrast, which is such a common part of the witness literature of conflict and other catastrophes, and also of so many other stories of adventure, survival and homecoming? More concretely: the experience of returning home and understanding that life there has carried on as normal. A metaphor? An archetype? A narrative theme? Or is it just a basic premise of life?

To travel at night from the front-line zone, to leave the horizon of flaring lights, is a journey towards inattention. The dark, unseen landscape envelops you in a cocoon. The meaning of words, of songs playing on the car radio, emerge, clarify. But when you drive into some small town beyond the range of Russian artillery the contrast startles:

the sudden lights, the sharply lit shop windows are visually shocking.

Imagine that light can be so . . . light. To travel through a blacked-out city, by contrast, weighs you down more than it shocks you. No street lights. Traffic lights blank. Moving through the dark valleys between high-rise silhouettes is eerie, no matter whether the lack of light is caused by yet another Russian missile attack or a planned shutdown of the grid. Only a few pale yellow rectangles are faintly lit, and you get the feeling that all of it could be the digital backdrop of one of those dystopian Netflix shows, a few lost people huddling behind those windows.

But it's easy to exaggerate the drama. Ukraine is a large country, and in most towns life goes on almost as usual. There is electricity, water and heating (mostly). The trains leave on time, as do the trams, and in the morning, when curfew ends, rush hour chokes up the roads just as it always has.

The malls are filled with shoppers. They may have to walk up the escalators, which are permanently turned off, but they can find all they need in the shops. Restaurants and bars, too, are full of people, young men and women doing what young men and women have always done. But in a second everything can be undone; because Russian cruise missiles and ballistic rockets can reach all parts of the country.

To hold on to normal life, despite everything that has happened, is happening, or could happen – is that an act of defiance or an act of denial? Or is it both?

Even in a town like Kramatorsk, so near the front that the thunder from Bakhmut is audible day and night, and where heavy Russian rockets and missiles fall most days, people refuse to be frightened. Men and women on their way to and from Arbat, the little shopping centre in the middle of town don't, on the whole, walk faster when the sirens come on, reverberating between the buildings. And when the howling starts at night, a dissonant choir of sirens, very few retreat to the bomb shelters. 'It's a lottery,' someone says, with resignation.

The contrast between what goes on *at this moment, over there* and the home front's reversion to normal life is crystallised by an image of a hospital for injured soldiers. On the one hand, the ward is quiet and peaceful: low voices, eighties pop from a CD player, a PlayStation 4, the smell of microwaved pizza from the canteen off the corridor. On the other, there is a constant parade of men (and some women) of all ages, in tracksuits, on crutches, in wheelchairs, with walkers or walking frames.

People without legs or arms, or without parts of legs, arms, hands, faces or eyes. People whose bodies were destroyed on the battlefield, learning to function again, with the help of prosthetic limbs. It's hard, and painful. The veterans' faces are sad, their eyes hard and dull. Most of them move cautiously, trying out new limbs. One man has lost both legs. He is in a cold sweat, staring, licking his lips. He definitely does not want to be photographed. (When he has learned to walk, he says, he will return to battle – and he is not alone.) Another rubs the stub of his arm while rocking back and forth. Phantom pains. There is a queue for the smoking room. All soldiers smoke, even those who normally don't.

There are no official figures on Ukrainian military fatalities. (Such statistics are normally not released during war.) Western sources estimate that the Ukrainian combat casualties is around 100,000 soldiers – killed, wounded, taken prisoner or simply disappeared. During the Russian summer campaign against Severodonetsk and Lysychansk, Mykhailo Podolyak, a close adviser to President Zelenskiy, admitted that between 100 and 200 Ukrainian soldiers were killed every day. So even if the Russian casualties are far higher (attack is always riskier than defence) it is obvious that the Ukrainians are paying a horrifyingly high price for this war.

Signs state that the ward is for injured soldiers only, and that members of the public are not permitted. The purpose is not to hide the wounded, but to protect them. Many of them don't want to be seen, much less photographed, in this state. Most of the doors to the hospital rooms are closed. The whole ward has forty beds. As soon as a patient leaves, someone else takes their place.

When the war is over; when nature has healed; when craters and trenches have grown over and all the rusty tanks have been smelted and turned into Teslas or roof beams; when the last fallen soldier has been found and buried with full military honours; when the ruins have been rebuilt or torn down to make way for new, more attractive housing; when a new generation who were not part of it, and whose memories are virginal, empty, grow up; when there are no material signs and when people begin to forget, these men and women will still be here, and their marked and broken bodies will remind us of how terrible this was.

For those who have lost an arm or a leg or part of their face the physical injury is all too obvious. But what about the mental wounds? 'Practically everyone who is admitted has some form of psychological trauma,' a soft-spoken neurologist says. 'They are in shock from the pain and their experience, and they shut down. They often become mute. It can take three weeks for them to speak again, and then they can be angry, raging against their fate. The most difficult part, psychologically speaking, is getting them to come to terms with their injury, to think about the future, and start training with a prosthetic limb. Everyone has some kind of PTSD; most of them become depressed, or even psychotic, though that is rare. We don't have our own psychologists on the ward, but we do have volunteers who come and help.'

Svjatoslav is twenty-six but looks younger, with large brown eyes and a short beard, wearing a striped T-shirt and cut-off jeans. Before the war he was an engineer with Siemens in Ukraine. His left foot is gone, and he moves the stump incessantly, not because of phantom pain, he is over that, but because the muscles have to be retrained, reshaped for the prosthetic limb.

'It happened on 10 October at the Kherson front, a fine sunny day, warm, seventeen or eighteen degrees. Our orders were to find a new passage to the river – the old path was under fire. On the way there we found and disarmed a mine, but it turned out there were two, and on the way back I stepped on the other one. It was a PMK, the size of a tin of shoe polish. There was a sudden bang, I was lying there

and saw that my boot was gone. This is the worst thing that could happen, I thought. I think I was more scared of being an invalid than of death. I have seen so much of it. Guys without arms, legs, faces, eyes.'

The war can often seem strangely distant, especially in western Ukraine. Then there is yet another reminder. A funeral procession is making its way down the road. The snow-clad tops of the Carpathian Mountains are visible in the distance. At the head of the procession is a police car, blue lights flashing, next a black van adorned with the text HEROES NEVER DIE in Ukrainian; after that a line of civilian cars, then a bus, all with their warning lights blinking, many draped with Ukrainian flags. Traffic comes to a standstill, people drive onto the hard shoulder and turn on their hazard lights in response. Many of them leave their cars, bare their heads. When the procession rolls past they make the sign of the cross. We are on our way to Boryslav.

In the black van is the body of Oleksandr, forty-six. Before the war he was a mechanic. Like many of the people who live in the foothills of the Carpathians, he loved being out in nature. The same day the Russians invaded Ukraine he volunteered to join the army. He fought for eleven months as a foot soldier. Thursday 26 January he and his platoon were on the Kreminna front, near Yampil, the medics' village. During the night there was a probing attack, and by dawn the Russian artillery was firing with everything they had. Yampil, and Oleksandr's platoon, were 'covered' (as the Ukrainians say) with grenades and rockets. The bombardment was relentless, and then the Russians attacked in force. Oleksandr rang his mother, Lida. 'Mum,' he said, 'it doesn't look as though I'll survive this.' An hour later he was dead.

The procession drives into Boryslav under a grey sky. There's a slalom slope with a ski lift, empty and quiet. People – men and women, old and young – line the road, and when the van with the coffin rolls past they fall to their knees in the patchy snow.

The coffin, draped in a flag, is carried into a small chapel by six uniformed men. A statue of the Virgin Mary guards the entrance. The

mourners crowd in, so many that some have to stand outside in the icy mountain wind. Someone struggles to manoeuvre a large stand of plastic flowers through the door. The priest's portable speaker is badly connected, and the sound cuts in and out when he sings a hymn.

Usually, funerals here are conducted with open coffins. But in this case that wasn't possible. Oleksandr was killed by grenade splinters to the head, one of them going through an eye. Of the twenty men in his platoon, sixteen were wounded that Thursday, three were killed, and only one survived unscathed. When the priest has done what he has to do the mother is the first to approach the illuminated coffin.

Lida is in her sixties, and dressed in a dark purple jacket. She takes a tentative step towards the coffin, then stops, weeping, covering her mouth and nose in an attempt to control herself. She closes her eyes, keeps them closed, and when she opens them again she is looking at a black-framed photograph of Oleksandr propped up on the coffin. He is in combat uniform, a powerful shaved head. His gaze is serious, or perhaps tired. There is no hint of a smile.

<div align="center">3</div>

The sky is grey, the temperature hovers around zero. The left side of the five-storey block of flats has collapsed, and three floors have folded on top of each other like an accordion. The communal staircase is sooty, the steps covered in ash, plaster and glass. The flat is an empty shell. Vjačeslav, forty-nine, is a stocky man dressed in a black jacket, baseball cap, trainers and blue jeans. He is home on leave.

This was his flat. His mother, eighty-one, lived here, too. 'I wasn't here. I rang on 11 March, and a Chechen soldier answered her mobile. Later a neighbour said she had been killed the day before, on the Thursday.' In what was once a kitchen I can see a wall-mounted dish rack, now bent out of shape. Near the window the heat was so intense that some glasses have melted into surreal, Salvador Dalí-like shapes.

Vjačeslav points to a stain on the floor. 'We found parts of her here,' he says matter-of-factly. This building, and others nearby, are ruins, impossible to rebuild. A crew has already begun to demolish the block next door. As we drive out of the area our translator points to a square in the plaster on one of the neighbouring buildings: 'That's where the Banksy painting was. Before it was stolen.'

S un, empty harvested sunflower fields. The lorry with its Grad rocket launcher is parked behind a narrow line of trees. The brick-red Bakelite lids on the back of the rocket pipes shows that they are loaded. The lorry itself is in good shape, with only minor damage. ('None have been killed,' one man says. But they have lost five Grad trucks like this one since the war began.) The battery commander, Roman, a dour man, forty-nine years old, wears blue body armour. When the conversation moves on from military matters and the situation in nearby Marinka, he comes to life. 'The most common psychological problem is this thing, the fear of death. You have to break free of that burden, you don't need it. The fear of death is a chain, it's a prison. What I tell people depends on the individual, of course, but the fear is often, in some complicated way, connected to various problems people struggled with before the war. I try to find out what those issues were, what was wrong. Often, it's some form of guilt. We are so much more than just our bodies.'

His mobile rings. It's time to fire. Within minutes the first rockets are launched: tails of fire shrinking to bright dots in the cold blue sky.

F og, temperature around zero. Visibility is only a few hundred metres. 'A good day to be a soldier,' says Orest, a Ukrainian officer, one hand on the wheel. 'Not much shooting. A day to rest, to wash clothes, to go shopping in the nearest village.' This seems to be true for civilians, too: along the road we see quite a few people, many of them elderly, cycling or on foot, carrying heavy shopping bags.

We lose our way in the fog, and suddenly we are alone: no vehicles, no people, nothing. Orest is not much bothered. 'These villages are all

alike,' he says in passing. Some Ukrainian soldiers wave, we stop, talk. Orest turns the vehicle and we drive back the way we came. 'What did they say?' we ask. He shrugs. 'That we were on our way into the Russian lines.'

We stop near a seemingly endless field of blackened sunflowers. It is like a gigantic Anselm Kiefer installation, the countless bent petals illustrating a world of death and nothingness. 'The field was mined by the Russians,' Orest says, hands in his pockets. 'The value of the harvest wouldn't cover the cost to clear the mines. That's why they've left it like this.'

Everything is grey, grey. Even the sound of explosions takes on a subdued grey tone.

B efore the war this was a thriving middle-class area of new, low-rise flats. Anton, thirty-five, is a copywriter. He shows us the remains of what was once his home: a study in the phenomenology of destruction. 'This was my Xbox. That was my computer. They were on the floor above, but the floor collapsed.'

'And this?'

'I think it was my PlayStation.' He touches the brittle thing with its cover of burnt white plastic. 'Yes, it was.' He brushes dust and debris from his hands. By the wall are some rusted bedsprings covered in fallen plaster: 'That was my bed.'

He seems curiously detached. Some bulging side of something – what might it be? 'The fridge.' The stove is still recognisable, and so is the dishwasher, buried under a pile of broken crockery and brick and plaster. He pulls the sooty front of it open. 'And there are the dishes,' he says, more curious than sad. We climb out the same way we came in, through a blown-out window. Anton is still pointing things out: 'And that was my motorbike.' His voice darkens. 'I have nothing now. Everything I owned has been destroyed, everything. I don't mind the things. I can get a new TV and a new motorbike. But what makes me furious is that my daughter has lost her home. And that the Russians killed my neighbours. The Russians were under cover over there –' he

points to the forest – 'and shot at anything that moved on the road. We found people dead in their cars afterwards.'

When he sees all the junk thrown into his garden, covering the little juniper bush he planted with his daughter, he suddenly becomes very upset. The bush was meant to protect the home, a miniature tree to decorate at Christmas. He digs into the mess, lifts and pulls, doesn't give up until the juniper is free and properly staked. We leave, driving past a large, empty supermarket, blackened by fire. 'That's where I used to go shopping,' he says quietly.

S ome snow is falling, it's minus one or two. There's a smell of oil, diesel and, yes, cold steel. It's striking how large and ugly and dirty they are, the tanks. As a species. So too this one, number 664. There's snow on the long gun barrel and front armour. The engine room is covered in dirty duvets. 'Firing takes up maybe 5 per cent of our time. Less so now, because we need to save ammunition and we mustn't wear out the gun barrel. The rest of the time we fix the tank, inspect it, service it. All the time. That's why a tanker's uniform is black. It's dirty work.'

Ihor, twenty-six, huddles with cold. As the gunner his place is to the left in the turret. The heavy latch swings open and reveals a hole with a mess of cables and boxes and buttons and dials. 'You don't think about how tight the space is when you are in battle.' He smiles faintly, and points to the left side of the tower: the tank has recently been repaired.

'We were in battle with Russian infantry. Long distance. We had shifted our position twice already and drew up to a third place to fire again. Then we felt a deep thud and a huge bang, very deep, bass. We didn't know what it was. So we withdrew, then we saw that the reactive armour on the left side of the tower was gone. Later we found the parts of one of those Russian AT missiles stuck on the back of the tank. We were lucky.'

He shows some photos on his phone. 'I am used to the war now. It took . . . two months. But I worry about my brother, who is a tank driver too, and my mum and dad, who are back in our village. The

Russians occupied it for a month, and they were too busy to torture anyone. But two people disappeared, and an acquaintance of mine was found executed in a trench.

Question: How do you keep in touch? 'My brother and I communicate via WhatsApp. I talk to Mum and Dad on the phone. In the beginning they would call eight or ten times a day, and in the end I had to tell them, "Listen, I am trying to fight a war here!"'

There are feral dogs everywhere, packs of at least two, quite often four. They move quickly, anxiously, as though constantly on the road to some distant goal known only to them. They are only rarely aggressive. Many are obviously family pets whose owners have fled or been killed. There is a golden retriever, over there an Alsatian and some sort of terrier, and there – a sad sight! – a dachshund.

Cats seem to cope with life at the front better. They are egocentric and solitary creatures, witnessing the downfall of civilisation with equanimity. Many of the cats in this ruined village look suspiciously well-fed. It is known that cats eat cadavers, but so do dogs, and they don't look so well. Maybe rats and other feline prey thrive in the mess of destruction. Later, in a warm, well-furnished bunker, we meet a grey tabby cat lazily basking on one of the rough wooden bunk beds. We ask his name. 'Sardine!' the gloomy sergeant says, lighting up. 'He keeps the mice away.'

Roman is well built, quick thinking and confident; has that aura of invincibility, as though he will come through it all without a scratch. He doesn't wear body armour. (He points at ours, laughs: 'These are mainly for psychological effect.') Later, waiting for the next transport of wounded soldiers, we talk in the warmth of the small house. He is resting on a pull-out chair-bed, mobile phone in hand, comms radio by his side.

'Sure, I miss my wife, and daughters of course. I don't like war. But to get through it mentally you have to accept it; accept this strange life and everything it brings. You have to separate from your civilian

self. We won't be soldiers our whole lives, but *now* that's what we are; it's our duty to be soldiers, and to be professional. If you accept that, your life will be easier. Sitting around feeling homesick will just make you unhappy. Just unhappy. Don't think too much, don't become too emotional. That can be dangerous – it breaks you down. It's important to find a balance. Imagine it like this [he demonstrates with his hands]: a globe. Up in the north: no emotions; down south, all emotions. Best thing is to stick near the equator. It's important to always keep a bit of empathy inside. But if you can't stick by the equator: go north! Then it's better to be hard, a bit cold . . . There is a logic to all this. When I leave the war, I'll leave it completely. That's important. Completely. It's a big problem, soldiers bringing the war home. I hate uniforms. I will go home, and I will leave all this, everything I have experienced, behind.'

In the background we hear the sound of boiling water and a quiet snapping from the warming stove. Every now and then an unseen heavy artillery piece is fired from the hill behind the house, and the door shakes a little. Otherwise nothing much is happening.

It is strange how quickly the brain learns to distinguish sounds, even in an urban environment. The cry of the sirens; the heavy thud and short shake that signals a missile hit in another part of town; the shaking windows which means that this time it was closer; the early-morning rattle over the rooftops indicating an Iranian kamikaze drone, a sound which may be new but which still lacks a certain menacing quality – the Ukrainians call them 'mopeds', because that is the noise they make.

But here is a new sound. BRRRRROP. BRRRRROP. An automatic cannon, firing nearby. We leave our plates and run outside. The sky is light grey. The wide Peace Square by the neoclassical Palace of Culture is suddenly empty. BRRRRROP. But where is it coming from? A large city is like an echo chamber. Silence. Nothing. (Quick amateur analysis: 'Light air force cannons shooting at low-flying targets; it must have been a cruise missile.')

We go back inside and resume the conversation and the meal – Ukrainian pizza with pickled cucumbers. BRRRRROP. BRRRRROP. Another cruise missile. On the street corner: emptiness. (A quick, even more amateurish analysis: 'That doesn't sound like a normal ZU-23, the sound is . . . lighter. Could be a German Gepard.') Silence. Nothing. Back inside. BRRRRROP. BRRRRROP. Again, we can't see anything. More cruise missiles fly over us. Fast as arrows. We eat our pizza.

It's hard to discern the logic behind the Russian missile attacks. Targeting the Ukrainian electricity grid is probably the most considered strategy in the Russian war effort to date. But even if those attacks cause considerable problems for the Ukrainians, they seem to be able to solve them, with their customary talent for improvisation. But to send a missile costing, say, £3–4 million, to a residential area to kill an old lady and her cat feels incomprehensible. One senses a bureaucratic machinery where attacks are carried out against a certain place in order for someone to be able to report that an attack has been carried out. Or perhaps it is simpler than that. Perhaps this aimless killing is not a means to an end; it's an end in and of itself.

During the night, the usual sirens. Early the next day we drive to Sloviansk. Outside a large warehouse of some kind, the road is covered in millions of tiny glass splinters glistening like sequins in the low morning sun. When we return that afternoon the asphalt has been swept clean.

You can hardly pass a cemetery without catching a glimpse of a grave for one of the fallen, adorned with a large Ukrainian flag. But this is a military cemetery. The first impression is just of flags, flags everywhere. A grey day. The only sound, even though there must be forty or fifty people here, is that of flags flapping in the cold wind. People walk in small groups, talking very quietly. Most of them meander up and down the paths of flags and portraits and crosses, a muted cry signalling that they have found the person they were looking for.

Most of the graves are new. Majestic plastic flower arrangements are still wrapped in cellophane, the graveside offerings of bread, chocolate, cigarettes or sweets are untouched. A woman in a fur hat is tidying up a grave with a toy spade. A tall young man with a sparse beard lights a cigarette, sits down on his haunches and places it on a grave covered in red carnations. He stands up, staring into the steel-grey sky.

'That one over there,' he says, pointing at a grave behind us, 'he was a cool guy, funny. Everyone called him Morzi (the Walrus). He was a Javelin operator at Bakhmut, the beginning of June. He destroyed two Russian tanks, one after the other, and he was about to stop the third one when the battery malfunctioned. A Russian sharpshooter got him. That was 4 June. This –' he points at another grave – 'is Black. He was a machine-gunner, using one of the heavy ones, a Browning. He disappeared. No one knows what happened. Then his body was found, identified, and yesterday he was buried. He wanted to come back as a hero, and he did, but not as he would have wished.'

The photo by the grave shows a serious young man in uniform. The man we are talking to is breathing heavily now. He sinks down to his knees, steadies himself on the sandy ground. 'We are paying an enormous price for this war,' he says, gets on his feet and starts to walk away. He doesn't want to talk any more. 'I can't explain, can't explain how it feels.'

In the upper part of the cemetery four newly dug graves are waiting for coffins. They are like narrow deep wounds in the dry and crumbly earth. You want to look into them, but you feel you can't. ∎

LORENA LOHR
Untitled, 2017

FAMILY MEAL

Bryan Washington

Most guys start pairing off around one, but TJ just sits there sipping his water. Everyone else slinks away from the bar in twos and threes. They're fucked up and bobbing down Fairview, toward somebody's ex-boyfriend's best friend's apartment. Or the bathhouse in midtown. Or even just out to the bar's patio, under our awning, where mosquitoes crash-land into streetlamps until like six in the morning. But tonight, even after we've turned down the music and undimmed the lights and wiped down the counters, TJ doesn't budge. It's like the motherfucker doesn't even recognize me.

For a moment, he's a blank canvas. A face entirely devoid of our history.

But he wears this smirk I've never seen before. His hair tufts out from under his cap, grazing the back of his neck. And he's always been shorter than me, but his cheeks have grown softer, still full of the baby fat that never went away.

I'm an idiot, but I know this is truly a rare thing: to see someone you've known intimately without them seeing you.

It creates an infinitude of possibility.

But then TJ blinks and looks right at me.

Fuck, he says.

Fuck yourself, I say.

Fuck, says TJ. Fuck.

You said that, I say. Wanna drink something stronger?

TJ touches the bottom of his face. Fiddles with his hair. Looks down at his cup.

He says, I didn't even know you were back in Houston.

Alas, I say.

You didn't think to tell me?

It's not a big deal.

Right, says TJ. Sure.

The speakers above us blast a gauzy stream of pop chords, remixed beyond comprehension. Dolly and Jennifer and Whitney. They're everyone's cue to pack up for the night. But guys still lean on the bar-top in various states of disarray – a gay bar's weekend cast varies wildly and hourly, from the Mexican otters draped in leather, to the packs of white queers clapping offbeat, to the Asian bears lathered in Gucci, to the Black twinks nodding along with the bass by the pool table.

As the crowd finally thins out, TJ grabs his cap, running a hand through his hair. He groans.

I'll be done in a minute, I say. If you want to stick around.

Fine, says TJ.

Good, I say, and then I'm back at my job, closing out the register and restocking the Bacardi and turning my back on him once again.

I hadn't heard from TJ in *years*.

We hadn't actually *seen* each other in over a decade.

Growing up, his house stood next door to mine. My folks were rarely around, so TJ's kept an eye on me. I ate at his dinner table beside Jin and Mae. Borrowed his sweaters. Slept beside him in his bed with his breath on my face. When my parents died – in a car accident, clipped by a drunk merging onto I-45, I'd just turned fifteen, cue cellos – his family took me into their lives, gave me time and space and belonging, and for the rest of my life whenever I heard the word *home* their faces beamed to mind like fucking holograms.

Not that it matters now. Didn't change shit for me in the end.

*

Before I start mopping, Minh and Fern wave me off. When I ask what their deal is, Fern says it's rude to keep suitors waiting.

He seems pretty into you, says Minh.

He isn't, I say.

And he's not your usual type, says Fern. I've never seen you go for cubs.

I'm constantly evolving, I say, but we're not fucking.

Spoken like an actual whore, says Minh.

Fern owns the bar. Minh's his only other employee. After I flick them off, I step outside and it's started to drizzle. And TJ's still standing by the curb, sucking on a vape pen as he taps at his phone, blowing a plume of pot into the air once he spots me. The rain pokes holes through his cloud.

You've lost weight, says TJ.

And you've gained it, I say.

Nice.

It's no shade. You finally look like a baker.

But it's different. You're –

That's what you want to talk about?

It was an observation, says TJ. I have eyes.

Did you park nearby, I ask.

Nah.

Then I'll walk you to your car like a gentleman.

Ha, says TJ, and we drift along the sidewalk, ducking into the neighborhood under stacks of drooping fronds.

The middle of Montrose is busted concrete and monstrous greenery and bundled townhouses. Scattered laughter bubbles along on the roads snaking beside us, even at this time of night. Bottles break and engines snarl. But TJ's pace is steady, so I ease mine, too. Sometimes he glances my way, but nothing comes out of his mouth.

Deeply stimulating conversation, I say.

I don't think you get to be like that with me, says TJ.

Is that right? After all these years?

It's not like I planned on running into you tonight, says TJ. This isn't a date.

So you're actually dating now, I say, instead of fucking straight boys?

Shut *up*, says TJ. How long have you been in Houston? And don't lie.

Relax, I say. Just a few months.

What's a few?

A few since Kai died.

Oh, says TJ.

He stops in the center of a driveway. A gaggle of queens searching for their Lyft walk around us, whistling at nothing in particular.

Shit, says TJ. Sorry.

Nothing for you to be sorry about, I say.

No, says TJ. Not about that. Or not completely. But I never got to talk to you, after what happened.

After, I say.

After, says TJ. You know.

He keeps his eyes on the concrete. One of his hands forms a fist. The reaction's totally human. But it still isn't good enough for me.

So I walk up to TJ, standing closer.

You didn't kill him, I say.

I know, but –

No *buts*. Don't be a fucking downer.

TJ doesn't say anything. He takes another hit of the pen. And he extends it to me, dangling the battery from his fingers, so I take that off his hands and huff a hit of his weed, too.

We walk a few more blocks, hopscotching down Hopkins's sidewalks, toward Whitney and Morgan and the gays honking in Mini Coopers behind us. We pass a pair of Vietnamese guys steadying each other by the shoulders, torn up from their night out, taking care not to step on any cracks. We pass a huddle of drunk bros holding court on a taqueria's corner, swinging their phones and laughing way too loudly. When one of them asks if we're looking to party, I feel TJ tense up, so

I tell them we're good, maybe next time, and add a little extra bass in my voice.

But the guys just wave us off. TJ and I duck under another set of branches. And then we're alone on the road, again, beyond the neighborhood's gravity of gay bars, where it's as silent as any other white-bread Texas suburb.

Hey, I say. Does showing up at the bar mean you're out?

I was always out, says TJ.

Right, I say. But are you –

My car's here, says TJ, nodding at a tiny Hyundai parked by the intersection.

He leans against the door while I fiddle with my pockets. It makes no fucking sense that I'm nervous. But when TJ asks if I need a ride back to my place, I decline, pointing toward the neighborhood.

I'm local, I say.

Of course you are, says TJ.

Staying with a friend. Another friend.

One that knew you were in this fucking city.

TJ speaks plainly, like he's describing the weather.

What the fuck would you have done if I'd told you, I say.

I guess we'll never know, says TJ.

He makes a funny face then. Another one I've never seen before. Something like a smirk.

So I think about what I'm going to say, and I open my mouth to launch it – but then I change my mind.

Because TJ's earned at least this much.

Instead, I reach for his pen, pulling another hit. I blow that back in his face.

When TJ waves it away, I blow another.

Listen, he says. Seriously. You're really okay?

It's a short walk, I say.

No. I mean, are *you* alright?

I twirl TJ's pen a few times. He really does look like he means it.

Come back to the bar and see me, I say. I'll be around.

TJ gives me a long look, pursing his lips. Then he reaches into his car, snatching something, pushing it against my chest.

It's a paper bag filled with pastries. Chicken turnovers. They're flaky in my hands, warm to the touch, and the smell sends a chill up my neck – entirely too familiar.

Are you the fucking candy man, I say.

Try them, says TJ.

How do I know they aren't laced?

Because I'd have poisoned you years ago.

So I take a bite of the pastry.

It's just as delicious as I remember.

And when TJ sees my face, he nods.

Then he steps into his car without glancing my way, and I watch him drive off, and I wait for him to wave or throw a peace sign or whatever the fuck but he doesn't. TJ turns the corner and he's gone.

So I take another bite of the turnover, tasting the food, rolling it around my mouth.

Then I spit it out.

It's only another block before I find a trash can to dump the rest.

A few streets later, my phone pings from one of the apps. The message's sender drops his location. This park's tucked a few streets away. But the guy doesn't send a photo of his face, just his dick, and I'm not entirely sure who I'm supposed to be looking for.

Cruising's a nightmare this way. You always run the risk of running into some fucking homophobe. Or bored frat kids looking to blow off steam with a baseball bat. Or a drunk married dick with twelve kids and a lovely, clueless wife. But eventually, I spot a dude sitting on this bench beside a playground, and I recognize him immediately: it's one of the bros we passed by at the taqueria.

He looks shook at the sight of me. Late thirties, early forties. When I'm close enough, this guy sticks out his hand for a shake, and when I tell him to calm the fuck down, he apologizes, blushing.

I wonder how drunk he is.

Or what it took for him to work up to this point.

But I let him bend me over anyway.

He fucks me on the bench. Our motions feel routine, like they're untapped muscle memory – and it reminds me of something Kai liked to say, about how the steps may be the same, but we each have our own particular rhythm, and this was just another one of his nonsense manifestos but I still haven't forgotten it – and that's what comes to mind as this stranger stuffs one hand in my shirt while his other one plays with my ass, searching for an angle.

But it isn't long before we start to stall.

I reach for the guy's dick, guiding him, and he grabs my wrist.

Wait, he says. Do you have a condom?

No, I say. You're fine.

Really?

Go for it.

You're sure?

Are you a fucking doctor?

And I'm thinking that this guy will ask a fiftieth time but he doesn't. He enters me slowly. Starts pumping his hips tentatively. And then quickly. I steady myself on the wood, buckling from our momentum, thinking of how I'll probably find someone else to fuck after this, until, all of a sudden, I hear Kai's voice, clear as day, and I'm pushing his face from my mind while the guy behind me grunts under his breath – and when he comes, our bodies jolt, and I almost start to laugh because it's fucking hilarious and nothing short of astounding that I thought the world could ever be anything but what it is or that I'd ever truly find myself outside of its whims. ∎

EBRAHIM BAHAA-ELDIN
Al-Haram area as seen from the Ring Road, Greater Cairo, Egypt, 2022

CAIRO SONG

Wiam El-Tamami

'as in not much new /
as in no news is good news /
as in the war is over; has been for decades now / '

– Victoria Adukwei Bulley, 'not quiet as in quiet but'

1

Cairo. From my parents' seventh-floor balcony I watch pigeons swoop and dive, as frantic as the city below them. Cairo is a relentless roar. A barrage of car horns, motors rushing and rumbling. Gangs of street dogs, barking, snarling, stalking the neighborhood. Scraping, drilling, grinding, vendors yelling out their wares, planes cleaving low through the sky. The air is an acrid haze, almost gritty, tinged with smoke.

There is a song about Cairo that my mother loves. It begins: 'This is Cairo: the sorceress, the enchantress; the uproarious, the sleepless; the sheltering, the shameless.' The whole song is an unfolding of love, of twisted tenderness, of impossibility – and all of it is true.

My mother. I'm lying in her bed, in the dark, my head in her lap. The last time I was here was a year and a half ago, in the summer of 2021; now it is nearing the end of December 2022. The darkness in the room was my request: I'm trying to soothe away a headache that has dogged me since I arrived. We have lit a candle and are listening to Erik Satie as she strokes my hair. My mother is a woman of strong and specific loves: mangoes; white chocolate; barbecued corn, sweet and dry and charred. And us. When I was a child, she was always able, with her firmness and efficiency and warmth, to make frightening things go away.

Now my mother tells me about things falling apart. She talks in a quiet voice about new banking regulations, the devaluation of the Egyptian pound, shops devoid of merchandise, the price of the most basic goods inflating beyond all recognition or sense. I listen as the piano plays, as the candle flickers.

February 11, 2011. Has it been almost twelve years already? That day, my mother and I were at a protest in front of the massive monolith of Maspero, the state television and radio building. The day before, Mubarak had delivered a speech declaring that he would not step down. We were continuing to protest, chanting our lungs out, en masse, among hundreds of thousands of others all around Egypt, others who were now brethren, in this uprising that had broken open our country and our lives: *Bread, freedom, social justice, human dignity! The people demand the downfall of the regime!*

My mother and I decided to take a break. We managed to find a taxi. It was late afternoon; the sun must have still been bright in the sky. We were sitting in the cab, listening to the radio, when the transmission was suddenly interrupted and an announcement came crackling through – the sonorous voice of the newly appointed vice president, a shadowy man named Omar Suleiman: 'President Hosni Mubarak has decided to step down from the office of the president of the republic . . .'

I remember hugging each other, something widening inside us. I remember being unable to speak, I remember the driver praying

out loud, I remember my mother's voice breaking through its usual decorum, crying out: *Take us back, please, take us back to Tahrir!*

Dream. Growing up, the news was constantly blaring out from the television. My mother had been among the first cohort of graduates, in 1975, from the Department of Journalism in Cairo University's newly inaugurated Institute of Mass Communication. She had grown up in the Nasser era: a time of soaring idealism, of dreams that seemed within reach. Who was it that said that a cynic is an idealist who's become disillusioned?

When the revolution broke out in 2011, I felt that, for my mother, it was a second chance at an old dream that had long been buried, that had seemed beyond rekindling.

I was twenty-seven. Mubarak had been in power for thirty years. That was just the way things were: greed, corruption, repression, brutality, stagnation, apathy. And then came the dream, and our collective surge toward it.

My mother doesn't watch television anymore. Every independent voice has been squeezed out over the past years, and only a cabaret of talking heads remains.

Next door, in the living room, from the early morning until hours after midnight, the television blares.

My father. He makes me a large plateful of fuul for breakfast, with little dishes of sliced cucumbers, tomatoes, arugula and olives arranged around it, and two round loaves of baladi bread. Egyptian flatbread is unlike any other: dusted with bran, the top layer thin and speckled with dark spots, the bottom layer soft and moreish. I smell the bread, the rough and sweet and grainy smell of it, my first in a long time. My father asks me how his fuul is, as he always does, every morning that I'm there – and he doesn't take anything less than a compliment for an answer.

He plies me with fruit, with date cookies from the bakery. He brings me oranges, brings me pickles, brings me peanuts. I find

myself gazing into his face, my breath held, trying and not trying to trace the changes. He walks more stiffly now, does not seem to go out much – maybe twice a week: a brief walk to the mosque on Friday for the communal prayers; another one to pick up fresh bread from the bakery, produce from the fruit-and-vegetable stall, and a few other groceries, if needed – cheese, lentils, olives, black tea – from the corner shop next door. Cigarettes were once a vital part of these rounds; he was a chain-smoker for much of his life. But he finally quit smoking after his kidney transplant six years ago.

He likes to tell stories, and he creates them (with generous embellishment) out of anything, even the modest fabric of his now-small life and the bits of news he receives from his siblings' daily phone calls. On the phone, when I'm far away, he tells me about family news, about the football results, and about what's in season. He waxes hyperbolical about guavas (like honey!), about gorgeous pomegranates and sweet green grapes. In the summer, he buys me mangoes, hoping that I will come. When I don't come, he tells me that the mangoes he bought for me are in the freezer, waiting for me.

Now that I'm here, he hands me the telephone: your aunt wants to say hello. He hands me the telephone: your uncle wants to say hello. He hands me the telephone: your other aunt wants to say hello. They were once eight siblings: four girls and four boys, a tight-knit gang. Three of them died in their thirties and forties: accidents, illness. My youngest aunt has just emigrated to the US. Many of my cousins are now living abroad. There's a contingent in California; a few others are scattered across the Arabian Gulf. Two are in Berlin, like me.

My father was once a beloved doctor. Now retired, his television is his temple. He watches football, and volleyball, and squash, and handball, and tennis, and swimming, and athletics; and in between sports, usually late at night or just after daybreak, he watches the talking heads – the 'drummers', as they're called in Egyptian Arabic, el-tabballeen: the percussionists of the regime. He watches them closely, peering at the screen. He counts money, tallies up the football scores, watches the daily newsreel of state achievements and progress,

reads the official newspapers, scanning every bit of information. He memorizes the statistics about all the new megaprojects, the new construction works, the new administrative capital, stores it all in his head.

2

Sara. When I get into the Uber to go see her, the driver glances down as the destination appears on his phone, then turns to me in alarm: *Where are we going?*

In the spring of 2014, in the aftermath of the military takeover that rendered our dream stillborn, I left Egypt. I moved to Istanbul, where I found myself in the wake of the Gezi movement. I found myself surrounded by people with whom I connected deeply and immediately, whose questions of life seemed to mirror mine. We had all experienced a living, waking dream: a utopia of collective power, agency, *oneness* – and now we were experiencing the nightmarish aftermath. And yet there we were, all of us who had been part of it, our lives forever changed, broken open in more ways than we could express or delineate.

In 2016, I found myself suddenly summoned back to Cairo: my father was about to have his kidney transplant. I ended up leaving my life in Istanbul in mid-air and staying in Cairo for almost a year, and it was during that time that I lived with Sara.

Since then, I have wanted to write about this apartment: this home that we once shared and which I was now visiting again. About the roof terrace bathed in sunlight, the birdsong and bougainvillea, the geckos darting across the walls. The frangipani that bursts forth with sublime flowers in the spring; the pomegranate tree that bears miniature fruit.

Inside, there are many more plants, cozy assortments of succulents, colorful cushions and rugs and books, pottery from a Fayoum village. A kitchen with fresh herbs and a turquoise wall.

Downstairs, the road is lined with smashed, disemboweled cars,

vehicles coughing up their entrails, glass sprayed on the tarmac. Sara's small road is barricaded, and at the mouth of the street is a checkpoint, guarded by several men with guns. Sara lives – we lived – next door to a police station. In the time that I lived in this beautiful home that was mostly a haven, I would often hear things. Shouting. Sometimes wailing. At least once, screaming.

Today, as Sara and I hang out in the living room and catch up, we're not sure if the ululations we can hear are coming from the police station – the family of a freed detainee? – or from a wedding at the hotel across the road.

Police Day. Police stations in Egypt are feared and loathsome places of possible torture, death, disappearances: nightmare incarnate. Police brutality was the initial impetus for the revolution, the spark that lit the great fire. In the summer of 2010, a young man in Alexandria named Khaled Said was beaten to death in broad daylight by the police. There were attempts to cover it up, lies about the cause of death, until photos emerged of his face in the morgue, mangled beyond recognition.

I was not political. It was the first protest I'd ever participated in. We all wore black and stood along the waterfront, in Cairo and Alexandria and other cities around Egypt, observing an hour of silence over the life and death of Khaled Said. We did not know until then that there was a 'we'. And that there were so many of us. So many of us who needed so much to change.

Meal. Sara and I cook together, as we love to do. I bought some ingredients for our meal on the way; when I went to pay and the man at the cashier told me the total, I could not believe my ears, though I tried to keep a straight face. The food cost three times more than the money I had in my hand.

We slice aubergines, tomatoes and onions into a tagine, anoint them with oil and spices, and cook them low and slow, until the aubergines are succulent and falling apart. We make a salad with

red cabbage, a mash of sweet potatoes, a dip with white beans and beetroot. We sit down to eat, delighting in the meal we've created. But as I look down at my plate, I feel something like shame – shame that we can still eat this way, can still fill our table.

3

Morning calls. Every summer as a child, I came to Cairo. Summertime meant waking up in my grandmother's flat: the dappled light in the room, sun streaming through trees. It meant morning calls – each street hawker boasted a different one – in response to which my grandmother would lower her basket from the balcony to collect a few kilos of tomatoes or bundles of greens. A world thrumming with life, with noise and crowds, street markets piled high with vegetables, families weaving through cars and donkey carts stalled in traffic, the latest summer pop album blaring out of microbuses as the passengers dangled arms out of windows and wiped away sweat from their brows. An army of cousins and co-conspirators, and endless rounds of tea and fruit and sweets in between long family meals, people filling every nook of that apartment, the apartment that my father had grown up in.

It was the antithesis of the hushed, air-conditioned sterility of the place we lived in for the rest of the year: Kuwait, an oil-rich state in the Arabian Gulf that my parents had moved to shortly after they were married, seeking out better job opportunities. My parents lived and worked and raised their two children in a place where they could never belong, saving their money and dreams for the time when they would return to the homeland they had left when they were young.

My father would tell stories of his daily stroll as a student from his home to Cairo University among peaceful, tree-lined avenues. Of his adventures with his siblings: sneaking into the cinema, the sandwiches they would buy at a street stall afterwards, all for a few piasters. The

family had eight children and humble means, but still managed to live well and eat well and share much of what they had with others: my grandparents' small home was always open, the table always laid, the rooms always filled with innumerable guests.

When my parents finally returned – my mother in 2000, my father in 2010 – they returned to a different place than the one they had left behind: a country disfigured, a city almost unlivable, choked with traffic, ear-splitting noise, unbreathable air and 20 million people jostling for space. A country mired in corruption and repression and simmering with discontent – on the cusp of boiling over. Just months after my father's return, the country erupted into revolution.

4

Disorientation. A feeling of disorientation has accompanied me every time I've returned to Cairo over the past years. This time, the feeling is more visceral than ever, because I keep getting lost. There are new bridges and flyovers blocking off and cutting through, into and over familiar streets, disfiguring old neighborhoods, like a perpetual merry-go-round. The garden running down the middle of my parents' street, where street cats lolled and a few trees grew, has been removed, demolished by bulldozers, along with so many of the precious few green spaces and gardens, already so scarce, around the city – razed to the ground to make way for more asphalt and concrete. Meanwhile, there's a glitzy new mall near my parents' place: the flashing sign outside boasts a starbucks 24-HR DRIVE-THRU. The historic neighborhood of Korba, fifteen minutes away, is now filled with sleek new establishments with names like Cai-Brew and Nomadic Espresso Bar, selling green smoothies and specialty coffees for 60, 70, 80 pounds.

An old woman sits outside, crumpled over, begging.

Milkmen. Growing up in the 1980s and 90s, I remember Cairo as a place of boxy old Fiat cars. There were still milkmen doing rounds of the neighborhoods on bicycles. They had large metal canisters filled with a disgusting substance that my parents first boiled and then made us drink: milk that had a skin and a smell. It was nothing like the milk we had in Kuwait, which came in cartons and was perfectly uniform, white and mild – almost as inoffensive as water. Unlike the huge, gleaming supermarkets in Kuwait, where nothing grew and everything was imported, there were only small grocery stores-cum-delis in Egypt, shops that smelled of rumi cheese and basterma. They sold, to our surprise and disappointment, no Twix or Bounty or Snickers, only locally produced BiscoMisr treats with faded wrappers. Fruits and vegetables were bought at markets and street stalls, and you had to squeeze and haggle and choose, and there were only certain things available in certain seasons. The fast-food chains we grew up with in Kuwait were nowhere to be found.

Commercials. Watching football with my father today, I make a note of the halftime commercials: ads for Cheetos, for KFC-flavored chips, for a new energy drink called Sting; for Coca-Cola ('Burgers taste better with Coca-Cola'), Doritos, Mirinda; for Vodafone (starring Mo Salah) and Orange (starring Ahmed Saad); for nachos, and for Coca-Cola again ('Pizza tastes better with Coca-Cola').

Billboards engulf the city, lining bridges and streets, advertising junk food and cell-phone operators and gated communities. And hospitals. The last time I was in Egypt, the entire Alexandria corniche seemed lined with billboards for hospitals. Illness has become omnipresent here, in every household, in the young as well as old. There are 24-hour pharmacies on every corner. Egyptians feed themselves enormous amounts of medication every day. I am acutely aware of how much lower life expectancy is here than it would be in a European country. How six of my mother's university friends – all in their sixties – passed away in the space of just two months last year, four of them from Covid-related complications.

Luxury. Cairo's relentlessness is not new. But I remember, when I was younger, having a sense of some of these burdens being shared: everyone was stuck in the same traffic, the sun bearing down equally and mercilessly on all. Rich neighborhoods lay side by side with poorer ones. It was hard to turn a blind eye to the suffering. But over the past fifteen years or so, Greater Cairo has begun to sprawl far out into the desert in every direction: new gated communities, highways and shopping malls, private universities and exclusive schools. Nothing like the Cairo I knew; everything like the Arabian Gulf I grew up in.

There are whole generations of Egyptians now growing up like this, in these newly constructed satellite cities, these new gated communities – far removed from the realities of others. My cousin, Hania, lives in 6 October City. Her sister just graduated from one of the new private universities with a degree in 'luxury brand management'. Hania herself is still at university, studying for a degree in business administration. She tells me she wanted to study political science and economics, but her parents talked her out of it: *oh no, it's not a good time to study that.*

5

Disbelief. Inflation. Shortages. Debt. Everyone, everywhere, is talking about the soaring prices. In homes, in shops, at mealtimes, in phone conversations, on public transport, on social media: el-as'aar. The value of the Egyptian pound is plummeting, the economy is in free fall, the country is in a crisis of foreign debt, which has tripled over the last ten years. Less than two weeks after I arrive, the pound is devalued yet again, the third devaluation in a year – it has lost half its value in the last ten months. For the millions of people in this country who live from hand to mouth, the burden is unimaginable. The price of the most basic goods is skyrocketing, with no end in sight. The price of bread, eggs, potatoes has surged in the last few days, is a

ludicrous hike from last week: an unknowable frenzy of figures, like flickering cards in a slot machine. There are widespread shortages, even of basic staples such as rice. In my parents' apartment, in this middle-class neighborhood, I hear an unfamiliar call from a street hawker, a man with a cart and a loudspeaker. I listen more closely and realize he is going around buying used cooking oil for fifteen pounds per liter. I have never seen that before; neither have my parents, but little surprises them now. My mother says he is selling it to restaurants, 'so they can feed it back to us'. My father says no, no, they're just selling it to factories for use in machinery.

My mother shows me a post on her Facebook feed: 'Runaway millionaire arrested!' The mugshot shows a man clutching a crate of eggs and a bottle of cooking oil.

As I leave the flat, I catch a glimpse of something my father is watching on television: a conference about the Suez Canal, a government official rattling off facts and figures of soaring optimism, proof of soaring progress.

How can we bear this, a taxi driver says to me. How can we keep bearing this?

Disaster. I'm on my way to a swimming pool close to my parents' place when we come to a roadblock. A paving machine had struck a gas pipe under one of the new bridges, and it exploded. Cars were set on fire; three people lost their lives.

That afternoon I hear my father telling a friend about the incident on the phone, in passing, before moving on to discuss the Mo Salah match that evening. Disaster is so common it has become almost routine. Buildings collapse, trains crash, bridges explode and burn, planes fall out of the sky.

There is such an inherent precarity woven into every day here, a sense of tenuousness, of the unknowability of even the most immediate future, of life always being lived on a knife-edge.

6

Weather. My father is watching the news, a litany of climate disaster. Torrential rains in the Philippines. Flash floods in Saudi Arabia. A state of emergency declared in New York. In Egypt, the season is unseasonably warm. Barbecued sweetcorn is still available on street corners. And because I had missed summer, the all-important mango season, my mother brings one home: a December mango. It is big and bloated, its skin flushed with a reddish tint: a strange variety we've never seen before.

On the phone, my aunt reminisces about those tiny strawberries whose scent will fill a room; sometimes, she says, it's still possible to find them. I think of small, fragrant guavas; of yostafandi baladi with its wrinkled skin and citrus tang, so different from the watery mandarins and clementines that have flooded Egypt's markets.

Crisis. Some of my closest friendships in Egypt now are those that were forged during the uprising and in the years that followed. Mona is a botanist who has been turning her attention to issues of food sovereignty and food heritage over the past years. When I go to see her, she's in the middle of writing a report about Egypt's food crisis. She tells me about exports and imports, about the conditions imposed by the IMF, about food subsidy cards, previously provided to 70 percent of the population, now reduced to 38 percent. About the price of bread, eggs and poultry doubling. About chicks slaughtered en masse because there was no feed; about whole harvests of potatoes left to rot because it was cheaper than transporting them. She tells me we import 70–80 percent of our fava beans now – our fuul, the national dish of Egypt – and 100 percent of our lentils, another vital staple. She tells me Egypt has become the number one importer of wheat in the world. The more I hear, the more my chest feels constricted, my lungs folding in. Doing this research has been exciting, she says, and heartbreaking.

7

Hunger. I arrived in Egypt with a clear mind, a lightness within. But the longer I stay, the more I feel submerged. I am waking up later and later. My body feels tense and painful, my shoulders tight as a fist. Everything is becoming muddied, bloodied with the mess of being here. At the beginning, I ate the things I had missed. I ate mahshi kromb, stuffed cabbage rolls. I ate my father's fuul. I ate molokhiyya. I ate black-eyed peas with rice: Egyptian white rice, starchy and soft and buttery-sweet, cooked with little tendrils of vermicelli. But the longer I stay, the more my appetite shrinks. Though I'm a cook, I find myself unable to do anything but boil things. I boil potatoes, boil carrots, eat them with canned chickpeas, some olive oil. I don't know how I feel anymore, my connection with my own body slipping away. I am not hungry and not sated. I am hungry, but unable to stomach anything. What kind of hunger is this?

Pool. Every other day, I go swimming. I swim to stay afloat. To be held. To be weightless.

It's women's day at the pool today. I watch a group of women, young and middle-aged, dancing by the side of the pool. It's a Cairo version of a Zumba class, the music a mix of mahraganat and shaabi. I watch them delight in dancing, I revel in the music, I want to join them, and I find myself crying. Crying at these hip-rolling rhythms, this capacity for joy and pleasure and laughter and playfulness and *life* that is so immense in this country, despite everything.

I see this everywhere. The creativity, resourcefulness and incredible talent for improvisation in Egypt. An aliveness that exists and persists, despite everything. It's a conversation I've had with friends in the past: is it possible that the enormous burdens of life here become a kind of resistance training? Part of me is buoyed by this idea, and part of me can no longer bear to hear it. Over years of living here, I saw how hard my body had to work to filter out so much, how my energy and

capacities were slashed down into a fraction of what they could be. And I am one of the more privileged ones. How much of our life energy and potential do we have to give up in order to keep pushing against a system and a state that are brutally and perpetually pitted against us?

That is why I left. I could no longer bear to live within a system that is actively rigged against people, against life, against human flourishing.

Familiar and unbearable. In this awful and bewildering and relentless city, I am beginning to feel once again like I am in purgatory. What if the closest place, the underside of your own skin, is also the most unbearable?

And yet I have missed this so much. Tripping into conversations with strangers, warmly, spontaneously. How quick Egyptians are to laughter, to jokes. And then there is the anger, the aggression, the heaviness, the crushing weight of everything, a cynicism so deep, built up like sedimentary rock over generations of suffering. And then there is a lightness, a buoyancy despite everything, an abiding faith that somehow, God will take care of it all, and life will go on.

I cuddle up to my mother's warmth and we watch a comedy show together that I missed last Ramadan and I am laughing again. Afterwards, I still feel chock-full of tears.

8

Writing. It's been several years since I have published anything about Egypt. I was thrust into the silence of perceived danger. Thrust into the silence of how I could possibly begin to explain. And yet, and yet. In the words of Charles Bukowski: 'Often it is the only / thing / between you and / impossibility.'

Silence. There are an estimated 60,000 prisoners of conscience in Egypt's prisons. Enough people to fill an entire city, languishing under

lock and key. Dozens of new prisons have been built in Egypt over the past ten years. And how many tens or hundreds of thousands of others are in exile, unable to return? And how many tens or hundreds of thousands of others have left of their own volition, but not willingly?

Yes, but. So many of us wanted so much to change, and now everything has changed for us. Society was broken open by that time of dreaming, of reaching. Spirits broken, hearts broken, lives broken, and yet also barriers broken; barriers between ourselves and authority, between ourselves and action, between ourselves and power; between who we thought we were, or what we were capable of, or what lives we thought we were expected to lead; between ourselves and society, between ourselves and received ideas, between us and our own sense of self; a broken, brittle awakening. And we are still here, an enormous web of connections that has been formed, forged. There is still a sense of allegiance, a sense of belonging. We still follow those of us who have been imprisoned. We still mourn our dead, of which there have been many – those who have been killed, along with those who have died suddenly and prematurely, lost to illness, heart attacks, suicide. A kind of community remains, which, for now, exists mostly in a realm we call virtual. I am reminded of James Wright's words: 'We know we are shining, / though we cannot see each other.'
The poem – 'Yes, But' – begins with these lines:

> We are not exhausted. We are not angry, or lonely,
> Or sick at heart.
> We are in love lightly, lightly. We know we are shining,
> Though we cannot see one another.
> The wind doesn't scatter us,
> Because our very lungs have fallen and drifted
> Away like leaves [. . .]
> Long ago.

Sometimes, perhaps often, we are exhausted. Angry, lonely, sick at

heart. But most of us are still alive. Still working, wondering, creating families and friendships. We are still feeling, listening, thinking, speaking. We are still living, and sharing our lives. We are still watching. And what we have experienced and witnessed, created and been part of, continues to ripple through our lives, and through the world, in waves traceable and untraceable. And our dream was not new. What we fought for, reached for, tried for continues to be fought for by so many others around the world.

Hania. I am thinking of my cousin Hania, who is twenty years old, the one who wanted to study political science and economics and is now studying business administration at a private university. I remember our conversation, when she took me up to the roof of her house in 6 October City and showed me a public park nearby, which has been taken over to make way for some exclusive new development for the ultra-elite. She tells me the news about Cairo Zoo, one of the few green spaces remaining in Cairo, a popular destination for couples and picnicking families. It was recently announced that it will be closed for 'development'. She laments how they're going to 'modernize' it, open a chain cafe, and raise the price of the tickets, making it inaccessible to most of the people who used to frequent it. As Abdullah, their driver, said to her, 'Now my children will never get to see the animals.'

I ask her if she's able to talk like this with her university friends. She says she can only speak with a handful of her friends, and they have to be careful not to be overheard by the others. They know they cannot speak publicly about these things or mention them on social media. And yet she knows. She knows.

9

Departure. I land into an empty flat in cold, rainy Berlin. In my neighborhood, the bars and restaurants are full of people: people still

consuming, able to buy things – I am momentarily startled by this. The morning after I land, I send a message to my friend Soraya, who also left Cairo a few years ago and now lives in Amman. *Lots of love from wintry Berlin. Some kind of enormous body relief to have made the transition between the two worlds. The last day in Cairo I felt such overwhelming fear, as though I was in mortal danger. I didn't know how I would do it, how I would leave, just go up into the sky. I tried to put one foot in front of the other, I kept praying for help. And then I boarded the flight and arrived here and the first day was shock and exhaustion, emptiness. I hope and trust it will get better. But for now still anxious – am I safe now? – and trying not to feel bereft.*

Balcony. My mother is taking drawing classes. She draws portraits of my sister and me from photographs, draws boats in the sea like the ones in Alexandria, draws three old women dancing in the rain. She sends me photos of her artwork, and of the flowers that she grows on her balcony, that seventh-floor balcony overlooking the roar of Cairo. She sends me photos of two tiny eggs that she found in one of her plant pots, laid by a recurring visitor to her balcony. And a few days ago, she sends me a picture of two tiny doves, furry and brown, newly hatched.

Cairo song. 'This is Cairo, the sorceress, the enchantress; the uproarious, the sleepless; the sheltering, the shameless. This is Cairo, the radiant, the redolent; the luminous, the benevolent; the pure, the poetess. This is Cairo, the mocking, the mighty; the patient, the portentous; the revolutionary, the triumphant. Whispers echo through the chaos and crowds. An aching loneliness in the gathering's midst. Here is loving and lying and pretense. Money and cheating faces and injustice. Here is love and truth, mercy and grace. We're caught in your vortex . . .' ■

All names in this essay have been changed.

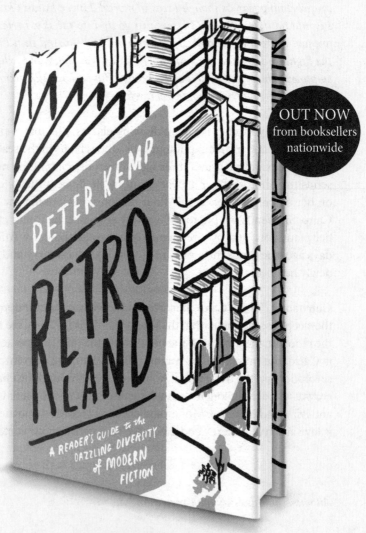

PLAINSONG

Suzie Howell

Introduction by A.K. Blakemore

In 1923 a group of women travelled from Surrey to establish themselves at the Tymawr Convent in Monmouth, Wales, to live a life of contemplation under monastic vows of poverty, chastity and obedience. The Society of the Sacred Cross celebrates its centenary this year. At the time of writing, eight sisters, from their mid-twenties to mid-nineties, remain at the Anglican convent, the only establishment of its kind in Wales. Among them are lawyers, nurses, academics, poets and painters. Some, who felt the call to devotion later in life, are both religious and *literal* mothers.

Tymawr, in the Wye Valley, is a largely self-sufficient community. The sisters' lives revolve around labour as much as contemplation. They clean, cook and work in the convent's expansive gardens and orchards (ecological sustainability is paramount in the community's approach to cultivation – in the Society's 2022 Advent Newsletter, the Reverend Mother Katharine writes with sadness of mankind's

'thankless misuse of the created world'). Alongside these duties there are five daily prayer services, including an hour-long midday mass. The sisters are also expected to spend two further hours in solitary, silent prayer. But perhaps it is wrong to separate the domiciliary and venerational strands of the sisters' lives in this way. The two endeavours dovetail – work is worship, and worship work. They live as much of their lives as practically possible in silence.

If this all sounds rather ascetic to your secular ears, I should stress that the convent's seclusion is far from anchorite in its rigour. The services are open to the local community and Tymawr often welcomes guests, including Suzie Howell, who in September 2022 spent six days photographing the sisters as part of her ongoing project on the theme of 'presence', a project prompted by her own struggles 'living comfortably in the present', finding contentment – perhaps even satisfaction – in stasis, or silence.

Like the voice, the hand is one of our primary means of interacting with the world around us, by which we might manipulate, move or change it. The hands of the sisters in Howell's photographs do not appear active or manipulative in this way. Evoking devotional artworks, they are open, upraised or still. Postures of graceful receptivity, or surrender. How do we tell the difference?

These hand-pictures were the product of necessity rather than intention. Howell, who speaks passionately of her time among the sisters, describes how at first they were reluctant to be photographed at all: 'There was no ego there. They didn't want their faces shown or names used.' Rather than be photographed in full, they offered up their hands.

As a historical novelist, I am interested in Howell's notion of 'living comfortably in the present'. I came to historical writing from poetry, when a series of upheavals in my life left me appalled by the vulnerability, the self-consciousness I felt I had too lavishly bestowed on my poetic work. Historical writing was – at least, at first – a kind of *retreat*. In writing about the past, rather than the present, I could masque, and play. It was also a way of ensuring I wouldn't write characters that might be mistaken for myself (specious, even intrusive,

autobiographical interpretations are something I think most female-identified writers experience). A sort of renunciation of a sort of *voice*. These practices do not bear comparison to those of the sisters of the Society of the Sacred Cross, whose dedication to devotion, silence and solitude leaves me sheepishly awed (it could, as they say, never be me, with my wine and vaping and impractical footwear). I just want to illustrate, by my own experience, that women's relationship to silence, in both the religious and secular realms, can be a complicated one.

I've been thinking a lot recently about how much of our contemporary language concerning liberation, especially the liberation of women, centres on speech and noise. The demand to 'speak up for' or 'speak out against', to raise your voice, to declare. To *divulge* – whatever the cost – the injustices, or traumas endured. The ubiquity of social media – where to *say* is to *do* – has profoundly altered our relationship with the declarative mode. I'm not saying this is bad. The freedom to speak for oneself should rightly be acknowledged as a privilege. But sometimes it seems to me that if 'speaking out' becomes a requisite component of liberation, there follows a corollary implication that silence is inherently oppressive. This implication, like anything blunt-edged, can be weaponised.

The anonymous author of the thirteenth-century *Ancrene Wisse*, a handbook for prospective anchoresses, quotes Saint Gregory: 'She who wishes God's ear to be nigh her tongue, must retire from the world, else she may cry long ere God hear her.'

I've been struck by the recent revival of interest in women who, through devotion and seclusion, fostered lives of relative liberation. Novels such as Lauren Groff's *Matrix* and a rereleased edition of Sylvia Townsend Warner's *The Corner That Held Them* recast the nunnery as a space of female joy and sovereignty in medieval England; while Robyn Cadwallader's *The Anchoress* and Victoria Mackenzie's *For Thy Great Pain Have Mercy on My Little Pain* address the apparent contradictions in the pursuit of spiritual freedom through the most complete social seclusion. I wonder if this revival is in part due to increasing awareness of the tensions discussed above – that the contortions and compromises required of the contemporary feminist have left us aching for alternative (and perhaps unexpected)

models of emancipation. Or perhaps it is the opposite: that we see in these women, struggling for self-realisation under the double bind of secular and theocratic misogynies, reflections of ourselves.

I don't want to fall into the trap of historicising the Sisters of Tymawr, because Howell's photographs so cleverly resist our modern, and perhaps rather patronising, impulse to approach the visibly religious as antiques – dusty, charming ornaments on the mantelpiece of our collective history. The women pictured in these photos are real: living and thinking and gardening and writing and painting and cleaning their glasses and attending workshops on non-violent communication and hosting prayers for female poets and single mothers – now. I'd rather let them speak for themselves. If that's their choice. ∎

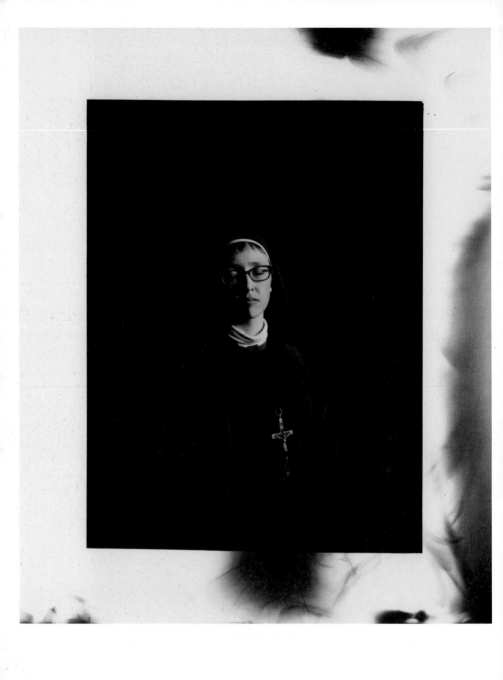

Vale Royal
AIDAN ANDREW DUN

We are delighted to announce a new edition of *Vale Royal*, Aidan Andrew Dun's first epic poem, almost 30 years after its legendary launch at the Royal Albert Hall.

Composed while Dun was living in King's Cross squats in the 1970s, *Vale Royal* explores the mystical significance of what was once one of the most neglected areas of London.

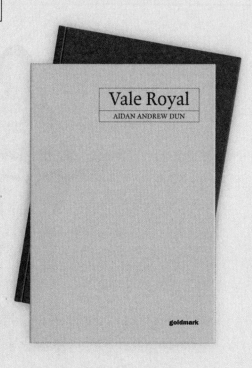

" *Vale Royal* moves with the ease and clarity of a fresh spring over ancient stones, making its myths casual, even colloquial – an impressive achievement.

DEREK WALCOTT, NOBEL LAUREATE

Dun stands apart from all schools and schisms... He is the carefully regulated trickle of water that cracks stone. "

IAIN SINCLAIR

STANDARD PAPERBACK
£10.00 +P&P

COLLECTOR'S HARDBACK
EDITION OF 100
SIGNED AND NUMBERED INCLUDING AN ADDITIONAL TRIAD IN THE POET'S HAND
£100 +P&P

goldmark, Orange Street, Uppingham, Rutland, LE15 9SQ
01572 821424 www.goldmarkart.com

Statue of St Cecilia

THE INDEX OF POROSITY

Adam Mars-Jones

I don't normally have troubled nights, but for several weeks in the autumn of 1987 I found it difficult to get to sleep. I had a short visiting fellowship in Cambridge and was staying in Leckhampton, a hostel that was part of Corpus Christi College but sat at the end of a considerable drive on the other side of the river, beyond Queens Road. My duties were light, the fellowship being designed to allow the lucky fellow plenty of time for his or her own work. It's a formula that sounds propitious but doesn't actually suit my habits, as I've come to learn. Away from my routines I felt a bit lost, and anxiety of a particular kind filled the space made available.

Every gay man of the period who wasn't celibate or well established in monogamy was likely to have fears, ranging in their intensity from moderate to obsessional, about the possibility of his exposure to HIV. My own fears were both rational, since my lover Michael Jelicich was already showing symptoms – he died a year or so later – and overpitched, since I had known his status when we met. (Michael made a couple of visits to Cambridge but was based in London.) Though we more or less avoided taking risks, 'more or less' is not a soothing formula in the wee small hours. There were grey areas in terms of sexual behaviour but they seemed to shift from month to month. What was the relevant shade of grey, anyway – pale or dark?

At night I would wander around the grounds of Leckhampton, quiet even by day, listening to a cassette on my Walkman. I'm sure I had other tapes but there was one that came to monopolise the miraculous little machine. It was the 1981 recording of Glenn Gould playing Bach's Goldberg Variations, less famous than his first recording in 1955 and vastly different from it, though at the time there was no element of connoisseurship in my listening. I didn't know the first version by Gould, nor any other. I hadn't heard the piece at all before I bought the cassette.

I did know, or had been told, that the piece had been written to beguile insomnia, and there was a certain satisfaction in recruiting it for exactly that purpose. Still, if that was the mildly pretentious reason for the first playing it had no bearing on subsequent ones. The distance the music travelled without the need to announce novelty, the fresh starts that were also serene continuations, all of this conveyed an implacable consolation. I remember the way Side 1 ended with a variation in the minor. A little run of rising notes was slowed teasingly down, so that the last two of them became a sort of present, something extra added to a moment that was already complete. This suspended resolution was also an irresistible invitation to take the cassette out, reverse it with a clatter, clunk the play control and embark on what becomes, with the technology dividing unity into halves, a return journey to the repetition of the theme.

The music's reassurance was formal and even architectural rather than emotional. Certainly what I hear when I listen to that recording now is Bach's music passing through Glenn Gould's hands – I've learned to filter out his crooning along. I'm not reminded of myself in mortal dread.

Is music absorbent? Is it dyed by the listener's emotions so that they become fixed in its fabric (for that one person, naturally)? Perhaps there's a spectrum involved, from which it might be possible to compile an Index of Porosity. At the high-absorbency end would be most popular music, whose success depends on the welcome it

offers to chains of association ('Oh, I remember where I was when I first heard this. . .'). These associations become the materials of a fond recall, the nest in which nostalgia will hatch. Bach's music would be at the other end, where the porosity quotient is close to zero. It's like a wall treated with anti-graffiti coating.

As if to make my argument for me, two film-makers of the 1990s accompanied acts of horrible violence with well-known pieces of music. In *Reservoir Dogs* a psychopath tortures a captive policeman with a razor, eventually severing an ear, all the while bopping cheerfully to Stealers Wheel's 'Stuck in the Middle with You'. Quentin Tarantino knowingly contaminates a song that was designed to be infectious and charming. It doesn't have the option of rejecting a new association but must accept it, like a dog returning to the home where it was abused, helplessly wagging its tail as it goes. There must be married couples who danced to the song at their wedding, but flinch at the loping bounce of its opening every time they hear it. Its aura has darkened. It isn't the same.

The year before, in *The Silence of the Lambs*, Jonathan Demme had featured parts of the Goldberg Variations over a scene in which Anthony Hopkins as Hannibal Lecter kills and mutilates the two guards who stand between him and freedom. In this he was following Thomas Harris's novel, where Lecter chooses to listen to a Glenn Gould recording, though it was Jerry Zimmerman who played what we hear in the film. But has anyone ever listened to the Goldbergs and felt the disturbing presence of those images? In the 2001 sequel *Hannibal*, Ridley Scott seemed to want to raise the stakes, using actual Glenn Gould this time – the 1982 recording – to accompany a scene that combines sophistication with savagery, a dinner party in which the mind-controlled heroine innocently eats human brain. (The music is not part of the scene in the novel.) Again the frisson fails to deliver. Music can't be poisoned if it didn't consent to be consumed in the first place.

John Updike in *The Witches of Eastwick* (the 1984 novel, very different from George Miller's film) made what could seem an even

more determined attempt to sully Bach's music, with an extended scene in which Jane, one of the witches, casts a spell (one that will manifest as a malignant tumour) while playing the D minor Suite on her cello. It's an extraordinary literary performance, seeking to turn music that is often seen as transcending personality into a vehicle for supernatural malice – it's Jane's playing of the cello that potentiates the cancer. Yet the moment the book is closed the spell falls to the ground. You can listen to the D minor Suite immediately after reading the scene and not hear anything of the sinister effect that Updike has worked so hard to produce. Chuck buckets of ugly human motivation over the music of Bach and its sheen is unaffected.

This seems to me characteristic of classical musics (including for instance Indian ragas and the 'big music' of the Scottish pipes), that they resist annexation, in contrast with popular music, which insists on it. Personal associations simply slide off classical music, while the various genres of popular music behave like different shapes of pasta, all of them designed to mop up the sauce of the moment. Why does this sound so snooty, as it clearly does? Popular music is where the money is, it's where the fame is, but the classical musics are patient. They don't need to make the first move.

I can give an example from closer to home, with music that is much more obviously emotional. In November of 1997 my mother Sheila was given a diagnosis of terminal lung cancer. She turned down the not particularly promising regimes of medication that might have given her a little extension of life. From one perspective it all happened very quickly. When she took me to the opera for my birthday in late October she didn't cough (certainly not to any antisocial degree), but she died not far into January. From another perspective there seemed to be any amount of time available, and Sheila made something remarkably like a controlled descent into the grave. I was slightly surprised that she went on reading novels after her diagnosis – I had somehow imagined that such a short future militated against the enjoyment of fictional worlds, any exploration of 'what if's. When she was reading Peter Carey's *Jack Maggs* she

might say dreamily, 'I must get back to dear Maggsy.' The last novel she read was an advance copy of Barbara Trapido's *The Travelling Hornplayer.* I thought it quite a tribute for any writer to be paid, that her imagination held its own against the forces of death, though I have to say poor Barbara Trapido's face rather fell when I mentioned the circumstances at the launch party for the book a few weeks later. We hadn't met before and haven't since. Altogether she must have received a peculiar impression of me.

I'm the middle brother of three, and since I lived nearest it had made sense for me to move back into my parents' flat during Sheila's dying. I remember telling her with mock briskness, 'Terminal illness is no excuse for not trying new things.' She certainly had her first taste of cavolo nero only a few days before she died – I only wish that her verdict on it (and mine) had been more enthusiastic. I hadn't yet learned how to bring out the best in that particular brassica.

We listened a lot to Schubert's song cycle 'Die schöne Müllerin', sung by Ian Bostridge with Graham Johnson at the piano, music that was new to both of us. It's plain that the impulse to explore it came from Trapido's novel, where the cycle is a strong if not dominating presence (the chapters are named after songs), though I had forgotten that fact until I refreshed my memory about the book just now. This time it's not a question of words not having the power to pin music down. It's more that my ego would rather not acknowledge being directed to a canonical masterpiece of music by a novel – preferring to think I had moved towards it spontaneously, turning on my stalk like a sunflower. I knew the 'Winterreise' cycle, after all, and a fair few individual Schubert songs.

I remember the effort of programming the CD player to omit the tracks on which Dietrich Fischer-Dieskau read Wilhelm Müller poems from the same group, ones that Schubert didn't set. By pressing the shuffle button I could have introduced some capricious extra drama, but there was a logic to the order of the songs, an implied narrative even if, lacking German, we had to seek it in the booklet of the CD. We did sometimes listen to the last song ('Des Baches Wiegenlied')

in isolation, occasionally repeating it as soon as it had finished. It's by far the longest song in the cycle, slow and hypnotic though with an odd sprightly bounce in the accompaniment, and a *Wiegenlied* is a lullaby. By implication the river in which the protagonist has drowned himself wishes him a good sleep.

When I happened to meet Ian Bostridge I thanked him for singing my mother so smoothly to her death (as if it had been his choice!). I realise that, on the evidence of what I'm writing here, my conversational openings tend towards the overpowering. It should be said in my defence that the occasion was a memorial service rather than a book launch, so I was likely to have a less destabilising effect on the mood. I've listened to the CD any number of times since then, and it has never reminded me of the circumstances of my first immersion in it. The music reminds me only of itself.

My brother Matthew and I washed Sheila's body and dressed her for the coffin, not something that had been planned in advance, an act of great intimacy though a surprisingly matter-of-fact one as I experienced it (can't speak for Matthew). We did the washing with some stephanotis-scented bath gel, and it seemed a sensible precaution for me to use up the rest of the bottle in my own baths thereafter, so that the fragrance had more than that one association. Smell operates in such a deep part of the brain, and I didn't want to be ambushed by loss after subliminally recognising someone's perfume in a crowd or at a party. I'm not sure this was a realistic fear – it was probably triggered by a Ruth Rendell novel in which the killer is triggered when exposed to a particular scent. (One woman wearing the perfume is spared because the wind is blowing the other way.) It did no harm to make sure.

At Sheila's funeral service, another song featured that we had listened to during her last days and weeks – Elizabeth Poston's 'Jesus Christ the Apple Tree', which I think appeared on a newly acquired Christmas CD, perhaps given away with a magazine. She had wanted it included not just for its piercing though somehow prosaic beauty but because it was written by a woman. I've heard it many times since,

I've even sung it in a carol service with a local choir of amateurs, and again it doesn't bring back the emotions that accompanied my first hearings of it. It isn't porous. It hasn't absorbed the subjectivity that once surrounded it.

Perhaps the various art forms are jealous of each other's advantages, without of course consenting to give up their own. Referential art – literature and the cinema – might covet the abstract immediacy of music. Art forms that rely on physical presence (dance, theatre) might cast longing looks towards photography and film, for their ability to reproduce and radiate outward indefinitely from their source.

Is there in fact a jostling for dominance between the art forms, some barely suppressed competitiveness? If 'all art constantly aspires to the condition of music', then music isn't in a position to congratulate itself by saying so. 'Music is powerless to make statements. It may evoke but can't describe – if music had the power to describe it could tell you things you don't already know, when in fact it can only remind you of things you already feel.' The Hebrides' overture isn't 'about' those islands unless you know its name, and even if you do it can't tell you where they are. Mendelssohn's music doesn't include map references.

There are art forms that depend on presence (dance, for instance) and those that glory in an indefinite reproducibility, such as writing since the invention of the printing press. Technology necessarily plays a part – until sound recording arrived (the dizzying acceleration from wax cylinder through LP and DVD to internet streaming), music was richly confined in the moment of its performance. Film showings, before the advent of home video, were in practical terms almost as unrepeatable as theatrical performances. Anyone who wanted to see *Rear Window* or *Vertigo* in the 1960s and 70s had their work cut out – Hitchcock had withdrawn five of his films and even after his death in 1977 was biding his time on the far side of the grave for the right moment to consolidate his reputation.

Funerals call for a delicate set of musical decisions, but the balance is easily upset when the deaths keep coming. My generation, or at least its gay cohort, had its bellyful of whistling-in-the-dark novelty choices in the Aids years, with the coffin of a young man going into the flames to the strains of 'The Time Warp' from *The Rocky Horror Show*. My friend Ron Davis, remaining true to his character, left money for a performance of a Mass by Tomás Luis de Victoria, an eccentric taste that has since become (almost) mainstream.

Weddings and their analogues require a different approach. When my partner Keith King and I wanted to formalise our relationship in 2008 (same-sex marriage not then an option), we learned that we could bring a CD with us to the registry office in Brixton Town Hall to be played before the ceremony. We spent a weekend trying to whittle down our choices, something that should have been enjoyable given our very convergent tastes and shared love of out-of-the-way repertoire. It was actually rather frustrating.

For me a liking for classical music (a liking rather than a passion) was part of a bundle of cultural assumptions – my father sight-read with difficulty but had picked up the guitar in his teens and never quite put it down. My mother dabbled in the piano and went as far in late life as taking lessons in harmony and counterpoint at the City Lit. I can't account for Keith's affinity with classical music, an interest alien to his family. It's as if he was born preloaded with the Third Programme (this was the 1950s), in the same way that computers come with apps and features already installed.

For heaven's sake, the man can identify Hummel's music from stylistic fingerprints! I'm not sure Mrs Hummel could claim as much.

At Slough Grammar School, Keith and his best friend Jeremy Black wrote art songs together. Keith wrote the words and Jeremy the music, though they could probably have done it the other way round (Keith played the cello). They sent their offerings to a composer they both admired.

It's a fair bet that in the 1960s the British composer in receipt of the plumpest mailbag was Britten, with Walton and Tippett perhaps

wrangling over second place. Instead these teenagers sent a sample of their work to Elisabeth Lutyens, best known for her film scores. I imagine her as slightly baffled at the breakfast table when she opened the envelope, though she sent an encouraging response.

Film music, even when written by classical composers, is almost always approachable. That's its job, to insinuate itself, to create or consolidate a mood without necessarily even being noticed. Lutyens's music for films was not like that, but then the films were a special case. Her style was astringent and often atonal, and she found her niche writing scores for Hammer and Amicus horror films, where the mood was allowed to do more or less anything as long as it wasn't soothing.

Lutyens's music was not on the shortlist when we were trying to choose music suitable to celebrate an intimate partnership, but nothing else sounded right. Our search for something sheerly beautiful produced something more like stasis, a frozen stillness smelling faintly of lilies. Our choices seemed closer to something deathly than a celebration. The music that we liked refused to sprinkle happiness in all directions as we wanted it to. Once again the specific emotions we tried to project onto it could get no purchase.

Then Keith took out a CD from its case outside my line of sight and placed it on the tray of the player, selecting a particular track with the remote control. 'We could always have this,' he said. It was track six of Bernard Herrmann's *The Film Scores*, played by the Los Angeles Philharmonic and conducted by Esa-Pekka Salonen. Yes – thanks, Keith! – it was the stabbing music from *Psycho*.

We let the CD play on without any particular intention, but by the time it had finished the decision was made. We would declare our commitment to each other after hearing not Martinů or Hovhaness (and get to the back of the queue, Hildegard of Bingen) but music with a strong current of unease. Perhaps to guard against being too blithe, against pushing our luck? Lustrously pulsing orchestral jazz giving way to an alto saxophone hauntedly wailing, the main title theme from *Taxi Driver*. ∎

ONE DAY IT WILL ALL MAKE SENSE

Tabitha Lasley

A writer gets in touch. This looks portentous written down, like the inspector who comes calling, or the postman who always rings twice. But it's a fairly normal thing to happen. Writers do get in touch with each other, from time to time. They know that writing is a boring, lonely job, that it fosters an unslakeable thirst for contact.

This writer is older than me and more established in his career. He has just finished reading a book I wrote. It is a memoir about an affair I had with a married offshore worker. There is the shadow of another book, contained within it, the book I had originally intended to write: a piece of reportage about the oil industry.

The writer says he wants to take me out for dinner and discuss it. He catches me at a low point. My sister has been diagnosed with cancer and I have been helping our mother look after my nieces. I love my nieces. I don't love doing childcare. I find this sort of work makes me feel so insignificant, I can't write afterwards. On the days I do get to my office, I just sit there staring at the page, unable to summon up the words. Dinner sounds nice. I decide I will go. When I get to the restaurant, the writer looks me up and down. There is a flicker of disappointment on his face.

'No Air Max?' he says.

'I don't wear Air Max any more,' I say.

'Are they the leather trousers you wore in the book?'

'No,' I say. 'They're long gone.'

It occurs to me then that he has not invited *me* for dinner, but my alter ego from the page. Though the events relayed are now seven years old, and as a memoirist himself, he must understand there is always a gap between the writerly *I* and the real thing. He was clearly expecting me to resemble this version more closely.

Over dinner, he tells me several things. That he thinks I might be a genius. That he had a fling with a friend of mine. That 90 per cent of writers are hacks who can't string a sensible sentence together. That I should only ever write non-fiction.

I tell him I might not write another book. I'm feeling disenchanted with the whole thing. I've started to think that being published is one of those abstract states people aspire to, like being married, or extremely rich. You think getting a book deal will have a transformative effect. But your life goes on being basically the same.

My book did well, by some metrics, but it wasn't successful enough to vitiate the failures that inspired it. My failure to acclimatise to the realities of adulthood. My failure to learn from my mistakes. My failure to read between the lines, to understand there is often a gulf between what a man says and what he actually means. I am still the person I was before I sold my book: a medieval peasant who stumbles through life, taking great account of signs and portents, and ignoring the self-evident truths staring her in the face. The writer looks as if he is about to cry.

'Oh dear,' he says. 'That sounds rather bleak.'

He invites me to talk to an extramural class he teaches. His students are men and women, of various ages and backgrounds. They have one thing in common: they want to be published. They want their talents ratified by an outside authority.

I remember this feeling. You want someone to see past your costume, ignore the raiment of your day job, intuit your gifts.

One student asks if I found writing my book therapeutic. I answer honestly that I did not. I understand that therapy is allied

to storytelling, that in some senses it is an attempt to make random events conform to a narrative arc, but I don't enjoy the process enough to derive any benefit from it. The part I found therapeutic was being compensated, seeing the advance hit my account. The realisation that I could sell my pain off for parts, that I could monetise my bad decisions, came as something of a breakthrough. I tell her I'm still sceptical about therapy. But I believe in getting paid.

This isn't strictly true. Like my memoir, it is emotionally truthful, but I've obfuscated a few key facts. I have started seeing a therapist again, for the first time in seven years. My mother initially sent me to a therapist when I was sixteen, and since then I've cycled through innumerable substitutes.

I periodically return to it, when I'm out of other ideas. When things improve, I decide it's a waste of money, and then I leave. This is my pattern. I'd like to break it. But if I knew how to break my patterns, I wouldn't need so much therapy.

There is an idea (put about by therapists, perhaps) that the longer you stick with it, the better the results. I have never found this to be true. I think the mind develops a resistance to treatment, just as the body stops responding to diets. I could be described as a yo-yo client. I dip in and out, go back and forth, without making any long-term gains. I am always returning to a dysfunctional default; my psychic walking-around weight.

My new therapist knows about my history with therapy. He agrees there are plenty of bad practitioners out there; he says the field is staffed by charlatans. During our first meeting he asks why I'm here. I say I struggle to cope with real life. I'm still telling myself stories, still indulging in magical thinking, as if I'm six years old. But now my sister is sick, and it has dismantled my belief system, if that is what it is. My sister is young. She has never done anything wrong; she lives like a monk. That she has been afflicted like this makes the world seem chilly and disordered.

My therapist asks if I read fairy tales as a child. I tell him I did. He asks me to name my favourite. I suspect him of being Jungian, though

I don't say this. I tell him I liked *East of the Sun, West of the Moon*.

'I don't know that one,' he says. 'What happens?'

'It's about this girl who marries a bear who's secretly a prince. She promises never to look at him in the light, but then she does, and she activates a curse.'

He regards me, over the steeple of his fingers.

'You like stories like that? Where people break their promises?'

'I don't know,' I say. 'I've never given it much thought.'

At home, my nieces go down with double bouts of illness: Covid, chickenpox. Things come in threes, I think grimly. When the eldest is better, I take her swimming. She is the best in her class, because she is the biggest. Watching her best her peers, I am struck by life's unfairness. So much of her progress feels preordained. She is taller, cleverer, more athletic than her classmates. She is always out in front. But then, her mother has cancer. Their mothers are healthy. Swings and roundabouts, I suppose.

On the way home, we discuss one of the other mothers in the group. She has long, silvery hair and a full, pale mouth. Her skin has a silvered quality too, because she wears stripes of luminescent highlighter along her cheeks and the bridge of her nose.

'She's pretty,' I say. 'She looks like a princess.'

'She *is* like a princess,' says my niece. 'She's so kind. Princesses are always kind.'

'That's only in Disney films,' I say. 'Real princesses are just as likely to be mean. Like Princess Margaret. She was very mean.'

In the car's mirror, my niece pulls a face. She wrinkles her nose and twitches her top lip, like a rabbit. It is an expression retained from her babyhood; we have photos of her doing it in her high chair. The baby she once was manifests before me. I know this image would lance her mother's heart. Mothers seem unable to contemplate their children's previous iterations without wanting to weep.

'Who's Princess Margaret?' she says.

The writer is a poor correspondent. He drifts in and out of range, like a weak radio signal. No matter how brief and light I make my replies, I feel like there is something leaden and loaded in their subtext. I feel like he knows he has me on the hook.

Eventually, he resurfaces, and takes me out for dinner. I drink two glasses of red on an empty stomach. He tells me some more things. That I should never talk down my own work. That my favourite author is reputed to be a horrible person. That his last girlfriend was a film star. That I shouldn't worry, because I'm better than her.

I excuse myself, and go to the toilet. In the mirror, I examine my face. I don't feel better than a film star. I place my fingers at my temples and pull. The last four years vanish. I take my fingers away. The four years reappear. They say daughters steal your beauty. Do nieces? I am forty: the age at which your choices are said to outstrip you. I have not drunk or smoked or sunbathed to excess. I have always prioritised sleep. But I still feel, in some obscure way, that I've ended up with the face I deserve. In the past, I borrowed too heavily against my looks. Now, I must service the debt.

I come back from the toilet and sit down. The writer gives me a moony look.

'You're not like anyone else. It's like you're an alien, and they've disguised you as a human, but they've kept your beautiful, alien eyes.'

'That better not be a recycled compliment,' I say. 'Did you use that on the actress?'

He bridles slightly.

'Certainly not. All my compliments are newly minted.'

I used to be good at talking to men. I was once fluent in their language, but for three years I have avoided them completely. I haven't slept with one, or kissed one, or even been on a date. My life is full of women: my mother, my sister, her children, my friends. Perhaps inevitably, I have reverted to my native tongue.

Later on, I learn this isn't the only skill I've mislaid. I can't remember how to have sex, how to respond to a man's ministrations. I lie there, while the writer prods and pokes at me. At one point, he

puts his hand over my mouth, a move lifted straight from my book. I find this disconcerting. Is it meant to be meta? Or has he forgotten the source? After a while, he rolls over and sighs.

'I'm slightly scared-slash-excited you're going to write about me,' he says.

'Oh *no*,' I say. 'I'm done with all that. I don't want moaning about men to become my brand.'

We lie together in the dark, talking about money. I sometimes feel like worrying about money is my second job. I go on Amazon, look at the number of reviews my book has, compare it to other writers' numbers, and try to calculate whether I'll get a second deal. The writer mentions my number, so inadvertently reveals he does the same.

The writer says getting your work on TV is the only way to make real money. His adaptation is further along than mine. I'm annoyed to hear they already have a director. My equipoise is restored when I learn I'll be paid more, should mine ever get made.

'Your agent sounds good,' he sniffs. 'She sounds better than mine.'

'She is,' I say. 'She's a beast.'

'How did you meet her?'

I tell him the story. I like this story; I enjoy its classic patterning. I went to see two agents, and they told me my book was unsellable. This agent was the third. She swept in like a fairy godmother. Or maybe a questing younger son. She read the manuscript and declared it finished. A few weeks later, it was sold.

The writer runs a hand down my spine.

'Do you like her?' he says.

'I do,' I say. 'But I also try to take what she says with a pinch of salt. She's not my friend. It's her job to gas me up.'

'You are *so* clever,' he says. 'You're just brilliant. I adore the way your mind works.'

I snuggle down into the crook of his arm. Maybe I *am* brilliant, I think. Maybe this person isn't laying it on thick at all, but simply acknowledging my true worth. I decide it might be quite nice to go out

with another writer. We could have long, wide-ranging conversations about my brilliance, and he could give me advice on my career.

When I wake up, he is already showered and dressed. He is hurling his things into a bag. He tells me he needs to get back early, because he is cooking dinner for his ex-student. I straighten the duvet and run my finger across a ridge in its fabric.

'Is it a bit . . . *awkward* to like, hang out with people you used to teach?'

'Not at all,' he says. 'She's a mate. She has a boyfriend, so she's safe. The film star was threatened by her. But that's because she's young.'

'The film star or your student?'

'My student.'

'Oh,' I say. And then: 'I guess actresses find ageing pretty hard.'

He tells me he is going downstairs to pay the bill. His manner is brisk and courteous, as if we are colleagues, compelled to share a room at a conference. I run the shower, twisting my hand beneath the column of water, waiting for it to warm up. I've heard stories before, about men being like this after sex, but I've never actually seen it for myself. It's probably a good job my book wasn't a bestseller, I think. Or this sort of thing would be happening all the time.

We check out and he walks me to the station. He strides several paces ahead of me. I try to hold his hand, but it keeps slipping out of my grip, like a fish. He buys me a ticket, checks the platform number and kisses me coolly on the cheek.

'Goodbye,' he says. 'Thank you so much for coming.'

I tell my therapist my father used to pull the same trick. Whenever we went out as a family, he would walk ten steps ahead. He left me with a preference for unobtainable men. I'm not that interested in the men as individuals. I just want attention, all the time.

My therapist doesn't really care about my father. He prefers to talk about my mother. I think this represents a failure of imagination on my therapist's part. My mother is the more dashing character.

People say she has a magnetic personality. My father is dead, so hard to get excited about. I didn't cry when he died. I still haven't cried about it, five years on. I haven't cried about my sister, either.

In the evenings, there are lots of tears. My nieces are staying. Their parents want to FaceTime them just before bed. This annoys me, because I have to deal with the crying afterwards. The girls are easily upset at night, perhaps because they're tired.

One night, they decide to self-soothe, by drawing pictures of their mother's face. They draw her over and over again, using different materials: crayon, pencil, ink. They are trying to capture her essence.

'This family is weird,' I say. 'It's like some weird cult of personality.'

They ignore me. They are making cards for her, to go with the portraits. They tell her they love her, they miss her, they hope her medicine works. The little one looks longingly at her sister's immaculate handwriting.

'E's letters are so neat,' she sighs.

'Yours will be too,' I say. 'You're two years younger than her.'

I put them to bed and they ask for a story. I fetch the big book of fairy tales, the same one I read as a child. I choose *East of the Sun, West of the Moon*. They begin to complain. They don't want this one. It's boring, it's stupid.

'Tough,' I say. 'We're having it. It was my favourite, when I was little. It's about a bear!'

For two weeks, the writer falls in and out of touch. There is no discernable pattern to his communication. Most of the time, it seems as if he puts his phone down in mid-conversation and wanders off. One day, he texts to say he is looking at pictures of me on the internet. I ask him to stop. Instantly, he falls silent, and remains so for six days. He's like a malfunctioning appliance that keeps switching itself off. I experience the urge to bang him against a hard surface, to see if I can get him working again.

In lieu of direct contact, I buy his memoir. I go through it with a pencil, underlining every sentiment I have heard him contradict or undermine in real life. He goes simultaneously up and down, in my

estimation. Up, because he is a better writer than I'd thought. Down, because he is a worse person.

My therapist taps his mouth with a pen when I tell him this. He thinks the writer is bad news. He is unusual, possibly anomalous, in that he is very forthright in his opinions. He always takes my side, about everything. He sees me as a drab, Cinderella-type figure; downtrodden by family, taken for granted by friends.

In common with everyone else I know, he thinks I pick the wrong men. I argue that this one picked me. He found me on Instagram and spammed me with long, lavishly complimentary messages about my book. He seemed to understand that for me, praise works like cocaine. The effects last fifteen minutes. Then I want some more.

'Some men,' my therapist says, 'treat it as a numbers game. He might have messaged thirty women that day, saying the same thing, waiting for one to bite.'

'In that case,' I say, 'he'd have to have read thirty books, in preparation.'

My therapist shrugs, as if this is not beyond the realms of possibility.

'Every time I meet a man,' I say, 'it's always the same story.'

My therapist smiles and spreads his palms.

'Time to write yourself a new story,' he says.

O rson Welles said if you want a happy ending, it depends on where you stop. I have never been very good at knowing when to stop. Perhaps this is why I am never very happy. I was briefly satisfied when I sold my book. Up until then, I had been working in a chicken shop and my book deal felt like a narrative pay-off; one of those fairy-tale reversals of fortune. I thought it represented the end of something: the end of uncertainty, the end of wondering if I could write. I know now that this stuff doesn't go away. The best you can hope for is a hiatus.

The writer says I struggle to finish things because I have high standards. I think this is true, though I don't say so, because I am ignoring him. It is the only way to guarantee a response. He will leave my texts on read for days, but the moment I fail to reply to one of his,

my phone starts to chirrup and buzz. As soon as he gets an answer, it goes quiet again. It is the kind of intermittent reinforcement that makes my dog-brain drool and bay. I cut a deal with the universe. If I call time on this, if I cease to behave like a literal hound, something good will happen. It will be my cosmic reward.

When he next tries it, I send a firmly worded text. I tell him he is a nice person, but I don't like his communication style. I say I'm sure it would be fine for some women, but it doesn't suit me. This is a lie: I'm sure it would be fine for no women. But I feel strangely guilty; I'm trying to sugar the pill.

I go to see my therapist, and show him the exchange. He isn't as pleased as I thought he'd be. He says I'm making progress, and that the writer's reply is manipulative. And then the discussion moves on.

But then something else happens. My sister calls. She is sobbing, which is unlike her. I hear her and my heart contracts. This can't be good, I think. This is not how good conversations begin.

'It's gone,' she says.

Her voice sounds tiny, as if she is trapped at the bottom of a well.

'*What?*' I say.

'The cancer. It's gone. The consultant says I have to finish my chemo, but it's already worked.'

I am so stunned, I have trouble organising my response. Finally, I burst into tears.

'I can't believe it,' I keep saying. 'I can't believe it.'

'Neither can I,' she says.

A few hours later, I sit down at my desk to check my emails. There is one from my agent. My book has earned out its advance in America. She attaches a summary of my royalties. For the second time that day, I am winded by shock.

I leave the office early, walk to the supermarket, and buy a lottery ticket. ■

Martha Sprackland

Animal Rescue

Will it die? he asks. I think it will, I reply,
and we watch it a little while, the wind-
shiver of its disputed breath. He says,
When you write about it, you should say it was
a different kind of animal. Not this. No? I say.
No! he says. *You know that,* and I do.

PAVLO YAREMAK
Set of Yevhen Stankovych's opera *The Terrible Revenge*, 24 February 2023

A REPORT ON MUSIC IN UKRAINE

Ed Vulliamy

M en arrive on crutches, two in wheelchairs, through a wintry
dusk at the monumental neo-Renaissance opera house in
Lviv, Western Ukraine – built for the capital of the then autonomous
province of Galicia between 1897 and 1900. Some hundred seats
tonight have been reserved for serving soldiers, who enter the
lobby – a *fin-de-siècle* wonder – in military fatigues. They check
these in, so that the coat check looks like a barracks locker room. A
contingent of some forty cadets from the city's emergency firefighting
department duly arrives, disarmingly young. For most, it's a first
night at the opera.

The occasion marks the anniversary of Russia's full-scale invasion
of Ukraine – a concert dedicated to the troops who have fallen during
this first, monstrous year of war, and the innocent civilian lives lost.
But also to 'The Invincible': homage in music to Ukraine's noble cause
and just war. The programme is *Bucha. Lacrimosa* by Victoria Poleva,
composed in commemoration of the victims of atrocities in that town
during the early weeks of the war, followed by Giuseppe Verdi's epic
Messa da Requiem. The stage is blackened, and on each flank red roses
are arranged and affixed so that petals fall towards the ground. A bunch
beneath the conductor's podium is upside down, an inverted bouquet
of flowers tumbling towards, rather than growing from, the earth.

Before the curtain, an announcement: 'In the event of an air raid or siren, we ask you to adjourn to the shelter. If the air raid warning lasts less than an hour, the performance will resume.' Orchestra and choir take their places, followed by Canadian-Ukrainian conductor Keri-Lynn Wilson, creator of the international Ukrainian Freedom Orchestra.

Bucha. Lacrimosa opens with hushed percussion, conjoined by solo violin – desolate and sparse throughout. Verdi's Requiem is terrifying at the best of times, and tonight Wilson achieves something strangely cogent: the notion of 'restrained Verdi' should be oxymoronic, but it turns out not to be. Subdued solemnity from the start; Verdi's cry against the outrage of death is shattering for the usual reasons, but focused by uncanny understatement entirely appropriate for this occasion.

The young fighters and firefighters are enthralled. During the day, through the doors of the former Jesuit – now Greco-Catholic – church wherein military funerals are held, coffins were carried in by their comrades, for benediction, then back down the steps, accompanied by a dirge from a military band and followed by young widows and scores of other mourners in tears. The same had happened the day before, and the day after. Now, Verdi's unforgiving 'Dies Irae' erupts from Wilson's discreet sonority, a swirl of acceleration and deceleration; mezzo-soprano Anastasiia Polishchuk's delivery piercing the air, and with it her audience's collective heart.

At the end, bouquets of roses presented to the lady soloists and conductor are peace-white rather than blood-red, and Wilson picks hers apart, stem by stem, throwing each flower to the military sitting in rows A to F. There are photos of ranked soldiers and firefighters on the foyer steps in front of a portrait of Solomiia Krushelnytska, the great Ukrainian soprano. Then out into the night.

Two evenings later, a different but no less impactful event: a new opera by Ukraine's prominent composer Yevhen Stankovych, *The Terrible Revenge*, based on the Gothic horror story by Nikolai Gogol, born in Poltava – then part of the Russian empire, afterwards the USSR, now Ukraine. Significantly, the libretto, by Stankovych, is

a resetting for stage in Ukrainian of Gogol's original Russian prose.

Here is a dark masterpiece of cruel but cathartic prescience, composed – and the production designed by the Germans Andreas Weirich and Anna Schöttl to commemorate Stankovych's eightieth birthday – before the Russian invasion. The story concerns the Antichrist, poisoning love and unleashing violence at an intimate level: he is also the father of the heroine, Katerina, whom he violates and murders. But it is also about the final defeat of this monster, hurled into an abyss by a young boy.

In several images during this war – including an anniversary postage stamp reproducing a mural by the British street artist Banksy – Ukraine has been portrayed as child David felling Russian Goliath. 'Now,' writes composer Stankovych in a programme note, 'all of this resonates with our reality, and what is happening.'

The work is conceived and performed on an epic scale; three long acts, Gogol's quotidian setting being used to deal with apocalyptic themes. Chiaroscuro lighting isolates the characters in a voluminous umbra. Stankovych's orchestration is vast, deep and dense, and especially remarkable for its use of woodwind. Katerina is like the great heroines of Leoš Janáček's operas, but – Stankovych says in conversation later – 'with a metaphysical dimension, between worlds, in Gogol's story, accompanied by her spirit character'. There is a dreadful but moving scene wherein she laughs, possessed, then dives into bunches of lilies, at once symbols of her marriage and the Annunciation. She is drowned by her sorcerer/father in a bath of water blessed in another scene, but her previously abducted child reappears, hiding behind a cradle, to overthrow the Antichrist.

'For the first time ever,' reflects the opera company's literature and drama director Alina Plakhtiienko, 'I ask myself: is this a time to play and hear music, with so many people dying? But I realise: there is no right or wrong time for music. Russia is trying to destroy our country and our culture, and so long as music is played in Ukraine, they will have failed in this. We still have culture, and therefore our nation.' We are talking in an elegant room at the theatre, once the private cabinet

of Emperor Franz Joseph I, with its own bathroom and door into the royal box.

Of these two unforgettable performances, Plakhtiienko says: 'These were occasions on which to step back from our lives of daily tragedy, and think in music about those soldiers who died for our independence, and all victims of this Russian terror, especially the children. Verdi's Requiem needs no explanation. And *The Terrible Revenge* conveys exactly what is happening now and, in its title, what we want: revenge against our enemy.'

Nights at the opera in Ukraine – where everything, including every kind of music, has changed.

Andriy Khlyvnyuk and his group take a break. This is not Andriy's band with which he plays as Ukraine's most famous rock star, but a unit of fighters from the front line.

Andriy is the songwriter and vocalist for Boombox, Ukraine's best-known band over the past two decades, recently launched to international stardom after a collaboration with Pink Floyd, with whom Andriy recorded, in April 2022, a searing rendition of 'Oh the Red Viburnum in the Meadow', a Ukrainian patriotic march of 1875, reset to music during the First World War. It goes: 'In the meadow a red viburnum bends down low / Our glorious Ukraine is troubled so / We'll take that red viburnum and will raise it up / And our glorious Ukraine shall, hey, hey, rise up . . .' Andriy recorded the vocal track in Kyiv, wearing camouflage and a New York Yankees cap, for Floyd's superstars David Gilmour and David Mason to accompany from London, under the title 'Hey Hey Rise Up'.

'This is my other band,' Andriy beams this evening, waving an arm around the company at the bar, enjoying beers in Kyiv, grateful for the intermittent electricity. Almost immediately after the Russian invasion, Khlyvnyuk joined the volunteer unit of the patrol police, TOR, or Tactical Reaction Operations. This is no normal police beat: Andriy proudly shows a video of his patrol crew in combat fatigues on the front line, deploying a Punisher drone against the enemy. The

remote-controlled glider can discharge munitions at a distance of up to thirty miles. The video shows the Punisher unleashing a bomb on a Russian tank. 'I call it a Ukrainian parking ticket,' Andriy laughs. 'Your vehicle is illegally parked in our country!'

Khlyvnyuk orders another round and introduces the 'band'. There is Zhenya, a professional soldier during the Russian annexations of 2014, and expert sniper, now returned as a volunteer. Miro is Ukrainian-American, a former US Marine from Los Angeles who has served in Afghanistan. Serhiy will only touch soft drinks, and says little; he's mostly on his mobile phone. The unit commander, Leonid, passes by the bar to say hello. Girlfriends arrive and talk shifts from war to music and love – until curfew at 11 p.m.

The world has been stunned by the courage and efficacy of Ukraine's resistance fighters. But few of these are professional soldiers: most are yesterday's taxi drivers, plumbers, computer programmers – and musicians. People who until February 2022 were singing into microphones, spinning discs, playing clarinets or guitars, are now learned in the arts of war. Overnight, they have become perhaps the most formidable fighting force in the world. Andriy Khlyvnyuk is one of them.

Andriy has a way of entwining stardom with humility; his manner mischievous and straightforward. In Kyiv Andriy must stop every few yards to pose for pictures; it takes us twenty minutes to get through a street market on a winter's day when seven missiles hit the capital city.

'Here I am trying to eliminate my own public,' Andriy tells me. 'Eighty per cent of our sales were in post-Soviet Russia. We won the biggest Russian music awards. These people bombing Kyiv today danced with their fiancées to my songs at their school graduations and weddings. These same men are now here trying to kill us, and I am trying to kill them.'

I ask Andriy: was it hard to shift from being the country's most famous rock star to a soldier under orders? 'I thought it would be,' he reflects. 'I was afraid of the brutality, noise and dirt of war. But it wasn't – it was surprisingly easy.' Why? 'Look, if I was sent somewhere to fight, I'd be useless, terrified; I don't want to kill or be

killed. But that's not what happened. They came for our streets and our children's playgrounds.'

Khlyvnyuk makes the point by referring to the manager of the band, Oleksiy Sogomonov, from Makariv, scene of heavy fighting in the war's early stages. 'Our guys were confronted by the Russian airborne forces. We kicked the shit out of them. Oleksiy grabbed a tank and neutralised it, and was nominated for a medal. Just imagine: this foxy punk gets decorated without even leaving his own neighbourhood! He was fighting for his own home. They came for our houses, and turned people like Oleksiy into war heroes.'

Andriy explains his motives for joining the TOR. 'Music is a universal language. But music also comes from where you come from; it reflects on the feeling of home, and what home means – and on the obligation to protect your family, your neighbour. Anyone who grew up to learn their language, and their poets and music by heart knows to say to the empire, any empire: "You will not do this to us." ' He recalls the time his unit 'went into Bucha when our army was pushing forward, and we saw our people – kids, wives, fathers – killed for their phones or cars, lying there, being eaten by their own starving dogs. So: what does it mean to be a human being when he or she finds themselves looking at this, or in trench warfare? This is not some natural disaster in Ukraine – this is being done to us. You have two options: run, or fight back.'

The war, he says, began in 2014 after the annexation of much of Donbas and Crimea. 'That's when Boombox stopped playing in Russia, unlike many others – young bands who couldn't resist the market. Since then, there's been a sense of the storm coming. But who'd have thought that our audience, those people who cried, laughed and danced to our songs would come to kill and rape us. That's the shock. It's beyond good and bad, it's even beyond irony. When this war is over –' he pauses to consider the possibility – 'we will have time to think: How did this happen? Russians didn't believe the artists and the songs they loved; instead, they believed their ruler, they chose to. I think of Goebbels and his propaganda: it worked.'

Boombox was formed in 2004, and their debut album *Melomania* made an immediate impact with its raw, flinty sound. They have played across Europe, Russia and America. Their spring 2022 tour was cancelled by the advent of war. Plane tickets to San Francisco were purchased, at the ready.

Khlyvnyuk's influences? 'Jimi Hendrix plays 24/7 in my vehicle.' We talk about Hendrix's cry about and against war, 'Machine Gun'. Which prompts Andriy to tell a story: 'I really wanted a machine gun, and one day I was delivering cars to a special forces unit. The commander asked me: "What are you fighting with?" and I replied: "All they give me is a pistol. I want a machine gun." The commander said: "As it happens, I killed a Russian yesterday, and took his gun. Have it." And he gave me a good PK general purpose machine gun. I said I needed some ammo, because the gun was useless without. And the commander said: "Honestly, you young people, you want everything! I do have a couple of clips though –" and he gave me them too.' Khlyvnyuk shows me a photo of his proud acquisition.

The most recent Boombox album, *Secret Code: Rubicon*, of 2019, was laden with forewarnings – songs like 'Drantya', with its raw, metallic menace: 'This is the last of your nine lives / Remember what you died of.' 'The album was about what the world seemed to look like in 2019,' says Andriy, 'but now in 2022, it's taken on a whole new meaning. Now we know what can happen.'

'War doesn't accept all music,' Andriy tells me, 'and not necessarily the music you'd expect. In war, people need to sing and laugh. Perhaps even the Russians are singing and laughing. It's interesting to see why a certain song works in a war, and another doesn't. I've yet to find an answer, but my hunch is that war needs love songs more than social and meaningful songs – mostly the love songs work better.'

The war has produced a genre of martial metal – one relentless song from a band called Surface Tension goes: 'Your mama won't come to fetch you / But the wind will blow your ashes . . . We will kill you all.' But, says Andriy, 'I know guys going into battle loaded with weapons, tattoos up their necks, hardcore – but they're not

singing [Black Sabbath's] 'War Pigs', they're singing something pop, something easy, or perhaps a Beatles song just for the melody – a love song to make them smile!'

Playing during the war is different, he explains. 'It's not a commercial act playing a show any more, it's a fundraising tour to keep our police units on the front line. We will play music so that our riflemen can fire bullets . . . Now, it has to be a communal thing, playing to people who have an extra reason to be Ukrainian together – a meeting of people with a common pain, people who've been to hell and back and have a story to tell.'

A rendezvous with Detcom, one of Ukraine's most renowned and beloved DJs, is fixed for the grounds of an empty school. It's a pluvial afternoon in the port city of Mykolaiv, at that time under relentless bombardment. There he is, waiting in the rain, wearing combat fatigues. Detcom is more than a DJ: he is one of the leading promoters of raves and musical events in a country that recently asserted itself as Europe's creative capital of electronica.

On the morning of our meeting, two Russian S-300 missiles slammed into the facade of the Petro Mohyla Black Sea National University, primarily a theological college, destroying it and twenty-seven houses. But the Grifel cafe in Mykolaiv is warm and agreeable. 'Here we are,' he says of his new life at the front. 'Shop workers, small businessmen and me, a rave DJ! Suddenly fighting this huge war.' It started with the Territorial Defence, he says. 'I decided: I cannot not do this. I started keeping guard on checkpoints, delivering medicines. Now I'm a soldier. Now I know how to fire an RPG, now I'm in the trenches, and I know how to dig them, properly, with dugouts.'

For some time, Detcom has been sharing photographs of comrades and friends who have been killed as Ukrainian forces moved to liberate occupied Kherson to the south; he sends them to me via WhatsApp: just a picture, and a name, in tribute. Kherson was liberated, but without Anatoly, with his four-square stare, or the older, bespectacled Oleg, pictured sitting in the corner of an L-shaped trench with a

camouflaged sheet around him, against the mud and rain.

Detcom was born in Kharkiv, and moved to Kyiv when it became 'famous across Europe for big raves'. But electronica's right-wing adversaries politicised the music by hating it; gangs of neo-fascists even attacked raves, throwing rocks and overturning furniture. 'We never looked for trouble with the right,' Detcom says, 'but at some point, the techno community became its enemy.'

But the coming of war in Ukraine has seen a remarkable tolerance – and even union – between erstwhile foes in youth and identity culture. Fault lines that exist in peace conjoin in times of war; former enemies realising that they now have much in common against a common enemy. Western visitors have been surprised to find militant patriotism – advocacy of 'the political nation', as Detcom calls it – to be just as strident among alternative, avant-garde and LGBTQ+ radical cultural circles as they are among the conservative and hard right.

Detcom's primary adversary on social media before the war was a prominent and public right-wing extremist called Karas – 'we were, shall we say, online enemies. But now it turns out we share the same aim: freedom for our country.' Now, Detcom and Karas discourse on Telegram, in the cause of national liberation. 'I admire what he is doing for the war, and he appreciates what I'm doing. With the war, people with such opposing views as ours can discuss their differences. And when we beat Russia, I hope we'll be able to understand each other better.'

What does one believe in here? 'Well, they say there are no atheists on a sinking ship, and there's none in a trench either. Things that felt important then are insignificant now. I miss those times, but now I know how precarious it all is – human life, happiness. What does one believe in now? More weapons, whatever it takes to kill more Russians. That we must drive them out of Ukraine – forever this time.'

On the right bank of the wide Dnipro River as it flows through Kyiv lies a neighbourhood called Podil – 'down under' – of disused brickwork industrial buildings, now strewn with graffiti, a warren of clubs and subterranean dives. Tucked away next to radio

station 20 Feet is one of the clubs that Detcom frequented and performed at: Closer, a funky space and garden with a slide to play on and a teepee for lovers to cuddle up in. Playfully serious and seriously playful, Closer still stages raves (though they happen in the afternoon now, to be over in time for curfew), as well as jazz-fusion nights that showcase sophisticated music.

The club used to be assailed by gangs of right-wing militants 'because they were against everything we epitomise', Serhii Yatsenko, the manager, tells me. 'Dancing, gay rights and LGBT, drinking, drugs, whatever.' But after the Russian invasion, the elderly resident gardener at Closer designed a special outfit for snipers to wear as camouflage, to appear like a bush. The club offered their design and product to a militia made up of members of Right Sector, one of the groups that used to attack them, 'for a laugh, really; to show them we're on their side in this fight'. Closer went on to add a fleet of customised cars to Right Sector's war effort, and in return came a framed diploma of official thanks from the group. 'We look forward to welcoming them back!' jokes Serhii.

Although Ukraine is losing fighters at a terrifying rate, there is still no conscription – a line that many non-combatants of fighting age fear may yet be crossed. Aleksandr, who runs Closer's estimable vinyl record store, calls his metier a 'guilty pleasure, while people are fighting. What I dread most is a kind of hedonism here in the city, while those boys fight for us.' 'We are motivated by guilt, basically,' says Serhii, 'because we are not at the front. People come here whose friends are fighting and dying . . . So we try to make it all down-tempo, meditative.' And sure enough, the jazz-fusion jam begins, with a haunting six-note riff played on the trumpet by Pavlo Halchenko.

Rather than hedonistic revelry, this is more of a private recital, 'dedicated to our armed forces', says Pavlo, 'without whom we would not be here'. A couple of lads in fatigues nod in acknowledgement of a ripple of applause, and sip their beers, on the house. The night, which months ago would have ended past dawn, concludes at 9 p.m., with the last metro at ten and curfew at eleven.

Taras Topolia keeps his military kit packed and ready by the front door of his apartment in Kyiv in case of an emergency call from his battalion. His wife and children are far away, in America – they, at least, are safe – so that he has the place to himself when back on leave from the front. The kitchen clock stopped at 6.35 a.m. on 25 February, the morning after the Russian invasion, 'just as we were packing to leave', says Taras. 'We stayed at their grandparents while sorting out their journey, then I returned to Kyiv to report to my battalion. That's the last time I kissed my wife and kids.'

Taras – now under the command of the 130th Battalion of the Territorial Army – is no ordinary soldier: he is Ukraine's most celebrated pop singer of catchy hit melodies, with his band Antytila (Antibodies). 'We were preparing to release our album on 25 February. It never appeared,' he says. 'Now everything has changed, and I'm unsure it ever will.'

'I never thought I'd be doing what I am doing,' says Taras, 'learning to kill, and trying to save my fellow soldiers from being killed. We're musicians, and you have to sing, even during this period, to keep the voice strong. And of course I sing when someone asks me to at the front, to boost morale. But being a public figure is not the main thing for me now. In the trenches, I'm just another soldier.'

He looks back: 'I wrote songs that make people happy – our music has a light inside it.' But, he says, in counterpoint to Andriy Khlyvnyuk, 'it feels wrong to sing these love songs at such a time. If I were to write anything now, it would be about what is around me, and it would upset people.'

The group was formed as a five-piece pop band in 2008, and rose quickly to fame with hits like 'Rosy Maidens' and 'Kiss Me More'. But during the Maidan democratic uprising of 2013, Antytila felt propelled to engage more seriously with Ukrainian society and politics, 'We were part of the revolution for dignity, and played on the stage during the Maidan protests,' says Taras. A video for the title track of their album from 2015, *In Books,* shows a little boy – an embodiment of Ukraine – running in flight from the city to fields of

corn, where he is found and returned home by his father, who wears military fatigues. President Zelensky appeared on the video for a song called 'Lego'. By the time of the 2022 invasion, Taras and his fellow musicians had already joined the Territorial Defence.

After the invasion, Antytila asked to join – by video link – a concert for Ukraine given by international stars in Birmingham, England; but the organisers rejected their offer because Antytila were fighting in the resistance. Their cause was taken up by the singer Ed Sheeran and superstars Bono and The Edge of U2: Sheeran recut his hit '2step' to feature Antytila, and the Irish duo staged an acoustic concert in a Kyiv subway station with Taras during their visit to Ukraine in May 2022.

Taras began learning classical violin aged six, studied as a chorister, then continued at the Kyiv conservatoire. 'I may not look like an academic [classical] musician, but I am. I don't actually have the attributes of a pop star – I have an analytical and academic mind.' His influences? 'Chopin, Stravinsky and Berio. I was an academic musician, disinterested in modern music,' he says, until 'the moment U2 became the biggest band in the world. That's when I realised what was out there. So that to sing with Bono was a dream I never hoped could come true.'

How will the war change Antytila's music? 'To be honest, Antytila has not always made the music we wanted to create. It's been targeted to an audience, and you lower your standards to do that. Now I will sing what I feel. What's the point of a song if it doesn't do that? When this is all over, if we survive, no more compromises with the commercial market. If people want songs that are not true, they won't get them from us any more. We'll present bad-tasting medicine in a sweet wrapper.'

And that is exactly what has happened, though the wrapper was not as sweet as Taras suggested. On the first anniversary of the invasion, Antytila headlined a major solidarity event and concert in London's Trafalgar Square. They played a newly written song, the video for which is a searing cry of rage and tribute, filmed inside a warehouse in the embattled town of Bakhmut and cut with merciless footage of the battle. Taras sang at full volume into a walkie-talkie:

'Bakhmut Fortress / All our prayers are here / And hearts of steel spirit . . . They give us strength from Heaven / Will, fire and fury! . . . Mom, I'm standing / Motherland, I'm fighting.'

Ukraine's second city of Kharkiv is subject to unforgiving bombardment. During the late afternoons of winter the city plunges into a silent darkness even when there is electricity – this is voluntary, done out of necessity, for the nocturnal cover. As night falls, the deep boom of explosions seems to ebb and flow – afar but audible, now horribly and loudly closer, then further again.

The next day there's a sudden burst of song across a shopping arcade on the city's frayed outskirts, between Bambi, the children's clothing store and Violet Balloon boutique.

This is one in a series of pop-up recitals by soloists and musicians from the Kharkiv State Academic Opera and Ballet, now rebranded Skhid Opera – *skhid* meaning east. It's a lovely folk song, accompanied on violin by Vera Lytovchenko, with blue and yellow ribbons on her instrument. The company performs similar concerts in hospitals, schools, metro stations and military installations. Here, shoppers rest their bags, children pause from chatter, teenagers park their phones, and everyone listens. 'It's more real than playing in the opera house,' says Lytovchenko, 'almost too real. This is the most important time of our lives, and therefore these are the most important performances we'll ever play. Before, people came to us to listen – now we go to the people to play. It's unlike anything we ever did before the war. It's a way of saying: we're not afraid.'

This afternoon's programme is almost entirely of Ukrainian traditional songs and arias from operas by Mykola Lysenko, the late-nineteenth-century composer. Singing baritone is the opera company's artistic director Oleksiy Duginov, who tells me this period has brought about 'a complete reassessment of values, a whole new understanding of what it means to be Ukrainian – and we hope that music will be part of that.'

Igor Tuluzov, CEO of the opera house, watches and listens with

a smile. 'Since the beginning of the war, we've had trouble with the building itself – the roof was torn off by a missile,' he says. 'We had an orchestral concert, but had to evacuate because of a bombing raid. So the performing changes completely – as does the repertoire,' he says. 'I hope one day at least part of the Russian canon will return to Kharkiv, but for now we have resolved not to play any pieces by Russian composers.'

Duginov, Tuluzov and I reconvene for coffee the next morning. Tuluzov tells me how he began his career in space physics, later moved into crisis management before beginning what he calls 'my second education, in theatre – and now a different kind of crisis management!' Can the opera company play any Russian music? 'It's hard to find the borderline between good and bad Russians,' replies Tuluzov. 'But the mood here is militant. No, we cannot play music by any Russian composer.'

Duginov posits that there is something aesthetically and aurally totalitarian in much Russian music, 'part of the genetic code in Russia's metaphorical DNA, a culture of authoritarianism and servitude.' To which I counter: What about Dmitri Shostakovich? What could be more anti-totalitarian than his music and story? 'I love Shostakovich,' concedes Duginov, who cites one of the composer's most overt mockeries of Soviet ethos and Stalin specifically, the satirical cantata 'Antiformalist Rayok'. Duginov's eyes widen, 'It's brilliant! I sung the baritone part of "No. 1", which is Stalin.' And he reflects, as though putting the discourse on hold: 'as time passes, we'll be able to we'll take a proper look at all this. As the wounds heal, people will welcome back Russian music, and when that happens, we will play it to them. But not now.'

The discourse is a reflection of the wider cultural landscape: across the country statues of Alexander Pushkin as well as those of Catherine the Great are being felled; streets formerly dedicated to Leo Tolstoy or Mikhail Bulgakov have been renamed. Effectively: the purge of Russian culture from Ukraine – which poses a problem in the matter of language in Kharkiv, where Russian is the predominant

quotidian tongue. 'But it's not a question of language,' says Tuluzov, 'it's about spirit and mindset, who and what we are. The division is between European democratic values and Russian imperial values.'

Nevertheless, the assertion of Ukrainian language – and its hegemony over Russian – is quintessential to the final forging of what Ukrainians call 'the political nation'. Libraries, including children's libraries, will keep Russian titles, but often do not display them, and acquire no new Russian books. Born Russian speakers – especially young ones – learn and turn to Ukrainian, eager to make it their first language. Here in Kharkiv, the most interesting local folk band, called Morj (Ukrainian for 'walrus', inspired by The Beatles song), have abandoned all their Russian lyrics and now sing only in Ukrainian. Roman Galaborda, who plays every conceivable wind instrument for Morj, grew up in now-occupied Luhansk, Russian-speaking, but, he says, 'even if I speak Russian privately, Ukrainian is my public language now, and that of the group'. Galaborda, who is blind – which, he says 'makes me read sound better' – learned his craft by studying Indian and Persian instruments. He was transfixed by their microtones and chromatic potential. Now, he finds the same in an instrument called a kaval, played by shepherds in the Carpathian Mountains, 'which you could call folk music if you wanted to, inasmuch as it is connected to the soul of the land'. And it is this word 'soul' which Tuluzov at the opera also deploys, and which, he argues, makes the matter of a musical separation from Russian culture even more important than a linguistic one. But in the field of music, Tuluzov tells me, the question becomes more complicated: 'Literature and language are for the brain,' he says, 'but music is for the soul, and all the more important for that.'

The resolution to avoid Russian music spans Ukraine, from north-east Kharkiv to the far south, where the Odesa Philharmonic Orchestra continues to perform in its magnificent theatre, built from 1894 to a neo-Venetian, neo-Ottoman design. Their concerts are now often interrupted by sirens or missile attacks, and they are forced to either abandon the programme or adjourn to the shelter below.

Principal conductor Igor Shavruk – who has spent much of his career conducting in Russia and Britain – explains. There is a 'hierarchy, in terms of what cannot be tolerated, and Tchaikovsky is top of the list. For Russians, he epitomises the national essence, so that for Ukrainians, he epitomises Russian imperialism.'

But what about Shostakovich? 'I do consider him to be an anti-Soviet composer,' replies Shavruk. 'He's a tragic, creative force, and I actually think it would be very interesting to play Shostakovich in this situation, but –' But? 'I have to respect the sensibilities of my audience. In this situation, people think of him as a Russian composer, not an anti-Soviet composer. I defer to the emotional climate; we cannot be searching out reasons to bite one another in this present situation.

'We never know who we will be in wartime,' reflects Shavruk. 'The strong may weaken, the weak might find strength. When the guns speak, must the muses be silent? We may not be able to break through the Russian lines with music, but we can feed people's will to do so.'

The week after the anniversary of the invasion, Kyiv's national opera gave a new production of Verdi's *Nabucco*, with all it signifies: Israelite prisoners of Babylon as metaphor for Italy's struggle for liberation from Hapsburg Austria–Hungary – now so resonant in Ukraine's war against the Russian empire. But also in the National Opera's mainstream repertoire is Ukraine's favourite, *Natalka Poltavka*, by Mykola Lysenko. The story is about power and love in a peasant village, but it was also a snipe at the Russian empire at the time of its premiere in 1889 – pointed towards imperial Romanov Moscow in the same comic-but-serious way that Smetana's *The Bartered Bride* took aim at Hapsburg Vienna. *Natalka Poltavka* was sanctioned by Russian officials, and Lysenko was later jailed in 1907 for supporting the 1905 uprisings against tsarist authority.

Crowds arrive for a matinee performance – the young lady in the seat behind me is here for the first time – 'Despite the war?' I ask. 'Because of the war,' she replies, 'because we don't know what will happen next.' My guest is Iaroslava Strikha, a literary critic

and translator of western European and American literature into Ukrainian. She calls the opera 'peasant kitsch – something important to Ukrainian identity. *Natalka Poltavka* is tableaux humour, but also a slur against the old imperial order, and thereby a nourishment of our national identity. It's funny, but it isn't. If you see it through the eyes of the empire that oppresses us, it's not kitsch, it's serious, even dangerous.' There's a line in that comfortless Boombox song of 2019, 'Drantya': 'Fierce kitsch is à la mode.' It certainly is.

Anatoly Mokrenko, director of the National Opera, receives me in his office next morning. *Natalka Poltavka*, he says, 'is symbolic for us, for reasons historical and recent. It was the last piece we gave on 23 February, the night before the invasion. We reopened on 21 May with Rossini's *The Barber of Seville*, to demonstrate loyalty to Europe. We worried whether people would come – but it was sold out. The next night, we took up where we left off, and revived *Natalka Poltavka* – and again sold out.' (Mokrenko qualifies this: 'The opera house usually seats 1,304 people, but we can now only welcome 430 guests, because that's the number our shelter can accommodate.')

When the house reopened, says Mokrenko, 'I was determined to give comedy, and Lysenko specifically, because comedy has its meaning, which is not always funny – and that is the significance of *Natalka Poltavka* in Ukraine. Not all my colleagues agreed, they thought this was not the time for *opera buffa* of any kind. They had a point, but I argued that this was a matter of culture against barbarism. The situation allows us to reconsider ourselves, and the world around us. We are not the front line, but we are part of the war, because this work is an integral part of our culture.'

At the opera house in Lviv – last November, months before the anniversary solemnities – there was pure comedy: Donizetti's *Don Pasquale*, with its sway, lilt and effervescence. It's played for fun, but as Alina Plakhtiienko affirms: 'comedy is only partly funny'. The previous night, some hundred missiles had rained down on Ukraine – seventy-two were shot down, but of the twenty-eight that reached their targets, eleven landed on Lviv, far as it is from the front

lines. At the end of *Don Pasquale*, something I have never seen: a standing ovation for a comedy, and almost every eye moist with emotion.

After the performance, Plakhtiienko and I are joined by Olha Lozynska, who directs the opera house's glorious mirror hall for choral and chamber music. 'The night we reopened,' she says, 'was the Orthodox feast of the Annunciation. We played settings by Lysenko of Taras Shevchenko [the iconic poet of Ukraine's nineteenth-century Romantic nationalist revival], and our audience was completely different from before the war. Before, when we played the mainstream repertoire, 70 per cent of those present were tourists; for national music, the hall was more than half empty. But for this, we were sold out to an entirely Ukrainian audience. And I understood that night the extent to which music is part of this moment. No empty seats – not that night, and never since. I think that with this war, people are discovering music, especially our national music, even when we are emotionally exhausted.'

Two nights after *Don Pasquale*, the ballet company presents *Esmeralda* by Cesare Pugni, based on Victor Hugo's *Notre-Dame de Paris*. Beneath the Gothic arches, there's a lovely pas de deux by two ballerinas dressed in white, with sashes and scarves. One of those dancers is Roksolyana Iskra, who recalls how on the night the war began, 'we were due to perform *Scheherazade*, by Rimsky-Korsakov. Nobody could believe it had happened, and we all thought the same thing: should we give this Russian music now? We'd been rehearsing for three months, but now everything had changed. Our director was clear: we cannot, on a point of dignity. And we all understood.'

So the conversation from Kharkiv and Odesa resurfaces in Lviv. 'On the matter of Russian composers,' says Plakhtiienko, 'we have the right to be categorical.' Iskra invokes the Jewish aversion to Wagner: 'I adore Wagner,' she says, 'but I understand that a generation of Jews could not listen to him after the Holocaust. Now they can, but it took a generation. We today cannot listen to Tchaikovsky for similar reasons. Now most Jews can listen to Wagner, and maybe one day, my children will listen to Tchaikovsky.'

'When Ukrainians listen to Tchaikovsky,' adds Plakhtiienko, 'they are listening to a genius, no denying that. But when they listen to Tchaikovsky now, they will hear the sound of a missile, or the cry of a mother who has lost her son. That is our Russian symphony.'

There's an overlap in personnel between the opera house orchestra and the band playing at Lviv's iconic jazz and folk club, Dzyga, which opened during the early years of independence, in 1994. Opera orchestra oboist Yuri Khvostov is part of an intriguing ensemble, Pyrih i Batih, playing music that defies category – folk, perhaps, but with overt references to classical.

Lead vocalist and guitarist Marian Pyrih plays his instrument with a singularly effective technique: he strokes the strings horizontally with bamboo sticks, to and fro into the guitar aperture, creating a shimmering sound that is at once eerie and rhythmic. His colleagues play violin, double bass and percussion, plus Yuri on oboe.

Dzuga was started by a group from Lviv's Vyvykh arts festivals, for 'music, avant-garde happenings, theatre and installations', as Pyrih recalls, inspired by the Czech band The Plastic People of the Universe, two of whose members were jailed for their avant-garde styles during the 1970s. 'Like The Plastics,' says Pyrih, 'the pro-Russian authorities before Maidan made us political by hating and harassing us. There were no normal clothes at our festivals.'

The music playing at the club is striking: it draws on jazz and folk chromatics, but also those of Janáček and Bohuslav Martinů. There's an arrangement of Mykola Leontovych's traditional song 'Shchedryk', but with a coda based on Procol Harum's 'A Whiter Shade of Pale', with its quotations from Bach's Orchestral Suite No. 3. Most of these pieces are settings of Ukrainian poetry, by writers whose lives and work were prescient of today's defence and attestation of Ukrainian nationhood. Most cogently: 'All Around Me – Cemetery of Souls' by Vasyl Stus, who joined the opposition to the Soviet regime during the 1960s, was arrested in 1972, and served time in labour camps. He was rearrested before the 1980 Moscow Olympics,

and sent to the infamous Perm-36 camp near Kuchino, where he went on hunger strike and died in September 1985, under unknown circumstances – either he starved or he was murdered. Stus was in solitary confinement at the time of his death, but a previous cellmate, Vasyl Ovsiienko, investigated a cry from Stus's cell of 'Damned murderers!' after lights-out on the night of his death, and reports of a stabbing on order of the authorities. One reason for the murder may have been to prevent Stus from receiving a Nobel Prize – an émigré committee had just been established in Canada to nominate the poet. Seven other prisoners in the camp died between 1980 and 1987, of which three others were, like Stus, members of the dissident Ukrainian Helsinki Group. 'Cemetery of Souls', sung as invocation with an extended instrumental coda, sends shivers down the spine; a spell is cast over the two hundred people who are gathered here. 'All around me is a cemetery of souls / In the white cemetery of the people. / I swim in tears, in search of a ford / A beetle flies above the cherries. / Spring. And the sun. And the green.' At the end, there's a painful but pregnant silence before anyone dares to applaud.

Pyrih receives me at his basement apartment in the arty old depot neighbourhood, beside a park wrapped in snow. On the wall above his desk is his grandfather's ammunition belt: Pyrih uses the bullet straps to store tubes of paint and brushes. 'Thirty-five years ago,' he says, 'Stus's body was brought back to Kyiv to be entombed. There was a mass gathering of blue and yellow flags – the police could do nothing. Stus is an inspiration to all of us. Oddly, his voice sounded so much older than he was, but it suited his face.'

Pyrih explains to me why he plays this music during wartime. 'Music doesn't change. Music is a constant, and does not remember. But we remember music, and during this war, music becomes an affirmation. I consider myself close to the classical tradition, but our music also connects you to the power of the earth beneath your feet – even if it's concrete! The chromatics mean something, and folk music reflects the energy of the land itself. In this crisis, that becomes more important: we are trying to work on a new Ukrainian music astride

the classical and folk traditions, one that resists Russian influence.

'The project,' as Pyrih calls it, 'is also based on poetry, and blending the sound of Ukrainian language with musical chromatics. It sounds paradoxical: that you have to convey your language through music, but that's what is happening. I'm trying to find my way, using work by Ukrainian poets who were persecuted or killed by Russia, and setting it to chromatically appropriate music.' Outside, an air raid siren wails across the oncoming night. Pyrih stays put in his apartment and accompanies it – or it accompanies him – with a setting, sung a cappella, of a poem by Shevchenko called 'My Thoughts'. 'It's like a prayer to me,' whispers Pyrih when it's over, 'or perhaps a Requiem Mass!'

Frankfurt, Germany, late November 2022. Andriy Khlyvnyuk and his band emerge from a hotel on the commercial outskirts of Germany's financial capital, searching for a meal on the eve of their concert at a rock venue of note, Batschkapp. Boombox's tour of Germany, France and the Netherlands is their most ambitious since war began.

Boombox on tour consists of twelve people: six on stage, six 'behind the scenes', Andriy tells me. One of these is a comrade from the police unit, Stanislav Guvenko, 'rifleman, and also director of music videos', shooting not with a gun at this point, but a camera. Stas – tattoos up his throat – is filming, here as on the front line, 'a documentary that tries to make sense of all this'.

The green room is modest, with trays of avocado, charcuterie and cheese, and a fridge of mineral water and beer. The band is quiet and focused. Band manager Oleksiy, the decorated, tank-grabbing hero of Makariv, is fine-tuning the logistics for tonight's show. Andriy introduces Inna Nevoit, who plays bass, 'Someone saw her cleaning and catering in a metro bomb shelter and said: "Hey, Andriy – isn't that your bass player?" She was serving borscht, and I thought: Inna, don't ruin your hands, they're golden.'

Down the metal steps and out into another world: the waiting crowd pressed against security barriers strewn with Ukrainian flags,

and the air is thick with anticipation. There are families in attendance, some of three generations. Up come the lights, the noise elevates, and on come Andriy and the band to a jubilant greeting. In reply, a now ubiquitous salutation among politicians and entertainers alike: 'Good evening! We are from Ukraine!'

As are most people in the house, and in this heightened atmosphere Boombox could get away with a creditable performance, and still send their audience home happy. But they give it their all and more – the opening number is aptly titled 'You Are 100 Per Cent'. True to his remarks back in Kyiv about love songs in wartime, Andriy then sings 'Hold Me': 'Never let me go / You won't find me again under the rainfall.' 'Angel' follows soon after – 'You want me to be yours / You want me to fly again.'

The audience speaks for itself. Anhelina Chumak and her twelve-year-old daughter Yeva fled their home in Zarozhne in late February; husband Danyil remains, fighting. 'We're now far away, in a strange place,' says Anhelina, 'wondering whether we will ever be home again, as it was. But I saw Boombox a few times, and when they play now, it's like we're all together again.' Volodymyr Pavlenko arrived in Frankfurt from still-occupied Melitopol, via Lviv, this past March. 'I had come to accept that I might never see my home again,' he says. 'Tonight, I'm not so sure – when I hear this band, anything feels possible.'

Later in the night, Khlyvnyuk darkens the tone and timbre, with the threadbare opening to 'Naked King': 'On the day you become a beggar / You'll love all you had / You'll fix what you broke.'

But both sweet and bitter are blown away by the climax of the evening: 'Oh the Red Viburnum in the Meadow'. It begins as incantation, a cappella, the audience clapping and swaying in time: 'And our glorious Ukraine shall, hey, hey, rise up . . .' The instruments join, building the song to vast, rock-symphonic proportions, even without the backing of Pink Floyd. Girls mount their boyfriends' shoulders and wave the flag aloft; children, teenagers and adults alike wear hard-won, bright, proud smiles.

Crowds wait for Inna and DJ Valentyn Matiyuk to sign their flags with Sharpies; two little girls with floral garlands in their hair get autographs scrawled along their forearms, giggling with glee. A man leans forward, in tears: 'I'm from Mariupol,' he says, with no elaboration necessary.

There's a short recuperative stop in the green room to greet friends and hardcore fans of yore. Then back to the hotel, where we have a round in the atrium lobby. Tomorrow: Stuttgart. Andriy is tired but elated, for all his consultation of the latest – today, horrendous – news on his phone. A shower of rocket attacks has hit several cities across Ukraine, leaving many dead, especially in the Kyiv suburb of Vyshgorod.

The plan now, he says, is to 'fight through the winter, hoping to be in one piece by springtime, and if we survive that long, we'll continue with America'.

Andriy reflects on the evening, and the wider endeavour, 'Tonight was the most charged so far,' he says. 'At least 80 per cent of that audience were at home last Christmas. Recent refugees almost all of them. They might have had tickets for the spring 2022 stadium show in Kyiv that never happened. And here we are in Frankfurt. But they pour out so much energy and love, it's almost embarrassing, in a good way. I have to look into their eyes,' and here Andriy's own eyes moisten. He sips his beer. 'But if I think about the importance of what's going on, my legs would turn to bronze – I wouldn't be able to sing. Still, we have to do our job.' I suggest that they do it very well. 'So we should; if we're not good after twenty years, we never will be. But it's never good enough, because we – the band – are not the important part of this now. *They* are.' ∎

A bus driver yelled at me, as I drove behind the back of the bus station today: 'Buses only! – *pay attention!*'

Barth, Barthes, Barthelme

'For could one not in his right mind be reasonably said to wonder if he was in his right mind and bring what is more his remains of reason to bear on this perplexity in the way he must be said to do if he is to be said at all?'
 (Beckett)

The foreign language is a relief – a retreat – from the busy meanings of English.

Sh--ty! That's just sh--ty!

'You were saying Fuck it?'
'As you were saying . . . where were we? . . . you were saying Fuck it . . . ?'

'That thou doest, do quickly.'
 (Jesus's words to Judas)

At first, she was pleased that the piped music on the phone was Chopin, but as she listened carefully to it, having nothing else to do while she waited, she began to object to the interpretation.

modern music
at the roller-skating rink, skating to 'modern music'

Though she herself is gone from the room, for the moment, she has left behind a noisy watch.

By 1907, telephones in France were being used to summon a tailor, order an ice-cream, or listen in on live opera or theater in Paris.

'You're no help at all.'
'Do not leave without my express permission.'
'That was a great mistake' (about the tea, which had spilled on the floor).
 (statements Dad made in the nursing home)

Heard him, before I reached his room, calling, 'Help, help me.' Saw him thrashing around under his blankets. Roommate Richard was quite impassive, matter-of-fact.
 (Dad in nursing home)

'dismal' (the cocktail party)
'worthless' (the poetry workshop)
'incompetent' (the workshop leader)
'not very talented' (the physical therapist)
 (Dad's judgments of activities and people in nursing home)

The Japanese leper (this was told on the radio) who lost his fingers and went blind; but being 'persistent' learned to read Braille with his tongue and sent petitions on behalf of all lepers to repeal laws discriminating against lepers.

She says it is very hard to understand him, and because of that, one tends to speak very simply to him, as to a child, but that when one manages to hear a word he has said, it is a word like 'allegedly'.
 (Mother reporting about father)

Dad's hearing aid is broken. He says, 'The man is a swindler.' I'm not sure which man he means.

Trying to make himself understood: When spelling doesn't work, he roars the word a few times.

Misheard (at meeting): 'breadth and depth' as 'breath and death'.

Sitting in the kitchen in the early morning 'on hold': not entirely unhappily listening to the Goldberg Variations played on electric guitar.

My stomach crying out like a hen . . .

'Yet are they turned about with a very small helm, whithersoever the governor listeth.'
'Even so the tongue is a little member and boasteth great things.'
'But the tongue can no man tame; it is an unruly evil . . .'
'Out of the same mouth proceedeth blessing and cursing.'
 (from the Bible)

a noisy quietist

Fascination with learning foreign language (new insight): that that is the juncture where I can witness, in the act, the attachment of meaning to what is really an arbitrary set of sounds (we can't see it in our native language because it happens before we are aware of ourselves) (another evidence of learning – by rote – coming before understanding).

The writer, invited to read, finds she has no audience and needs an audience in order to receive her fee, says to the janitor who is there by chance in the room: 'Please stay in the room and rest, with your broom.'

Realize suddenly that the title speaks in a different voice from the piece

itself: it is allowed to be more neutral, cooler, more objective. The title, in other words, may know more than the body of the piece.

Peggy O'Farrell farewell

United Abrasives

prig, martinet, fop, dandy
 (R.K.'s words)

Angry trap, trap shut –
'set her mouth into an angry trap, then kept her trap shut'
 (*No Lease on Life*, Tillman)

still champagne

For 'Puccini', Spellcheck suggests 'pecan' or 'zucchini' . . .

A filling of the chest: hysteria. (Where crying and laughing join.)

Salem, Salaam, salami, salmon, psalm

isms.

Online thesaurus cannot find 'this way' and suggests replacing, instead, 'thistle'. Such a beautiful, innocent choice.

Certain endearing speech habits she has, like her fondness for the word 'vignette'. (Mother)

drill, twill, duck, ticking

Influence of nursery rhymes, again: the music but also the fragmented and puzzling nature of a lot of them – and they may be read to us over and over again:

> *The world is so full of a number of things,*
> *I'm sure we should all be as happy as kings.*

The oddity of 'a number of things' – vague, general, 'weak' – and of the whole sentiment.

gormandizing, gluttonous, lickerish, guttling

Online thesaurus: 'wept' not found, replace with synonym 'werewolf'
 Replace 'find again' with 'find customers' ∎

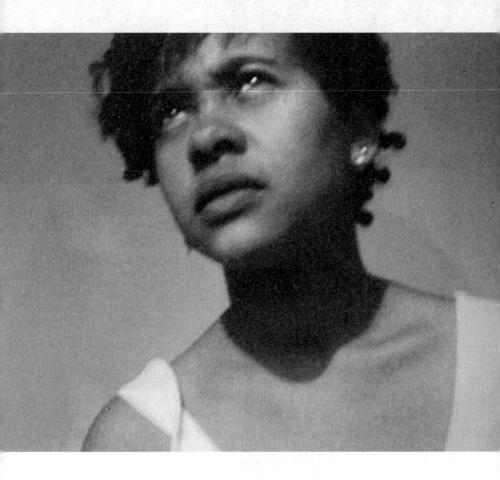

Diana Evans
Courtesy of the author

ONCE A DANCER

Diana Evans

One cold, dark Monday night in a March of my midlife, in that moment of winter when spring wants to hold on a little longer before arriving, I travelled across London to a bathhouse basement in King's Cross to learn the dance routine to Beyoncé's 'Single Ladies'. The basement was part of an establishment called Drink, Shop & Do, and like several feel-good, eclectic pop-ups founded by twenty-first-century entrepreneurs, it no longer exists post-pandemic. The idea was that one might wander in from the urban concourse and hang out in the bright-toned cafe, maybe browse for a while the gift cards or jewellery on sale in a corner, and then, if the mood took you, or indeed if you had come especially, you could venture downstairs to the bare floor and the waiting music to get your freak on. There were many other activities offered under 'Do', as I recall, such as candle making, Lego robot construction and tea towel screen-printing. It was a nice concept, just flimsy in the face of a plague.

We gathered, us women – there were no men – in the subterranean dim, shyly at the edges, apart from the usual one or two dance-class regulars who knew the moves or each other or the teacher or just didn't mind being upfront and visible while shaking it. We set down our bags by the wall and took off our coats. We were wearing leggings and fluorescent trainers, sports bras, scrunchies and ventilated T-shirts,

and all of us wanted to move like Beyoncé in that monumental black-and-white video of 2008, while at the same time remaining respectfully aware that we would not. She was a recurrent theme at Drink, Shop & Do, her slew of hits headlining many a dance class – 'Crazy in Love', 'Run the World' – sometimes she even made a personal appearance (via an impersonator). Her dexterous, swift-footed routines were taught by resident dance teacher Jemima Bloom, whose repertoire also included tango, belly dancing and flamenco.

At that time I was missing dancing. It's a feeling that still comes over me, the need to stretch, leap, shake, flex, snap, flicker, shimmy, mosey, step, strut and swipe in an open space with the air zipping past my face and music surrounding, directing. To lose control in a melody. To be fast and in flight, and in so doing, to escape the world. Having shifted occupations from dancing to writing some years earlier, thus now being a person who spent much of the working day in a chair where once I had been on my feet, in motion, I missed the abandon and swirl of the theatrical life, the waking up of a morning to the prospect of consistent, purposeful movement. And so I went to a class sometimes. I had tried African, Afro-Cuban, Caribbean, jazz, contemporary, African contemporary. I had been to The Place in Euston, Pineapple Dance Studios in Covent Garden, to the IRIE! dance theatre headquarters in Deptford to try a reggae fusion style, all in an effort to retaliate against my swivel chair and reconnect with flight. It never quite filled the movement void. It was never quite high enough. I was an outsider now, had conceded to gravity.

In the corner of the Drink, Shop & Do basement was a battered old grand piano next to a few stacks of plastic chairs. On the wall were five glittery, jumpy silver letters saying DANCE! Having set up her music system, Jemima announced that it was time, whereupon the majority of us positioned ourselves as close to the back as possible, away from the accusatory frontal mirrors. It can put you off your steps, glimpsing yourself fluffing the routine or struggling to keep

up, getting a sense of what your body looks like in relation to other bodies. The attendees at the front are watched from behind as exemplars, demonstrators, and for a routine as complicated as 'Single Ladies', they would be referred to here with the utmost need and intensity. Street dance is hard. Of all the styles I've tried it's the one I've found the most difficult. There is so much intricately timed coordination required, with the snapping of the head and the pumping of an arm and then the mathematics of the feet, hands and hips. Every time I've tried street dance I've felt like a marionette manoeuvred by a mismatched puppeteer – as cool as it looks in the videos, it's not my natural language.

Jemima did that thing, though, where the teacher divides the group into two and makes them perform the routine to each other, so in this class there was no hiding. After a thorough cardiovascular warm-up involving running on the spot to Maroon 5, army-style knee-ups and some killer abs exercises that left us panting for less, she took us through the hallowed choreography (originally inspired by a 1969 Bob Fosse routine), from the wrist-dropping two-step at the beginning to the jaunty circular strut and gyrating lunge, the specific dips and turns. It was quite stunning amid the heat and challenge of the situation to think that this routine is usually delivered in heels, that most of Beyoncé's high-octane performances are given in an assemblage involving stilettos, flapping hair extensions and very little ankle support – how does she do it! How do those ladies balance! We were inadequate, humbled by their spectacular prowess. During our group performances there were squeals of embarrassment and face-hiding shame. We persevered for the full two hours, which, it turns out, is not much time for a class of amateurs to learn a professional dance routine. We had to rush through the last few moves, and our final performances were shabby, flawed and floundering. In no way, not at any point, did I stand out as someone who knew a thing or two about dance.

M y first grown-up dancing lessons took place in a community hall in Moulsecoomb, on the A270 towards Lewes. There, I had been chosen. I had been walking through my university campus one bright blue afternoon, and a stocky, warm-eyed South African man came up to me and asked if I was interested in being in a dance company. I was, kind of. I carried around a vision of myself dancing on an outdoor stage at a Maltese auditorium, next to DJ decks (I have no idea why Malta). When I listened to soukous or R&B, for example, I saw the dancing in my head, like an extra bass or layer of sound, or an internal music video. As teenagers three friends and I had choreographed and performed a dance routine to Michael Jackson's 'P.Y.T.' I regularly went to the Zap or the Beachcomber nightclubs on Brighton's seafront and shocked out all night to house or disco, sometimes on the stage, and I would often find myself breaking out into random jigging in the middle of a conversation or family gathering when a fine song sailed in on the airwaves. Why wouldn't I be interested in joining a dance company? So, I 'auditioned', and was 'chosen' (there wasn't exactly a lot of competition, it must be said; to an extent we had already been chosen – the audition was more to check that we were trainable).

Our talent scout, dance instructor and artistic director proceeded to teach his newly assembled troupe traditional dances from South Africa, from West Africa, from the Caribbean. After a day spent in the library studying audiovisual analysis or the politics of representation in the British press, I went to Moulsecoomb and learnt the Kpanlogo of Ghana, the mask dances of Senegal, the gumboot dance of South Africa, performed by gold mine workers during the Apartheid era. Light would be falling in from the large windows like an enfolding lace. An array of teachers and instructors were brought in to show to us the Kumina dances from Jamaica (via Congo), the Bata of Nigeria and the Vodú moves of Cuba, so that we might deliver them anew, preserving cultures with our bodies. We shared special moments of corporal endeavour and spiritual, world-expanding fulfilment. We practised and practised. Martha Graham wrote once that the

activity of practise, be it dancing or living, can lead to the 'shape of achievement, a sense of one's being, a satisfaction of spirit. One becomes, in some area, an athlete of God.' It did at times feel like a training and an adventure of divine proportions to be present in that slanting-ceilinged hall, sweating and stepping to the djembe pops and the call of the elegant hollow congas.

Our director had a plan, to bring African and Caribbean dance to the peoples of south-east England and possibly beyond, starting with Brighton, and for a while he succeeded. Our first performance was at a seafront pub-cum-club called the Volks Tavern, where I forgot most of the steps out of stage fright. It got easier. I realised that an audience notices less than you think. I learnt to 'style it out'. We performed in little summer festivals, then in bigger ones. We did WOMAD. We were the run-up act there for South African percussion ensemble Amampondo, and we went onstage in a huge tent containing thousands of cheering, tipsy spectators. We felt at times groupie-susceptible. I had a passing flirtation with reggae sing-jay Eek-A-Mouse after his gig at my university, which had nothing to do with the dance troupe but I reasoned that there had to be a showbiz link. As part of his master plan, our director got together an entire dance theatre production in which I played the lead part, and this toured for a while in theatres and other large tents. We had a tour schedule. We performed at the Edinburgh Festival and London's South Bank. Once, we gave a show in Victoria Embankment Gardens by the Thames – we had made it to the West End.

The 1990s were an exciting time for black dance forms in Britain. There was a proliferation of companies and troupes bringing movement modes from all over the black and brown continents and across the diaspora, the largest and most successful of these being Adzido Pan African Dance Ensemble, founded in 1984 by George Dzikunu, who were fixed-term funded by what was then the Arts Council of Great Britain, and toured nationally and internationally. There were African dance innovators fusing traditional vocabularies with contemporary lines, such as Bode Lawal's Sakoba Dance

Theatre, and Peter Badejo's Badejo Arts, which tackled themes of migration and black subjectivity through dance. Former Rambert dancer Sheron Wray founded her company JazzXchange in 1992, her repertoire a fusion of jazz, classical and street styles, while MC and choreopoet Jonzi D merged street culture and dance theatre in his 1995 production *Lyrikal Fearta*, a precursor to *The Aeroplane Man*, all of this activity building towards the staging of the first Black British Dance Festival in 1997. It was a scene full of such dynamism, excitement, seriousness, passion and substance that I became convinced, in the futile design of hindsight, that I had made the wrong choice of degree subject: I should have been studying Choreography and Spanish at Middlesex, or Dance Therapy at Hertfordshire, or IRIE!'s pioneering Diploma in African and Caribbean Dance, the first course of its kind in Europe.

Instead, having finished my now-regrettable academic degree and moving back into my childhood bedroom in London, where I wondered how I was ever going to afford my own place while waitressing at Chiquito, I took off to Cuba for two months to take a course in Afro-Cuban dance. I went with two friends, and we stayed with a Cuban family in Guantánamo Bay, by day learning the dances of the Yoruba Orishas – the majestic, flowy blue sweeps of Yemaya the ocean goddess, the charging, stormy ferocity of Shango, god of lightning and thunder – which I imagined I might bring back to the London scene and blend into some profoundly original choreography. We travelled east to Baracoa on a rickety bus lurching towards the cliff edge, then west to Santiago de Cuba, learnt more dances, ate *yuca con mojo* in the *paladares*. By the time we got up to Havana, though, my two friends were missing their boyfriends. They sighed and slumped with longing. I found them disappointing in their loved-up helplessness. 'We are in CUBA,' I said. 'We are actually in HAVANA.' But they just wanted to go home. They changed their flights and left me there, and I spent long afternoons walking up and down the Malecón alone, watching the chopping waves and the curly drifting foam as it dipped and turned with the tide.

When I tell people that I used to be a dancer, it seems only half a truth. I was never officially trained. I went to no Laban, conservatoire or Rambert. I sidestepped into it and rode its fairground waltzer for two or three years and then I went and got a desk job. I can't imagine, now, getting up onstage in a swaying Xhangani skirt and African Dutch wax headwrap and mentoing to live percussion, or screeching or ululating in accompaniment as we used to at the heights of beats. Time has passed. Life itself has moved. Now much of my dancing is internal, still in my head inside of music, and also, I tend to think, inside of sentences, the rhythms of language, in the movements made possible with words. Otherwise, 'my body became increasingly strange to me', as Lorrie Moore once wrote in a short story ('Strings Too Short to Use') that comes to mind. 'I became very aware of its edges as I peered out from it: my shoulders, hands, strands of hair.'

After Cuba I was still doing shifts at Chiquito (balancing cornflaked ice-cream desserts and sizzling fajitas on a large oval tray), and, approaching my mid-twenties, I realised that I needed to make a major career decision. Was I going to devote myself to a life in dance with all its hardship, instability, crushing auditions and infrequent waitress-doubled employment, or was I going to follow my penchant for writing and try for a job in journalism? I chose the latter, my hand forced by another audition failure, this one in Brixton Hill where I performed a humiliating solo improvisation, during which I sensed that an ending was nigh. Whereas before it had seemed that the black dance world was a thriving metropolis of enthralment, travel, enrichment, spiritual connection and fulfilment, now it seemed just basically impossible to get a gig or make some money to buy a sandwich. Troupes were struggling to survive. Funding was fading. The already-fragile fringe dance infrastructure was coming undone as the political slaying of the creative arts began, and the Brighton ensemble had all but disbanded. Perhaps, after all, my degree choice had not been so misjudged. It was as though my dancer path had meandered away beyond the Malecón wall into the waves of the Atlantic; I had left it behind in Cuba.

What happens to a dancer when they stop dancing? What happens in the soul? This was a question I became preoccupied with post-troupe, during the subsequent writing of a novel that I never imagined I would ever want to write, having been a (kind of) dancer: a novel about dancing, an encapsulation of its nature. I had thought of writing and dancing as opposing creative callings. I had thought it would be pointless and purely nostalgic to try to bring the two together in a book. But the urge surfaced, most probably as a symptom of missing dancing, plus I had been doing some reviewing of London performances, scribbling the spectacle in the dark and sending in my copy the next morning. I began to read biographies of dancers. I read about the lives of Alvin Ailey, Lucia Joyce, Vaslav Nijinsky and others – and what recurred in these life stories was the theme of mental malaise, an unravelling in periods of dormancy or after-dance, the dangerous misery of motionlessness. They (we?) were fallen beings, and they had descended from realms ethereal into the madness of ordinary life. Or, in some cases, the after-dance exacerbated an instability that was already there, and had previously been carried in the wings of flight. I wonder also if it is that dancers exist in a retained, physical state of childhood, and when they no longer dance they are met with the sharp impurity of adulthood.

The writing of that dance novel, *The Wonder*, acted as a necessary bridge towards a post-dancing life. On a wall in my house now there is a black-and-white picture of Nijinsky, who became something of an obsession for a time, and another of Katherine Dunham, who also makes an appearance in the novel. The threading together of a narrative in which these lives could be outlined and reimagined allowed another kind of internal, cerebral flying, in which I could conjure in the sentences the magic gloom of an empty theatre, the silent stage wings, a bus sloping along a Jamaican mountainside containing a little boy who wants to be a dancer, and most of all the delicious feeling of movement itself, that fevered writing of oneself across the air.

At the end of the Drink, Shop & Do 'Single Ladies' class, Jemima Bloom played a relaxing Romain Virgo song called 'Love Doctor' and we did our warm-down. We stretched and lunged, lay on the bathhouse basement floor in states of exhaustion, in full acceptance of our humility in the face of Queen Bey. As the warm reggae chords drifted up and down over our aching abdominals and shaken limbs, I was thankful for the way dancing can return you to your own body, whichever language the choreography is written in. Jemima told us to breathe deeply in and out. We stood and brought our arms up over our heads and then let them float down again. Three months later I tried ballet, a few months after that couples' salsa, more recently I danced at an eighties student nightclub in Brighton where they played Madonna and Chico DeBarge's 'Rhythm of the Night'. Dancing is good for us. According to psychologists, a thorough get-down in your local club once a week has a positive effect on the cerebellum. I am working on this utopia. I am looking for a local place that plays the right music. Once a dancer, always a dancer. ∎

WE'RE NOT REALLY STRANGERS

Sama Beydoun

I was sixteen the first time I went to a nightclub. I remember the end of a dark alley, walking past a series of generators, down some metal stairs to an underground venue that no longer exists. Everyone was dressed up – or down – performing themselves in a way that struck me as completely theatrical. But parties in Beirut are like the full moon to a werewolf: people get the opportunity to transform. They shed their daily selves, blow off steam, express themselves and see and are seen in a way that is less celebrated in the daylight.

As I grew up I started to photograph the nightlife scene. For years these parties seemed to be the only constant in my life. I took photos when my friends emigrated; when the revolution started; when my parents separated; when my friends came back; when the government fell; when the city changed.

The people I've photographed made Beirut liveable. If this were a bigger city they would have been strangers to me, but I know every single person imprinted on these rolls of film. We were on the streets together, marching, and on the dance floor at night. These photos are an attempt to build a bridge between two dreams; freedom, and escapism. ■

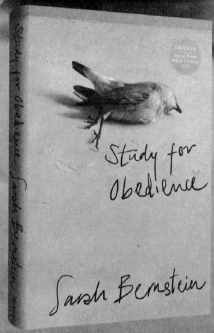

'Sarah Bernstein manages to combine cool, perfectly weighted prose with an extraordinary emotional sensibility'
Fiona Mozley

'A fully absorbing, beautiful and sinister portrait of becoming and unbelonging, of violence held in time and place'
David Hayden

'A unique novel that is primal and eerie, where language creates silence and vivid images reflect a kind of earthiness where our most intimate selves live'
Asale Angel-Ajani

GRANTA

SENSORY LUXURY

A motorcycle travels past an advertisement for the Peak Cambodia mixed development project,
by Sino Great Wall Co., Phnom Penh, 2018

SOUNDSCAPES
OF PHNOM PENH

Anjan Sundaram

'*B ot sadam*,' I said, making my voice nasal and sticking my right hand out of the tuk-tuk. '*Tini bot chwein.*' The new ride-hailing apps hadn't yet arrived in Cambodia, so I had to direct the tuk-tuk driver at each turn, right here and left here, to get us across the Cambodian capital, Phnom Penh, to my meeting at the Ministry of Commerce. 'Indeeya?' he said, smiling in the rear-view mirror. '*Khmai la-aw*' – 'Your Khmer is good.'

Cambodia was a rare country where I felt welcomed as an Indian, not derided as an immigrant, or regarded with suspicion as a foreigner with strange ways. Cambodian and Indian sailors had for centuries ridden the twice-annual monsoon winds between these countries, trading goods, gods and languages. Some Cambodian people, to me, even looked like my cousins.

'*Khnyom rien khmai, bong,*' I said. Brother, I'm learning Khmer. I hadn't yet learned how to say that I found the language difficult, although its alphabet mirrored that of Hindi and reminded me of my childhood ABCs in the old tune I had memorised, *ka kha ga gha na . . . p pha ba bha ma.* The words for 'stop here' were appropriately curt: '*Chhop tini,*' I said at the ministry gates.

A secretary let me into the minister's vast office, appointed in white and beige. '*Somto Mé?*' a man said, sticking his head past the

door. In Khmer, which is close to the ancient Indian language Pali, once spoken by the Buddha, *mé* was the word for 'mother'. I raised my eyebrows at the minister. 'My ministry staff call me Mother,' he said in English. It turned out that 'mother', in Khmer, was synonymous with 'boss', and many of the men who ran Cambodia were addressed as women.

Minister Pan looked at me nervously, I suspected because of the news that had been announced on the radio just two hours before, on that morning in June 2017. But he digressed, telling me that Cambodian men in traditional households handed over their salaries to their wives, who returned a smaller amount back to the husbands as monthly pocket money. Houses and land in Cambodia were inherited by daughters.

The minister was a digital pioneer of the Khmer language. Digressing more, he told me that Khmer's complexity, and the main difficulty in learning it, lay in its vowels. Khmer has about twenty-eight vowels and vowel combinations, called diphthongs, as well as about seventeen independent vowels, which I struggled with. I couldn't pronounce the *oeu* in *kroeung* – for 'curry' – and the *aw* in *kdaw* – for 'hot' – well enough to make myself understood in the markets and found myself running through those vowels' every possible variation, hoping vendors would eventually understand.

'The election results,' I said, gently alluding to the breaking news. Minister Pan evaded the subject a third time. He was trained as a computer engineer, he said, and had encoded Khmer's subtle variations into ASCII, the American Standard Code for Information Interchange, the global data standard. 'Khmer uses five layers of written symbols, two above and two below each consonant, to denote its vowels, but the American coding system only allowed for three layers, one above and below each consonant, as is needed by Latin languages. I solved the problem of fitting Cambodian complexity into Western simplicity.'

Finally, I mustered the courage to ask him directly about the morning's news. I waited. Minister Pan, and all of Cambodia's ruling

party, were in trouble. Communal election results had been announced. Once a French protectorate, Cambodia was still organised into communes, districts and provinces, and the opposition Cambodian National Rescue Party (CNRP) had grabbed 2,000 extra communes, out of about 11,500 nationwide, from Prime Minister Hun Sen's Cambodian People's Party (CPP). The opposition had taken control of nearly half of Cambodia.

It was widely believed among human rights activists and the political opposition that Hun Sen had stolen the 2013 election from his CNRP rival Sam Rainsy. After that crime, Hun Sen had burnished his credentials, insisting it was he who had saved Cambodia from the genocidal Khmer Rouge regime in the 1970s and who had made Cambodia prosperous during his three-decade rule, warning that if he were ousted, 'rivers of blood' would flow. But two successive election results had now confirmed his waning popularity.

'Have you looked at the Phnom Penh skyline?' Minister Pan asked me in response, pride in his voice, gesturing towards the window, avoiding a deeper conversation about the difficult news. He glanced at his watch, and stood. I had travelled across the city and the minister had fobbed me off.

In 2017, I arrived in Cambodia to report on its transition away from the West and liberal values such as free speech and democracy, for the *New York Review of Books*. I investigated how Cambodia was now drawing closer to its neighbour, authoritarian China. East Asia was growing faster than anywhere on Earth, and in return for new prosperity, supported by China, Cambodia's government forced a silence – a harmony, as government propaganda had it – upon its citizens. I was learning Khmer in part because the Khmer Rouge had systematically decimated Cambodia's intelligentsia, killing an estimated 2 million people, targeting those who spoke a foreign language, in particular. A Cambodian friend's parents had told him that Khmer Rouge cadres tricked potential targets into speaking French by walking up to them and exclaiming, '*Bonjour!*' The effect could be felt forty years later, and helped explain why I met

so few English or French speakers on the streets of Phnom Penh, Cambodia's bustling, cosmopolitan capital. In a country increasingly repressed, I learned Khmer so I could listen in on the hushed conversations in bars, in the Vietnamese yellow-pancake restaurants, and in food markets.

'*Bai roi kaw sup*,' – 390 – was all I had to tell the tuk-tuk driver whom I hailed on the street, his carriage drawn by a Honda Cub motorcycle. The numbers in Khmer were easier to pronounce, and 390 was my street number, the only instruction I needed to give.

My apartment was situated just off the city centre, in an area called Boeng Keng Kong Bai, near an old school that had been turned into a grim genocide memorial visited mainly by tourists. But such landmarks were unnecessary: my street number was sufficient to navigate Phnom Penh's grid street system, a Cartesian urban plan designed by the French. Streets running east–west were even-numbered, and those running north–south were odd-numbered. A pair of even- and odd-numbered streets denoted an intersection.

The street numbers decreased as we drove east from the ministry, until we arrived at *moi roi pram*, Street 105, known colloquially as the 'shit canal,' for the open sewer that ran along it and into the southern Boeung Toumpun lake. We turned south. I lived about twenty metres from the canal, where it intersected with street 390. On some nights, the monsoon rains stirred the canal's waters, and I smelled its odour.

Three months after the communal elections, in September 2017, a dozen Cambodian radio stations, including Voice of America and Radio Free Asia, as well as the prominent newspaper the *Cambodia Daily*, were shut down. 'Descent into Outright Dictatorship,' yelled the front page of the final edition of the *Daily*, one of the country's two independent English-language papers. A new edition of the second independent paper, the *Phnom Penh Post*, was bought out a few months later by an ally of Hun Sen, its once-critical pages carrying honeyed flattery of the government.

A journalist friend, Mech Dara, lost his job twice, having reported for each of those two newspapers. We sat at a Khmer restaurant, eating *bai*, white rice, with *mahchou youn*, a tamarind sour soup with lotus stems, while I helped him apply for jobs. On the restaurant's speakers, radio stations played the legendary Sinn Sisamouth's love songs, and then modern Cambodian death metal. Silence had descended about whom the regime arrested or evicted, and whose land it stole for lucrative housing developments. The non-profit Global Witness had, the year before, reported on Hun Sen's family's involvement in criminal activities such as a $1 billion heroin-trafficking operation and illegal land grabs on such a large scale that they amounted to 'crimes against humanity'. Several international watchdogs listed Cambodia as among the world's most corrupt and least free countries, while Hun Sen insisted that his only source of income was his prime-ministerial US $1150 monthly salary. The government expanded its high-tech military surveillance unit, which, rumour had it, was powerful enough to listen in on phone conversations and track anonymous Facebook posts. The government was building a 'National Internet Gateway' to channel all of Cambodia's internet traffic through a single point, where everyone's words would be monitored.

Hun Sen wanted his voice to sound across Cambodia without dissent.

Local activists responded to the imposed silence by expressing dissent through colour. 'Black Monday' became a weekly ritual in Phnom Penh. From my balcony I watched Cambodian police patrol the streets in their pickup trucks, stopping to question and sometimes arrest anyone who wore black. The Interior Ministry spokesman called the protesters 'drunk with human rights', and the police, unable to formally charge them with a crime, often released them shortly after the arrest, which was used as an intimidation tactic. Hun Sen banned protests in which people were all dressed in the same colour. He said, 'It does not matter what colour you are.'

The trade-off that Minister Pan had pointed to on Phnom Penh's skyline – economic opportunities for people who stayed out

of politics – were manifest in the soundscapes on my street. These were the sounds of construction and renovation: money poured in from China to build high-rises that blocked off the horizon and the precious view from my balcony of the sunset's last moments. Even people like my neighbours, including my landlady, took up home improvement as a hobby. They smashed up old tiles and cut new tiles with power saws, working on their balconies and in the open street, sending up plumes of fine dust, to which I was allergic.

The elite's teenage children drove Bentleys without licence plates, hardly looking up at the road as they texted their friends, knowing they couldn't be arrested even if they ran over a pedestrian. When I showed up at a bank four streets from my house to open a checking account, a bodyguard stood by an automated cash machine in the lobby for an hour, feeding the machine from bundles of hundred-dollar bills, each crisp bill swallowed by the machine with a *sip*.

After shutting down Cambodia's media, the government targeted human rights organisations, dissolving the US-based National Democratic Institute and warning other 'terrorist' non-profits against trying to 'topple' the government. I invited a friend, a prominent human rights and youth activist who'd lost her job, to dinner of *amok*, fish steamed in a banana leaf. She told me her now-unemployed activist friends had taken up driving *motodops*, motorcycle taxis, and selling handbags on Facebook channels. Her parents had seized on her lack of income to pressure her into marriage. 'Two gunshots still echo as the government takes down the last of us,' she said.

Those two shots instantly killed Kem Ley, a leading Cambodian radio host and Hun Sen critic. They were fired, execution-style, shortly before 9 a.m. on 10 July 2016, at a Caltex petrol station a couple of blocks from my house. Cambodians filled Phnom Penh's streets for one of the country's last mass protests, screaming slogans against the police penning them in. Government officials who attended Kem Ley's funeral left money as a mark of respect but did not write their names in the official funeral register, so as not to leave a trace of their presence.

At Kem's murder trial in March 2017, I watched as the judges giggled, filling the courtroom with their gleeful impunity, hiding their faces behind large black folders. They accepted the accused's name as 'Chuop Samlap', which farcically meant 'meet to kill', and was very unlikely to be his real name, and listened to the man's surprisingly detailed confession to having killed Kem Ley over an unpaid debt of $300, an implausibly small amount over which to risk a lengthy prison term. The trial lasted only half a day. The prosecution lawyer, suddenly not needing to prove the accused's guilt, after his ready confession, could only play up the farce during his cross-examination. 'You must've had a hard time at school,' he told the alleged killer, 'growing up with such a name.' The court sentenced Chuop Samlap to life in prison, and the case was closed. No government officials were implicated in Ley's killing. The trial became a show of government power, of how the authorities could eliminate their critics with impunity.

In November 2017, the opposition party CNRP was officially dissolved by Cambodian courts, turning the country's 2018 parliamentary elections into a de facto one-party vote. The CNRP's figurehead, Sam Rainsy, had fled to France in 2016, for a second time, after accusing Hun Sen of killing Kem Ley, and realising that he was in danger of arrest or assassination. And he was right: his successor, Kem Sokha, was arrested and accused of treason. A hundred and eighteen members of the CNRP, once elected by people in constituencies across the country, were banned from politics for five years. A few months after Cambodia's communal election results had been announced buoying the opposition, in June 2017, the country's fledgling democracy was finished.

From my bronze-painted balcony, I chronicled the sounds of Phnom Penh's private industry. Pursuing prosperity was apolitical, and it became a popular endeavour, even among the young Cambodian activists who had once campaigned for human rights. The screeches of power saws travelled across the streets from

far away, their frequencies warped by the echoes on buildings and blending into a metallic cacophony. I purchased a pair of protective earmuffs like those used by construction workers, in order to write, and wore silicone earplugs to sleep, to defend against the building noise that started at 7 a.m.

Construction stopped each evening at about 5 p.m., when it got dark and the sounds of rush-hour traffic rose, and it also stopped every day at lunchtime, around noon. Workers then took leisure in games of street chess, their wooden pieces knocking on wooden boards, the players and spectators crying out in unison when someone made a surprising move. Street carts attached to cheap Chinese motorcycles brought the workers food, their speakers blaring *numpang kdaw kdaw*, for 'hot hot bread', or *num kroch* for the fried balls of dough filled with mung beans served with a sweet sauce. Coconut sellers who couldn't afford speakers screamed out '*Doung!*'

But many of Phnom Penh's new high-rises, with English names like 'Skyline', 'Sky Villa' and 'The Peak', were empty. I walked into one of these new buildings in Boeng Keng Kong Moi, the heart of the expat district. Guards waved me towards the building's management office, assuming I wanted to rent an apartment. But I skirted the office and walked up a wide, white-tiled staircase, my footsteps echoing in the high stairwell. The building was a shell, floor after floor unoccupied. I was told these high-rises were built to launder illicit Chinese money. The Cambodian government allowed Chinese companies to create fictitious rental receipts, pay a small tax and present the rent as legally earned revenues.

According to a French urban planning professor who gave a seminar one night near the city's Russian Market, Phnom Penh has begun to sink under the weight of its new skyscrapers. The French had built Cambodia's capital on the site of a former swamp, at the intersection of the Mekong and Tonlé Sap rivers. The ground beneath the city was wet and soft. The new construction had made floods more frequent. Excess waters during the rainy season used to drain into canals and empty into the city's large lakes. But real estate

in Phnom Penh had become so valuable that the wealthy, with Hun Sen's blessing, were filling in the lakes to create valuable new land for sale. Water rising in the canals had nowhere to go. Seven blocks south of my apartment, at around *buon roi hok sup*, street 460, the annual monsoon swelled the shit canal and made its sewage spill over.

It needed a force majeure to stop Phnom Penh's construction noises outside mealtimes; a torrential storm, or a global pandemic. When the monsoon bore down in sudden flash storms, the water banging on my neighbours' tin roofs drowned out other sounds.

On Saturdays, after the rains, I smelled the wet earth and heard men sing karaoke. Their voices, broadcast on speakers so the whole street could hear, were drunk and out of tune. I recognised them as the drivers who manned the tuk-tuk stop at the intersection of streets 105 and 390, right on the shit canal. When they saw me step out of my building, often in the evening, they would pop open a can of cold Angkor beer for me. The Cambodian way of drinking was to celebrate every second sip with clinks of cans of beer, loudly cheering, '*Eyyy!*'

The tuk-tuk drivers were forced to stay home when the pandemic hit. Street 390 turned silent. The rising economy had concealed the Cambodian elite's power and wealth grab, but now the economy stopped, exposing the country's poorest people to destitution. The authorities resisted calls for lockdowns – word in the markets was that the government feared lockdowns would starve those Cambodians who lived day to day – until February 2021, when a superspreader club party a ten-minute drive from my home ignited a fresh wave of infections. A first lockdown was imposed. Officially, Cambodia's death count still stood at only a few hundred. I asked to see the mortality records but they were suddenly secret, unavailable even to US Embassy epidemiologists who advised Cambodia's government. Hun Sen appealed to China, which sent some of its earliest exports of coronavirus vaccines, precious Sinovac and Sinopharm stocks, allowing Hun Sen to again present himself as a hero and the country's saviour.

On the morning I left Cambodia, I was woken at 5.30 a.m. by a corner shop that had just received its daily ice delivery. The shopkeeper broke the morning silence alone, as if oblivious to it, hacking his wide ice block into smaller pieces so they would fit in a cup.

'*Bot sadam*,' turn right, I said for the last time, to the driver of the four-by-four I had procured on Grab, a Singaporean-Indonesian ride-hailing app that had sharply reduced the income of Phnom Penh's tuk-tuk drivers. I gave the directions out of habit and a sense of nostalgia for how things used to be in Cambodia's capital, even though I no longer needed to direct the drivers who were now using maps on their smartphones. I waited in the almost empty airport hall before boarding my flight.

About two years later, in February 2023, the Cambodian government shut down the last remaining independent radio station, Voice of Democracy, funded by the New York-based Open Society Foundations, a Danish Christian organisation and other foreign donors. Hun Sen and his ministers cemented their power. My reporter friend, Mech Dara, lost his job for a third and perhaps final time, since there was nowhere left for him to work as a journalist. Phnom Penh's Municipal Court sentenced the country's leading opposition figure, Kem Sokha, to twenty-seven years of house arrest. ∎

AESTHETICA
CREATIVE WRITING AWARD | 2023

WIN £5000 & PUBLICATION
SUBMIT YOUR POETRY | FICTION

DEADLINE 31 AUGUST 2023

aestheticamagazine.com

Coast with chalk cliffs, Normandy, France

THE TIDE

Adèle Rosenfeld

TRANSLATED FROM THE FRENCH BY JEFFREY ZUCKERMAN

1

It was the Castaigne building, I'd heard it as Castagne. Before I went through the double doors that swung like an old western, there was a small sign saying 'Oto-Rhino-Laryngology (ORL) and Head & Neck Surgery, Implant Services'. Only Oto-Rhino-Laryngology was familiar to me. When I was little, I'd seen it as a sub-branch of rhinoceros studies.

In my ears were muted thumps, the drumbeat of my pulse. I took a seat at the end of the hallway, next to a table covered with magazines about deafness, one of them offering up anecdotes about isolation at work. I glanced up with every line so I wouldn't miss my name being called and saw that an old woman in a wheelchair had parked across from me, right by the magazine *Thirty Million Deaf.* I read a sentence in a box on the cover: 'Language can be reassuring or restrictive: people think that complicating blunt words softens them. They're ashamed to say deaf, blind, old, mentally ill: from "hard of hearing" to "critical cases" by way of "vision impaired" and "senior citizen", the dead will soon be called the "unliving".' When I realized that the old woman, or the senior citizen, or the elderly person – whatever I ought to call her – was shouting at me, I interrupted: 'Ma'am, I don't think

I hear any better than you do,' but she didn't understand and kept on with her croaky monologue.

A man put an end to the one-sided conversation: 'Come with me, please.' I followed him into the padded room; he shut the door behind me. I noticed the huge chrome-metal handle and couldn't help making the parallel to butchers' cold rooms. Here, what was slaughtered was sound, meticulously, sliver by sliver. He placed the headphones over my ears, delicately, as if putting electrodes on a chicken's head, and handed me a joystick. The first sounds came through, but not all; some just pulsed against my eardrum.

Then it was time for the words. I had to repeat the list like a messed-up parrot. Most of it was absurd and I had to resist letting my imagination fill the gaps.

woman
lemon
boulder
soldier
poppy
button
blacksmith
apron
shoulder

The deep voice ran through the words which grew more and more muffled before slowly fading into fog. To fend off the emerging landscape, my mind chased in the half-darkness after these words: they were my stronghold against the widening craters of language being shelled. I was in the habit of drifting amid the silences and lost words, swallowed up by that imaginary force, but this time the wisps of words had so heavily pockmarked reality that certain images rose up in me with renewed vigor. This was an old-fashioned, post-war space where a husband was back home from so many dead bodies, rediscovering a forgotten world. I could see his face in the slanting

light, he was there naming things in a flat voice to reclaim the life
he'd had. He said 'woman' and his eyes were lost in the ringlets of
his wife who was sobbing silently, then his eyes dropped to the fruit
basket, and he said 'lemon', and then his face tilted up to the window
and the craggy Brittany shore, and he designated it with his mouth:
'boulder'. And he recalled the life he'd returned from: 'soldier', and
all the seasons he'd spent in that role. He said 'poppy' while looking
at that spring flower swaying between her and him, now split open.
He looked down to hide his misty eyes and uttered 'button'; his
uniform reminded him of all those other soldiers. His lips whispered
'blacksmith'; he was dead behind the eyes, but his lips went on
whispering something his wife didn't hear, 'apron' – the blacksmith
always kept with him a piece of the dress of this woman he loved.
The soldier couldn't hold back the smile that came over him, until he
said 'shoulder', loud enough for the woman to startle and look at him
with concern, recalling the shoulders of the other soldier torn apart
by heavy artillery.

'Now we're going to do the left,' the audiologist said, pointing to
my other ear. The story of the soldier reverberated in my deaf ear. The
sounds that crashed against the dead eardrum were the soundtrack of
his memories. The lingering trace of words was reduced to a presence.

I sat once again in the chair that faced the office to assess the
damage on the audiogram. I took careful note of the concave curve
on the paper, a tight grid of x- and y-lines quantifying the remaining
sound. It was like a bird's-eye view of the Normandy coast: the tide of
silence was now covering more than half the page.

<p style="text-align:center">2</p>

In the ORL consultant's office, cutaway diagrams of the inner ear
enlivened the room with their red and blue shades. The depicted
outer ear was a harsh pink while the inner ear was sand yellow,

carmine red, pinkish beige ending in a blue labyrinth. That was the cochlea. It looked more like an overcooked Burgundy snail.

The doctor sat down at her desk, the folder with all my audiograms in her hands, and over-enunciated her words. It doesn't bode well when a doctor who specializes in implants looks at your latest audiogram and then talks to you like you're an idiot. I wasn't feeling so good all of a sudden.

'You've effectively lost fifteen decibels. That's a lot.'

I told her how it had happened, or rather how it hadn't happened.

No warning signs – but why would any signs have come and warned?

It had just withered away, it was as simple as that.

But actually there were two moments in time when I realized that the sound was gone.

The first time was early August in London, when I had a coffee and the server spoke to me. He stood there, lips moving, but no sound coming out. I stammered in broken English that I didn't understand, not a thing, the distress was clear on my face. He responded – well, I think I got a response from his lips and the words parting them – that I spoke bad English. I lost the soundtrack there, in the city of London. Somewhere between Churchway and Stoneway, the tide ebbed.

The second time, in Brittany, at Plougrescant, I'd gone to see a friend and while we were having dinner, once again the sound cut out. I saw his white hair and his mouth stretching into a smile, the corners of his lips bracketing a story. But it was carried away by the wind, while a heavy silence dropped between us. I could make out 'Brazil', so he had to be talking about his conference. I laughed to keep the conversation going.

All I told the doctor was: 'It happened gradually, in August.'

To which she replied that I needed to consider a hospital stay to undergo a treatment, but that it wasn't a sure thing. That otherwise there was another *solution*: 'a cochlear implant'. She thought an implant on the right, the ear that worked, would be best; with the left ear, the sound would just be an unintelligible mess. She clarified that

after a long stretch of rehabilitation, between six months and a year, I'd be able to hear better at every frequency. However, this operation would be irreversible, and I would lose my current 'natural' hearing.

The few cilia remaining deep in my right ear caught high pitches and a few low ones, which just barely allowed me to reconstruct the meaning and mainly to get a sense of the warmth of sounds, this light patina of wind, of color, all the roughness of sound.

I looked at the gray and blue plastic buttons, those scale models of implants on her desk. They could have been fridge magnets.

I didn't know what else to say. She held out her hand, I gripped it and felt like someone clinging to any branch she could.

3

I made my way to office 237 so the secretary could give me the paperwork, then on to the Babinski building, named after an early-twentieth-century neurologist. His portrait was by the entrance, on the small enamel plaque: JOSEPH BABINSKI (1857–1932).

I learned that he was mainly known for a neurological exam that consisted of stroking the arch of grown-ups' and babies' feet. His concept of pithiatism (from the Greek for 'to persuade') wasn't as well known, but still had had a huge impact on many World War I soldiers. At the time, war-related trauma still wasn't recognized. In the vein of Professor Jean-Martin Charcot, who was a pioneer at the neurology school, Babinski had defined a new form of hysteria: in the absence of a clear causal relationship, many soldiers were suffering from issues that were orphaned.

Orphaned.

Yes, that was very much what I'd always felt, this sensation of not belonging to any world. Not deaf enough to be a part of Deaf culture, nor hearing enough to be fully within the hearing world. It all depended on what I'd convinced myself to be or not to be.

The collateral damage that had chipped away at my ego and my confidence were, for those soldiers, orphaned issues that they struggled to understand. Did the void in me come from that? Was it an absence that had to be filled by excess?

'With you, things are *tout noir ou tout blanc*,' I was always told. Black and white. But I kept hearing '*trou noir*' there. Black hole.

'You hear what you want to hear.'

How could I have convinced them otherwise?

But this was perfectly real, and the hospital was shining a light on the hole at the center of it all.

My mother was beside me, staring at the newspaper. She showed me the front page: 'Look, it's the first photo of a black hole.'

<div align="center">4</div>

The room was on the third floor, I could leave my belongings there, I had a full schedule and a procedure to undergo. A nurse came to ask me slightly odd questions like, my bathroom routine – bath or shower? Jacuzzi, please.

The nurse left me there, befuddled, then so did my mother. I still had trouble believing that it was my ears that had brought me here. I'd tried my best to make them keep this secret, but they'd told on me and trapped me here between these four white walls, forcing me to reconsider my past.

After years of denial, followed by years of fighting that denial, I'd tried to settle the matter, twisting my existence this way then that, but loss had blown it all up.

The door opened and a nurse by the name of Eddy came in to puncture my eardrum and inject a fluid directly into my auditory organ. The anesthetic was pointless, it was just a procedure to carry out so that patients believed that something was being done. But when I saw the needle I couldn't believe it. He was going to stick it

into my ear just like that? I could feel my eardrum puckering like an oyster that had just had lemon squeezed on it.

The procedure also involved seeing a psychologist, a tall woman with sad eyes. With an elegant wave, she had me sit down in the facing chair and explained that this meeting was an informal conversation to assess my prospects as a hard-of-hearing person. I gave her the bullet points of my career, a practically spotless academic trajectory, gaining a degree without any help.

The psychologist took down all this information, looking serious, and sketched out a summary, repeating herself any time I furrowed my brow: I'd worked so hard to adapt that I had to be on the verge of collapse; the new bit of hearing loss could possibly revive old specters of trauma.

I wasn't alone on that front, she went on, all hard-of-hearing individuals went through bouts of depression, a result of the accumulated effort unseen by hearing society. It's hard to measure this effort and it's not easy for friends and family to understand it, or any other invisible disability. The hard-of-hearing subject has a tendency, at such times, to cut themselves off from other people.

At the sight of my face riddled with questions, she suddenly became reassuring: 'There are solutions, and an implant is one of them.'

'But with an implant I won't hear the way I did before.'

'Your brain will have forgotten what "before" means.'

Then she added: 'It's true that there's a sense of mourning; something's lost, and there's no knowing what will be found.'

5

The hospital stay relied on the file's continued existence. Documents were added to it, but nobody read them; it was merely a pass to justify my presence. My days were a long string of

pop quizzes, except the quizzers had no idea what answers to expect. 'What are you here for?' 'How long have you been here?' 'What procedure are you undergoing?': a morass of faces asked me a morass of questions because they didn't read the file.

My file got lost, but I was told not to miss any of my appointments. 'Which ones?' I asked. 'My colleague will get back to you about that.' Except they were all colleagues and not one of them seemed bothered.

My trust in medical institutions was crumbling. I hated those doctors doing grand rounds with a gaggle of internists trailing behind like crabby teenagers who'd been dragged off on a field trip to Dieppe one rainy day.

Everything was weighing on me: within the room's confines I was an ailing woman, a future implantee. The only place where I could get away from prying eyes was the chapel, a seventeenth-century edifice shaped like a Greek cross, hidden within the hospital grounds. I'd always steered clear of such religious spaces, but this was the only place I could rely on. The chapel was under the patronage of Saint Rita, an Augustinian nun and the patroness of impossible causes. I could pray to her. I wrote a note for her, even though I knew she wouldn't be looking through the file either.

I dragged my IV drip to the chapel each day, the stand's wheels clattering on the stones. Then I made my way up in a slow, silent procession, with my metallic pole for a shepherd's rod, to the Babinski building. And, back in my room, I chewed my bland food each brightly lit night.

I dreamed that my soldier was tucking me in while I slept, singing a song with no consonants. Saint Rita twirled her skirts, which were layered like a Russian doll to fend off the cold. The consonant-less song disappeared amid the snow, the bassline crackled, the vowels snuffed out by the snowflakes' least touch.

I never heard the door open in the morning despite the nurse's yell. The nurses seemed annoyed. Even in the ORL hospital ward, not hearing still resulted in a class war with the hearing.

On the last day, I had an appointment with a specialist so I could

be released: 'The procedure hasn't produced any conclusive results,' she said as she handed over a folder thick from appointments.

As I made my way down hallways, up paths and through the yard toward the exit, I tried to get my mind around my impending silence.

6

Upon returning to civilian life, the street struck me as a stage set, scarcely real with those blocks of buildings and those narrow roads. The roots of trees planted up and down the avenues burst through the asphalt. It was October and the chestnut trees were all skin and bones already. 'Let's get a drink to celebrate your return!' my neighbor and friend said. In my apartment, I took pleasure in pulling on soft clothes to cover my body, which was hurting all over, and I spun around so I could feel again how this space was mine. All the sounds clumped together and stretched out like in one of those anamorphic drawings; both the ambulance in the street and the toilet flush were a single streak of sound with shrill points.

When I got to the restaurant, the neighbor-friend was waiting and his cheek-kiss and round voice pushed away the hubbub. I clung to his words ringed by high notes. When my eyes weren't locked on his lips, his voice seemed warm, its contours sharp like a solar eclipse. The middle-register core was inaudible, but its luminous edges formed by the higher tones allowed me to grasp the meaning. I managed to follow almost everything he was telling me and that made me happy. We laughed in the night about returning to the world. For a second, he was serious again.

He was telling me about an architect in Japan, about the concrete church he'd erected with its massive cross carved like a window in the chancel's wall: the outside light cast its shape throughout. I couldn't help thinking of how well this picture matched the perception I had

of his voice, the sharp high notes bright with the light of meaning, separated from the heavy, gray vocal range of the middle registers.

'Tadao Ando!' he exclaimed.

And at my bewildered look, he clarified:

'Tadao Ando is the name of the architect I was telling you about.'

His huge blue eyes were smiling, and mine were, too. The drink made the language being gutted by my cilia-less ears reel and sway. His boozy breath recalled the odor of antiseptic. I must have had too many artichokes. He didn't like them and had pushed them all my way. And he was starting to get delightfully sloshed, too, his words drifting off and his eyes getting lustier. After eight days at the hospital this rowdy meal with a man was getting the better of me. Suddenly he looked terribly sad; I saw the bluish halo of the circles under his eyes. There was something of Turner in the coloring around his gaze, his blue eyes like a sailboat violently adrift in his anxiety. For a second I thought I was looking at my soldier.

His form appeared behind the neighbor-friend, the ringlets of their hair tangled, the black ringlets of my soldier practically the shadow of my neighbor-friend's pale ringlets.

'What are you looking at?'

My eyes came back down to his lips which were forming a whirlwind of words, his tongue swinging like a bell's clapper in his mouth.

What was he talking about? Between the two of us sitting there, the words escaped me. The various parts of his body provided no clarification – but I could sense desire surging up – his hands were driving home the thrust of the story, hammering the point home but not revealing a thing. His eyes were no help either and that was actually what I hated most: they were only checking to see if I understood. Thankfully, my own eyes weren't blue, well, that was one useful thing for now. With my jet-black eyes I could drown the phatic function of language, its social play. At least in the darkness there was nothing to plumb. Behind my dark eyes, I felt safe, the other person would never know whether or not I understood. Behind my

eyes I sealed up every crevice, I probed every nook and cranny. There was a chalkboard on which I was the hangman: 'F I _ _ S H _ _ ?' the waiter was asking me. Given the state of my plate, he was probably asking me if I wanted it cleared away. What could the waiter be asking me in a single word? My soldier's massive hands formed a cross as a clue: done? The word had to be a longer synonym. Too late, the neighbor-friend answered for me and the plate was gone. The dark ringlets disappeared, my solider vanished. Once we were outside, my confusion cleared up in the quiet of the winter street, the neighbor-friend's voice felt all-encompassing again. Our bodies walked in lockstep, our strides aligning within the darkness and our drunkenness.

By his door, in our building's courtyard, I felt a new kinship with him, and when his lips brushed mine, I became a sensuous fruit clasped in his arms.

The light or brown ringlets shook free under the sheets, coiled around my fingers, my nipples. But when we retraced the paths of bodies traveled a thousand times before, I was quick to realize that our desire wasn't enough to be called love. I watched him sleeping curled up and I finally slipped into slumber. ■

Derhachi, Kharkiv, November 2022
Courtesy of the author

THE SOUNDSCAPE OF WAR

Ada Wordsworth

I moved to Kharkiv, the embattled second city of Ukraine, in autumn of 2022, one month after the surrounding area's liberation. I had founded a small charity to help restore war-damaged buildings in the spring of that year, and we planned to begin repair work in the heavily shelled surrounding villages. Kharkiv still felt as though it were sleepwalking, nobody quite believing that the horrors might have partially subsided.

My first flat in the city was in the only undamaged building on what was once a beautiful street in the centre. Sod's Law ensured that the apartment above mine belonged to an amateur DJ, the only other resident left behind on the street. All through the night he would mix blaring music. I have had noisy neighbours before, of course, and I have lived with amateur DJs whose hobby would keep me up throughout the night. But in time of war, when the city is a black hole of silence in between the sirens, its few residents having cleared off the street long before curfew, electronic music poring through the plaster of the ceiling somehow becomes comforting. Music is such an intentional noise, and the sound of this inescapable proof of life provided some comfort in the context of the enveloping silence around us. The consistency of it – the knowledge that the beats will maintain their rhythm, that the next bar can be predicted, the pattern

maintained – compared to the spontaneity of the other sounds that permeate a war zone, felt reassuring.

Driving up the main highway to the villages where we work, you could be forgiven for thinking that there was a warplane flying low overhead. The weight of the hundreds of tanks that moved up and down that highway during the height of the fighting last year damaged the asphalt, meaning that now any contact with a car in motion creates a loud, aggressive hum, recreating the sounds of the battle machinery that was stationed there not long ago.

Once you have turned off that main highway and entered the villages, the first thing you notice is silence. The Kharkiv soundtrack of regular air raid sirens: gone. Electricity here was cut off almost immediately after the war began, and with it went the wailing. The loud generator rumblings that you heard in Kyiv or Lviv over the winter months as Russian bombs pounded Ukrainian infrastructure are also noticeably absent. The few cafes and shops that once existed here have either been destroyed or lie empty, owners and workers having fled. Silence rules in the villages and the people who still live here have gotten used to this new, uneasy peace. The silence is not like the silence you will find in a village untouched by war. It is deeper, filled at first with a taut tension and then eventually with an uneasy calm. In Kyiv or Kharkiv, a sense of panic reverberates with the sirens, no matter how used to them you might become, but these border villages are closer to danger than the cities, and have suffered a far greater damage, and yet, in the absence of sirens, the silence cocoons you.

Other than the occasional thud of artillery in the distance, all you will hear is the barking of the hundreds of stray dogs who roam the villages. Many were abandoned when their owners fled and the streets are awash with puppies. Occasionally an international charity will turn up and evacuate some for adoption in Europe and America, but the problem goes beyond what adoption could solve. One woman half joked to me that there had been more evacuation buses for animals than there had been for people. Some of the dogs went mad when

the shelling was at its worst and turned violent. Ukrainian soldiers shot them. Generally, the ones left are friendly, if loud, and will follow you around begging for food. They aren't provoked by the sounds of shelling any more, though villagers say that at the beginning of the war the barking dogs and bangs of artillery always came together.

Peace is a strange word to use for the silence that exists in these post-apocalyptic villages. The war is only a few miles away and the scenes of burnt-out cars, flattened homes and makeshift graves on the sides of roads would surely attest to anything other than peace. It does feel peaceful, though. You know that you are deluding yourself, that the lack of notification of danger is not a real absence of danger, but we choose to bask in our ignorance, filling our ears with wax. For the residents, this peace has even more pertinence. If you ask them to describe the worst months of the war, the answer is unanimous: *holosno* – 'loud'. For them, the silence now is a promise of momentary safety, a reassurance that, at least for this second, the danger has passed. They describe the hellish months when they found themselves at ground zero, in the so-called 'grey zone', held by neither Russia nor Ukraine, and tried to learn to distinguish between 'our' artillery (Ukrainian), and 'theirs' (Russian), and between 'incoming' and 'outgoing' fire. People claim that they can tell the difference and will immediately announce each thud to be one or the other, but I can't hear either way, and the head of one village admitted in hushed tones that, a year into the war, she still can't tell them apart.

For some, the silence becomes permanent. One woman I met had been rendered deaf by German and Soviet shelling in Kharkiv during the Second World War. Deaf charities worked hard in the beginning of the war to evacuate people like her, the most vulnerable to the shelling, but she, like many others, refused to leave. When her village was under attack, she would work out the need to move to the bomb shelter by the severity of the vibrations underfoot. If the shock wave became visible – that is, if she could see her windows shaking – it was time to go to the basement. Other people I've met have constant tinnitus, as though the sirens on the streets have occupied their eardrums.

A Kyiv music producer, Timur Dzhafarov, now serving on the front line, described to me the horrible loss of control over what you hear in the context of the war. In peacetime, you can put your headphones on, ask someone to be quiet, or shut the door to a room. Some sounds may be unavoidable, but generally you consent to what you hear. On the front line, sound attacks you, trapping you within it. In towns and cities across Ukraine, the thunder-like bang of an explosion can come at any moment. Cities are big, and most people will not see explosions for themselves – but the sound is not so easily avoided. A rocket hitting any part of Kharkiv or Kyiv can be heard across the city. This creates a constant feeling of claustrophobia, of being trapped at the whim of people you don't know, or see, or understand, who have taken control of your hearing. Most countrywide air raids are caused by a particular type of missile-carrying plane taking off in Belarus, regardless of whether it actually crosses the border. Sometimes, these planes are launched just for the sake of playing with Ukrainian air defence, confusing it and sowing panic, plunging the country into the wailing of the air raid.

Ordinary sounds change their meaning in the context of war when the reverberations of sound can mean death. The kamikaze drones used by Russia to inflict terror across Ukrainian cities are called 'mopeds' in popular vernacular, as they sound like an engine revving. Suddenly the sound of an actual motorbike driving past evokes new terror. Fireworks sound like gunshots, while the whistle of a train can be heard as an air raid siren. I watched a child accidentally burst a balloon on the street in central Kharkiv, and the adults around her jump and swear. A refugee from Dnipro, now living in Ireland, told me that the best investment she had made since leaving Ukraine was door silencers. Before then, every slam of a door in her new house would induce tears and panic in her young children. One bar in Kharkiv, which reopened over Christmas, insisted on playing tracks that have air raid sirens in them. Each time, newcomers jump when they hear the music. When I first went there, I couldn't quite believe the callousness and insensitivity of the owner. On reflection,

I understand it better. This is a reclamation of these sounds, and a reclamation of autonomy over your reaction to them.

Since I moved to Kharkiv, I have seen a slow, tentative rebirth, both in the city and in the surrounding villages. While some villages are completely destroyed, those that have suffered less damage are coming back to life. Residents are returning from Europe, or elsewhere in Ukraine. They clean up their rubble-filled homes and begin to settle into this new reality. Liuda, who has remained in her home throughout the war, described stepping out of her home one morning in December and crying *Dobryy ranok!* ('Good morning!') and hearing people from practically every house on her street respond, a cacophony of greetings and undeniable proof of life. Where electricity is restored, people can once again tune into the radio or television, making a private soundscape within the walls of their own homes, entirely separate to that which the villages had to endure as a collective. The wildlife is returning too – human beings are not the only victims of shelling; small birds and squirrels often die of heart attacks induced by the shock of the noise. Now birdsong is coming back, joining the soundscape of stray dogs. It will be a long time before live music returns to these villages, but that isn't to say that plans aren't in place. In the settlement of Velyki Prokhody, ten kilometres south of the Russian border, the local house of culture was occupied by Russian soldiers for seven months. With blown-out windows, rubbish piled on the stage and shrapnel holes in the seats, the work to restore it will be massive. The plans, however, are already in place. The village mayor, a kind man called Oleksandr, who was himself captured and tortured by the Russians, shows me the dressing room, still filled with traditional Ukrainian costumes, hidden by the residents who remained during Russian occupation. He promises me that soon enough they will reopen the building. Only ninety of the village's 800 residents remain, but as more and more come back, he knows that the need for music and art will return with them. ∎

GREAT NORTH WOOD

James Berrington

The Great North Wood was once a vast area of coppice and wooded commons stretching seven miles from Deptford to Croydon – forested continuously since at least 1600. The photographs here were made in one of the few remaining fragments of this wood, which have slowly been overrun by the expansion of London's suburbs.

The woodland is very varied – in parts dense, in others more open. As you walk, you cross a disused railway track that was once painted by Pissarro. It's hard to feel that you are still in south London – it is an extraordinary place of tranquillity.

One of the things that keeps drawing me back is the wide variety of birds. You hear them more often than you see them. On my walks I relied on an app to identify them, and I began cataloguing their names in a notebook. I made a field recording of the dawn chorus, which became part of the project itself.

The act of making photographs in the woods provided an excuse for me to slow down and stop, to look and be present in the moment. Using a single small camera with a fixed lens added to the sense of simplicity I wanted to capture. The final images you see here are all as they were taken, with no cropping or editing. I wanted to show the place as it is, and as I saw it. ■

Give the gift of Membership

Set someone special on a journey through human history. They'll enjoy 12 months of extraordinary exhibitions as well as an exclusive programme of Membership events.

The British Museum

Buy now

Ways to buy
britishmuseum.org/membership
+44 (0)20 7323 8195

Large vase, tin-glazed earthenware (maiolica), from the workshop of Orazio Fontana, made in Urbino, Italy, about 1565–1571, with gilt-metal mounts made in Paris, France, about 1765. Part of the Waddesdon Bequest.

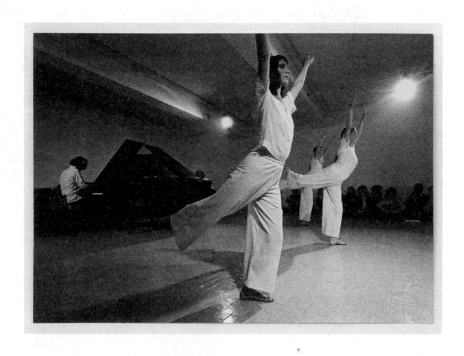

CLAUDIO ABATE
Steve Reich and Laura Dean, *Four Organs* with performance by Trio, Music and Dance USA, 1972
Courtesy of Archivio Claudio Abate

ENDURANCE

Maartje Scheltens

**Piano Circus Performing Steve Reich's *Four Organs*,
Cambridge, 9 March 2023, Duration: 19′**

Four electronic organs stand in a circle on the stage.

 *Four members of Piano Circus take seats at their organs and a fifth
performer is standing in the middle to explain to us how to listen to the
next piece, the second of the concert –* Four Organs *by Steve Reich (1970).
The same performer introduced the first piece too. There, he was one of the
pianists but here he is standing by an empty chair.*

Both the concert programme and the music festival director have
already warned us that this piece will be intense, both for the players,
from whom great concentration is required, and for the audience. I had
previously heard it described as a single chord for nineteen monotonous
minutes, and so I expected exactly that – a chord held for that time,
a kind of mirror in sound of John Cage's *4'33*, but much longer. I
expected it to be quite hard work to sit through, leaving room for terrible
thoughts, the kind that come to mind while lying awake in the dark.

 Instead, like most of Reich's early, minimalist work, the music is
complex – and mysterious. Performers often feel it needs introducing,

explaining. Conductor Michael Tilson Thomas once told his audience, '[it] really asks more of you than almost any other piece in the program. It's a piece, really, for virtuoso listeners.' He called understanding *Four Organs* 'a bit like learning to look at one of Ad Reinhardt's black-on-black paintings'. The experience of looking at a black canvas, like staring at a blank wall, mirrors your thoughts back to you – it doesn't offer a narrative to follow, or new information, just an invitation to experience that moment of looking, listening.

The notes played are simple, but the rhythms are extremely complex. Reich wrote that the composition 'began with a sentence on paper: "Short chord gets long!"' The chord is deconstructed through the piece: each note is gradually separated in time from the others, so the chord is stretched out (a process known as augmentation). By the end it has slowed almost to a drone. Of the dominant eleventh chord he used for *Four Organs*, Reich said, 'it contains the direction in which it wants to go and the arrival point simultaneously. It has the driving force of "I've gotta move!" in the bass, and the soprano voice doubled at the octave saying, "I'm already there!" . . . it's a model of tension.'

After a few listens, the chord takes up residence in your brain. Even though I've heard a number of other Reich works live, none has stayed with me the way *Four Organs* has, especially the memory of watching the performers. Weeks later, having listened to and researched the piece ever since that March evening, and despite its lack of melody, I absent-mindedly find myself trying to whistle it.

The fifth player mentions that during one of its early performances, at Carnegie Hall in 1973, Four Organs *provoked a riot.*

This 18 January 1973 concert has become legendary – the story has been retold often and perhaps embellished. Now, *Four Organs* is rarely mentioned without bringing up the chaotic response at Carnegie Hall.

The piece was slipped into a context of otherwise familiar classical music. The audience, explained Tilson Thomas in a 2016 interview, expected '. . . elegant, gorgeously upholstered traditional music, and instead they got this piece for amplified rock organs'. People couldn't bear to stay in their seats. Interviewed alongside the conductor, Steve Reich recalled, 'We got about two, three minutes into it, and I think people in the audience were beginning to realise, this chord is not gonna change. And they didn't like it!' People coughed, booed, shook their fists. 'We could scarcely hear ourselves playing and I had to in a very loud voice count out the numbers of the beats,' said Tilson Thomas. Both used the same term for what happened afterwards: the conductor said, 'at the end of the piece, there was a moment of silence and then there was just an *avalanche* of noise'; Reich echoed, 'there was this *avalanche* of BOO, BRAVO, BOO . . .'

I'm struck by the contrast between that story and this quiet, fascinated and respectful audience. We stay silent as expected, a middle-class Cambridge crowd, until we applaud for the expected time, volume and length.

'Relax and let the patterns do their work,' the fifth performer tells us. Then he picks up a pair of maracas.

Surrounded by his colleagues piecing out the complex, nuanced elongations of the single chord, this player is doing exactly the same thing from beginning to end. The score reads: 'maracas continue unbroken eight notes throughout'. He is the still form in the centre of the ensemble, but also the rhythm around which the rest of the piece revolves. He sets the speed, and helps the others precisely align their playing with each other and to count the beats. His rhythm provides a background structure that is almost like white noise at times, and then comes to the fore as my attention circulates between the different players and sounds. In his continuous, small repetitive movements he is an unchanging anchor.

Four Organs was Reich's return to live instrumentation after his electronic experiments with the 'phase shifting pulse gate', a machine he invented for his compositional works structured around a repeated pattern played at gradually diverging speeds by players and/or looped tapes, known as phasing. He later wrote that 'the "perfection" of rhythmic execution of the gate . . . was stiff and unmusical. In any music that depends on a steady pulse, as my music does, it is actually tiny microvariations of that pulse created by human beings, playing instruments or singing, that gives life to the music.' The maracas player has become the human machine, providing the pulse that sets the pace for the development of the chord.

The maracas player starts off with his eyes closed.
 The stage lights flicker on the concrete wall behind the players as their small, rhythmic hand movements create reflections, like the rippling water of a canal reflected on the ceiling of a houseboat at night. I watch each player in turn and then I watch the signals between them, but again and again my attention is drawn back to the central figure, the maracas player, even though the drama – the concentrated counting, the tension between the four organists, the exactitude of their synchronised movements – is elsewhere. By the end I can't take my eyes off him. In his moving stillness he exudes something extreme and meditative.

It makes me think of when I was younger and worked some evenings as a life model.

Posing was both intense and peaceful. I felt a simultaneous awareness of the cold in the large, ill-insulated space and the warmth of the small electric heater. I loved the liberation of taking off my dressing gown in a room of clothed people. The absolute freedom – dare I say minimalism – of being nude, possessionless, anonymous; just a body, lit, arranged and drawn. The liberating clarity of a single, simple task. There is just one thing being asked of you, to be still. You're unreachable, and no one speaks to you once the pose has started.

Everyone is concentrating deeply, looking at you, yes, but looking as artists at a shape in an impersonal way, so you're also removed from yourself, from judgement.

I would not move for five, ten or twenty minutes for quick sketches, or up to forty minutes for a detailed drawing. During the short stints, I mostly thought about what my next pose would be, wanting to give the artists variety, but also to move my muscles in the opposite direction, bending a different limb, untwisting my spine.

Long poses were harder and often uncomfortable. The best way, I found, to get through it was never to think about the time. To settle into the stillness as though it would last forever; to stop wishing for it to end or thinking about the next thing, except to vaguely plan what to have for dinner. There was never a clock in the studio. I tried to focus on nothing and let my thoughts wander. I could do that then – I was still young, confident and healthy. I learned that while keeping still I could make small, invisible adjustments to stretch muscles, relax or tense them, to stay comfortable within the unchanging arrangement of limbs – Reich's microvariations of the human body. Once I had fully accepted that the pose would not end, it was a delightful surprise when time was called.

Sometimes I would realise a position was really impossible to hold for the length of time given, whether long or short, especially if I'd stupidly raised an arm – wanting to provide a dynamic subject for drawing, but forgetting it would soon go numb, then dead, then spookily cold. I'd know I'd have to break pose, disrupt the drawings, start a riot, but I'd hang on as long as I could and then a bit longer, into the discomfort, too long, sometimes hurting myself, keeping to the absolute stillness I felt was required, that I'd committed to, was being paid for.

This was all excellent training for what followed. I could always hold my poses until what turned out to be the last session, when I suddenly felt old, and felt the cold in my bones all night afterwards. A few weeks later I was diagnosed with leukaemia. Cancer treatment is an endurance too.

For many minutes, the maracas player makes eye contact with the player closest to him. He seems to be seeking encouragement to keep going from his friend, and this man, his eyes hidden by a black baseball cap (a nod to Reich's signature look), seems to give it to him. Sometimes the maracas player raises his eyes to the ceiling, which I interpret as an expression of suffering or despair. He never looks at the audience. The organists around him in their deep concentration don't either, but exchange looks with each other regularly to ensure they are in alignment throughout the piece. The player at the back dips his head as a cue to indicate a change in the pattern, a progression in the chord's unravelling.

The maracas part doesn't have a full score; only the first few measures are noted. The first measure is the maracas alone, before the organs come in. Then follows that instruction: 'maracas continue unbroken eight notes throughout.' I wondered if the maracas player was counting, up to eight and then again and again and again and if, when he lost his way, he just started again – or whether it was absolutely crucial that he was accurately playing in eights.

The percussionist and member of Reich's ensemble Russell Hartenberger used to join Reich in practising yoga before rehearsals in his New York loft in the 1970s. 'I remember Reich saying that it was important for musicians to do these breathing exercises in groups of eight,' Hartenberger writes. 'This was the first time I had ever thought about why music, at least most of Western music, was created with eight as its base . . . For Reich, this interest in yoga breathing eventually became an element in his music . . .'

I was once taught meditation at a cancer survivors' yoga retreat. There was an optional meditation before breakfast in the barn, and only a few of us showed up to these sessions, led by a former Zen Buddhist monk. We stared at a blank wall. We were taught to count each breath in and out to our natural rhythm. If you lost your way, you just started again because the counting itself wasn't crucial, it was a tool for concentration, to drive out other thoughts, so you let go of time.

The pressure to keep to the exact rhythm for almost twenty minutes without error must be immense, as well as the physical discomfort. While the maracas in *Four Organs* is not the longest of Reich's challenging percussion parts, it's unusual for a musician to perform one single action for this length of time. Hartenberger described playing *Clapping Music*, Reich's piece for two performers clapping, which only takes about five minutes. The movement is similar to that of playing the maracas, as a repeated movement of the lower arms, wrists and hands. The maracas make a sound when they are stopped, by the arms rather than by hitting a hand or percussion instrument. To play them, a relaxed tension is required. Your shoulders should be relaxed, and the movement is in the elbow rather than the wrist. 'One of the biggest difficulties in performing *Clapping Music* is endurance', Hartenberger wrote. 'I try to transfer points of tension in my arms and hands mentally while playing the piece to cope with the stress of the repeated clapping movements . . . I find it also helps to think about my breathing . . . These are physical tools that I have developed in order to have the proper technique to perform the music.'

Later on in the piece, the maracas player seems to start to sweat a little. He looks pained by the seemingly endless repetition of the movement of his arms and the pressure of having to keep going consistently, never to falter or he would ruin the performance, but without the concentration on specifics that must make time pass more quickly for his colleagues. He is imprisoned within this span of time.

Researching *Four Organs* later, I'm struck by its association with torture and something to be endured (or that can't be endured). Despite the variations in the chord, the way it continuously resolves and is sounded by four amplified organs hammers into my ears. It's relentless. As Reich said, 'The piece is played on four screaming rock-and-roll organs, so the timbre is like talons on your ears. The high

frequencies assault you.' The *New York Times* review of the Carnegie Hall performance reported the audience reacted 'as though red-hot needles were being inserted under fingernails'. According to the lore of that riotous evening, one audience member shouted, 'All right – I confess!' There is a connection with Chinese water torture, the torture of endless-seeming repetition. The dropping of water onto the subject's head for a relentless, unspecified time. The victim cannot see the drops, and because the pacing is irregular, they can't prepare for it or predict when it will happen. While an individual drop of water to the head is not painful, the repetition amplifies it to assault the brain.

But isn't this in poor taste? How can we call the experience of listening to or playing a twenty-minute piece of music torture when we think of the real pain in the world? When we willingly put ourselves through a discomfort we know to be temporary, to act out endurance, what are we trying to prove to ourselves?

Poet Harriet Truscott walked the Camino de Santiago alone in 2017. A structured route, the pilgrimage is broken up by stages of accommodation and pages to be stamped in the official pilgrim passport. In her poem '827k from Irun to Santiago', having arrived at Santiago de Compostela, she has a conversation with a nun, who asks her to describe one memorable day of the walk. She recounts a day she walked in relentless rain, completely drenched and enclosed in cloud, but she kept trudging on and on, making the miles 'by the book', and 'never cheated once'. The nun listens carefully, then 'She said, *Yes.* / *When have you done that before?*'

When have you done that before? I think of the poem often, and this question runs through my head as I listen to *Four Organs* and watch the maracas player in his monotonous endeavour. I watch him and I project onto him all my thoughts about endurance, pain, stillness and suffering. When have you done that before, keeping going through the pain, enduring? That seems to me to be one of the questions *Four Organs* is asking.

Truscott's rainy walk feels akin to my modelling pose or the maracas player's repetitive rhythm. It's like when you're caught in a storm and

there's no bus and you don't have a raincoat and the only way not to despair is just to accept where you are and keep going. Accept the rain and the walk, and walk as if it will last forever. To inhabit that time and space without giving in to your wish to be elsewhere or for this time to be over. In the walk you are both still, because your small movement is unchanging, and travelling through time and space. Looking at a walk from a different perspective, your quiet, repetitive, walking movement, like the maracas, stays the same while the world turns around you. Truscott walked on without the variety of the landscape to break up the monotony: 'each roadside shrine lost in a weight / of rain, the famous view a road disappearing / into the rain'. There is an inward turn from the landscape to the body walking, a desire to just make the miles, to reach the end both of the day and the walk. Without the view, the walk becomes a solitary act of endurance, one beat, one breath at a time.

Once, on a long lockdown walk in the Fens, I turned a corner – actually a right angle following a lode away from the riverbank – and the straight path stretched seemingly endlessly ahead. I'm attracted to these flat walks where the view changes so slowly it looks like you'll never arrive anywhere. Nothing to do but just follow that path to infinity for however long it takes. And within that straight walk and unending view there are colours and details to focus on. A pilgrimage is a set of instructions, a world of counting and rules. A time-limited and yet open-ended time. A decision to begin something and follow it until the end. Your steps become an automatic rhythm, like breathing, the beats underneath the chord.

So, what the concert was showing us was not just our own endurance in experiencing the piece, which I enjoyed though it was so hard for the Carnegie Hall audience, but something about endurance and suffering in our own lives. Our desire to obey the rules – making the miles without cheating or giving up – was exploded by that riotous audience.

The maracas player perks up for the last few minutes. He seems refreshed, recommitted to his rhythm, concentrating hard to ensure that all five players will come to an exact stop at the end.

During an experience of endurance, there comes that moment when you suddenly see a little way around the corner. That moment came around my penultimate round of chemo, when I was suddenly aware that there would be a time after, a recovery period.

During cancer treatment, the days run into each other and time passes slowly, except when something goes wrong and then it passes fast. My treatment involved stays in hospital of four, five, six weeks, most of the time confined to the ward, to avoid infections. It was like being trapped in a prison where you're being imaginatively tortured with poisons and needles. I tried to accept it, to stop waiting or yearning for it to be over, the relentless tedium and horror of it. People say it's a journey, but it is only like a journey where you have no idea of the route or the destination. You're travelling through time rather than space, trudging along inside the clouds, the view obscured. But will you end up somewhere different to where you started, or is the destination already determined in the point of departure?

The claustrophobic environment of an MRI scanner with its soundtrack of drones, bangs and whirring repetitions becomes easier to bear after thinking of pieces like *Four Organs*; you can imagine the MRI sounds, like drums or electric organs, as an electronic Reich composition. In the claustrophobic scanner, unable to move, I draw on the mindset of the model's pose and try to stop thinking about when it will end. Then comes the view around the corner, that moment when they tell you, 'We're nearly done, just checking the scans.'

Four Organs allows us to step out of time and briefly inhabit infinity. But isn't that what we always do – live as if time will never run out?

And then somehow all the players simultaneously stop.

The perfectly timed exact collective silence is made possible by their deep knowledge of the piece, as well as their wordless communication, the nudges and eye movements.

We applaud respectfully. We stand. The players pick up their scores and walk off. The lights snap on. We come back to ourselves and each other, chatting in the queue for interval drinks.

Time is called. I stretch, smile, wrap myself up. The artists turn the pages of their sketchbooks and pack their charcoal away.

Time rushes in and floods the landscape, an avalanche of silence and sound. ∎

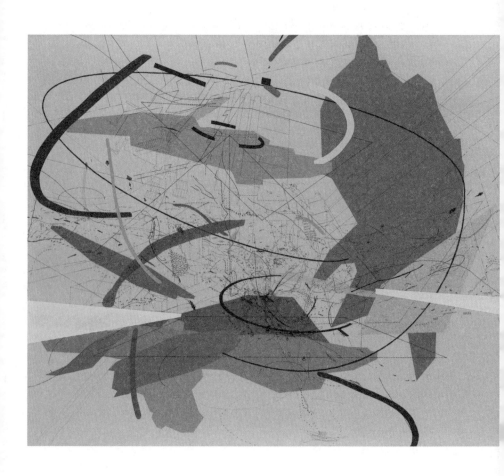

JULIE MEHRETU
Untitled 2, 1999
Courtesy of the artist and White Cube

THINGS THAT DREAM

Brian Dillon

How much do we notice sonic texture or particularity when
we listen to popular music? Some technologies impinge,
snagging the mind and ear for better or worse. The wah-wah pedal
in 1960s psychedelia and 1970s funk. The electronic (but manually
played) Syndrum that pinged away in the background of certain
disco records in the late 1970s, and was used to sinister effect by Joy
Division on 'She's Lost Control'. The squawk of the cheap bass synth
on house and techno records a decade later. Autotune on everything
for the past twenty years: an inhuman enhancement becomes, in
the right hands, potentially heartbreaking. But technology doesn't
exhaust style, even in styles of music that are all technology. We hear
everything all at once, and only the most obsessional 'gearhead' would
imagine the sound of a Jimi Hendrix record to reside in the guitar and
amp settings, say, or the precise chain of effects, or the ambience and
wiring of a studio.

The early 1980s was the era of synth pop, and as the decade
continued these new sounds met with more conventional rock
elements. We went from the amateur futurism of Depeche Mode and
The Human League to a pop landscape in which even the venerable
likes of Yes and Genesis partly aspired to a machined modernity,
adding drum machines and sampled instruments to their records. By

1985, the year of Live Aid, the extant generations of post-1950s pop had been flattened to a single plane of bright and brittle-sounding production, governed by thunderous drumming, real or not. As always, this story is pure cliché, and polishes a vexed and knotty history to a series of smooth transitions, solid outlines of period or genre. But forty years on I think, or feel, that something really did change, some shift in the aural landscape of pop. It seemed then that a force both vast and breakable had taken over from the more sci-fi but home-made forms of early-80s synth pop. Lofty, fragile, sublime and ecstatic, this new aesthetic taught us about the emotional weight of artifice. Despite its heartless, glacial advance over the music of the mid-decade (which for a time was all that mattered to me), it was consoling as well as estranging.

How to describe this sound? It had partly to do with drum machines, and in particular with the Linn LM-1 that Prince, one of its most imaginative users, deployed on *Purple Rain* (it is the detuned knocking sound you hear on 'When Doves Cry') and continued putting on his records after everybody else had moved on to newer technology, or simply adopted cheaper alternatives. Among the last superlative uses of the Linn (before its sounds seemed fully antique, and appealing only as retro samples) was on 'Mia Bocca', released in the spring of 1987 by Prince-associate Jill Jones. The song starts with four naked bars of Linn percussion: a slow bass-drum stutter punctuated by a noisy knock-on-wood sound. Where a snare drum ought to snap, instead there is something muffled and prolonged, not so much arriving on time, twice in the bar, as swallowing the rhythm whole, digging a void underneath.

As Dan LeRoy notes in his recent book *Dancing to the Drum Machine: How Electronic Percussion Conquered the World*, the drum machines of the 1980s – and therefore also the texture of music today, which so frequently harks back to that time – were indirect products of urges and experiments that emerged almost a century ago. The declared ambition was for a technology that would

keep reliable time, while obviating the need for a human player, but it is possible that a more secret impulse was at work: a desire for the inhuman itself. In 1930 the American composer Henry Cowell wrote: 'It is highly probable that an instrument could be devised which would mechanically produce a rhythmic ratio, but which would be controlled by hand and would therefore not be over-mechanical.' Examples of the Rhythmicon still exist, and you can watch demonstrations on YouTube, the bristling metal contraption chirping away, from one note per beat up to sixteen. The machine's output is surprisingly adaptable: a polyphonic keyboard will combine different note clusters to form complex patterns that sound more insectoid than robotic.

For much of drum machine history, programmability – to be able to build a rhythm out of discrete percussive sounds – was the dream, rather than simply pressing a button and having preset combinations emerge at fixed or variable tempo. In the late 1950s, the organ manufacturer Wurlitzer brought out the Side Man, a table-height wooden cabinet with an inset control panel. Its name points to the role filled by drum machines for the next quarter-century: adjunct to a keyboard, allowing a solo performer to augment his sound – *Now you can be a combo all by yourself.* The first records to feature such instruments were the three volumes of Raymond Scott's *Soothing Sounds for Baby*, released in 1962. Scott, a popular innovator in electronic music, whose compositions were used in *Looney Tunes* and *Merrie Melodies* (and later in *The Simpsons*), was also the inventor of a number of drum machines. Even he seems to have thought of them as fundamentally unserious; in 1960 he named his new iteration Bandito the Bongo Artist.

Such inventions could not exist for long without being creatively misused. Fixed-rhythm drum machines provided, or augmented, percussion on several songs by Sly and the Family Stone, notably 'Everyday People', where the electronic rhythm proceeds calmly and precisely beneath the looser funk of a real drummer. At another extreme, in the mid-1970s the New York avant-garde duo Suicide

repurposed lounge-music instrumentation and rockabilly vocals to primitive, spectral ends, drowning the output of their $30 rhythm box in effects and distortion until it sounded like nothing on Earth. In Osaka, Japan, Ace Electronic Industries, which had been selling fixed-rhythm drum machines for over a decade, renamed itself Roland and launched a new line of devices that combined presets with minimal programmability. These are the drum machines that made turn-of-the-decade sounds for the diverse likes of Roxy Music, Blondie, OMD, Throbbing Gristle and Visage. (Also Phil Collins, who is never far away in this story, though it would have pained me as a teenager to acknowledge his prescience, so much did he seem a relic of the 1970s.) Roland drum machines sounded like the future, which means they were not quite the immediate future – not yet.

The actual future was being rehearsed in unlikely places. Roger Linn was born in Whittier, California; his mother was an opera singer, his father a composer and music professor. As a teenager, Linn dabbled with computers, guitar and effects; the all-female rock band Fanny bought one of his adapted guitar pedals, but he later heard that onstage the device picked up broadcasts of baseball games. Linn was in his twenties when he began working with the singer Leon Russell and put together his first drum machine. (Russell is a hard musician to pin down: at one time a session pianist who played on records by Frank Sinatra and The Beach Boys, he was later at home in rock, country, blues and soul – all in all, a curious artist to have been experimenting with drum machines.) You can hear the prototype on Russell's 1979 album *Life and Love*: dismayingly thin compared to how the finished product would sound, and indistinguishable from any preset model of the time. In fact Linn's LM-1 Drum Computer, as it was soon to be known, was a different proposition. Its dozen drum sounds could be played live, or programmed in any pattern you liked using a built-in sequencer. But the main innovation was this: each sound was a digital recording, an eighth of a second long, of a real drummer hitting a real drum. (The drummer behind most

of these sounds was Los Angeles session musician Art Wood.) There were no cymbals on the LM-1, Linn having concluded that the extra cost of memory for longer sound samples would make his product too expensive even for professional musicians, producers and studio owners. The machine cost $5,000 on its release in 1980, and Linn made just 525 of them. In trade-press advertisements, the black, wood-panelled LM-1 hovered, like a Spielberg spacecraft, below the playful and affronting slogan 'REAL DRUMS'. The Human League's 'Don't You Want Me', recorded that same year, may have been the first hit to use the machine.

Alongside its successor the LinnDrum (which was released in 1982), the LM-1 is just one of the sounds you are thinking of when you think of big 1980s drums on big 1980s hits. At the end of the previous decade, while working on a Peter Gabriel album, producer Steve Lillywhite and engineer Hugh Padgham accidentally hit on the technique of gated reverb. The sound of a drum reverberating in a large or sonically 'live' room is suddenly cut off so that each drum hit now sounds both immense and contained, roaring with life and quite artificial. It's a violent sound, to be found on records by Public Image Ltd, Duran Duran, Bruce Springsteen and Phil Collins. In the 1990s it was sometimes said that good or even great records of the prior decade had been ruined by the intrusion of gated reverb, or by sounds such as the Linn's, but I prefer to think instead about the mediocre and perhaps even terrible songs from the 1980s that were enlivened by their strange, almost avant-garde percussion. 'Some Like It Hot', a 1985 hit by Duran Duran offshoot The Power Station, is to my ear a tuneless mess – but its drums are sublime.

Kate Bush's 'Running Up That Hill' might well be the greatest record to feature the Linn drum sound. Bush's machine was probably a LinnDrum from 1982: in some ways more sophisticated than the LM-1, but lacking the ability to tune all drums. Bush, who produced the seven-inch single and its extraordinarily rambunctious twelve-inch mix herself, instead adjusted or enlarged some sounds at the mixing desk – or added a live drummer who overlays, and at times

seems to rage against, the strictly quantized and immovable machine. I remember Bush performing the song on early-evening television, wielding a bow and arrow while her band mimed behind her with acoustic instruments. There was such a distance between the sonic reality and mock-medieval performance: it might have been comic had the record itself not sounded so huge, so insistent, so annihilating.

By the mid-1980s, at the limit of its mainstream sway, the sound of the Linn drum already seemed doomed. Instead of growing a line-up of drum machines, Roger Linn replaced each iteration with a new one, orphaning the old technology and its users, killing off an established stream of custom. It is also significant that the dominant genres of the latter half of the decade were using drum machines made by other manufacturers: hip-hop was dominated by Roland and Oberheim; house and techno favoured low-end, obsolete Roland machines with analogue but 'artificial' sounds, such as the squelching TB-303 bass synth. But it was sampling that more or less killed off the stand-alone drum machine. The dream of the LM-1 in 1979 – real drums at the touch of a button – was now ubiquitous reality, and the raw material that could be sampled apparently unlimited. Linn himself joined in, designing a sampling drum machine, the MPC, for the Japanese company Akai, which launched in 1988 and became a staple of hip-hop ever after – an MPC3000 belonging to the late J Dilla is now part of the Smithsonian collection, along with his Moog synthesizer.

But the Linn did not really die. The sampling boom that overtook the drum machine also ensured that, when fashion decreed, its sounds were still available to be used once again. And the survival of those sounds would in time start a craze for the original machines. Today you can buy an original LM-1 for two or three times its original price. At least one manufacturer claims to be developing a cheaper replica, and a number of software copies exist. Much more prevalent: the individual sounds of Linn's machines, like those of countless other rhythm boxes and synthesizers of the 1970s and 1980s, simply exist as sampled possibilities alongside all others. It is a state of affairs that

Linn and his hired drummer had in a small way already predicted in 1979. Among the drums that Art Wood brought with him to Linn's home studio, and which likely provides the snare drum sound on the LM-1, was a Slingerland Radio King snare from the late 1930s: the big-band sound of Buddy Rich and Gene Krupa haunting records made fifty years later and our century in turn. ∎

Oluwaseun Olayiwola

Strange Beach

—unable to get from the underneath side of
 the stones
 that flank the sand, the body: blown

from every direction, into like a conch shell

where the echo of excess emotion enraptures

 the chamber

where once was a body willing to die inside of, longing to—this
 is the obsession, this hour

of philosophy, this transatlantic voyage
 spread on the page
 like an oil spill, the blue-and-black

arsenal of water whispering, inevitably, as if

it were in a wind: *was it worth it?* Worth.

 Worth. It circles around you—

the increasing gap between the surface
 of the water
 and the stillness you entirely inhabit

so as to sink to the ocean floor: but properly
with no effect on velocity. Sting rays.

Desire: inseparability of light
 and dark. How beautiful

you have been and are

 giving your whole life to a pointless competition—

Oluwaseun Olayiwola

More Night

after John Ashbery

Nothing is wide open
 in the Book of Unusable Minutes.
The sun lifted its broken arms
 like a dying thing, the centrr
moving along time's cargo
 archaic gauze, each individuated
perpendicularity a mazed
 patchwork of vein
where healing had words
 to unpick and kept its mouth
shut, a genteel child in the cabin—

Long haul. Year of trillions
 and the plane soaring
into its wilding airscape, the farther-out
 distances of carbon—This
is my airborne home, I cannot
 outrun it, these, our eyes
focusing downward
 where God is just
this once, yes, the origin
 of interiority from our lungs

starting a wind and do you
 hear it? The ears
in our chests? The chapping,

 the past in each of us
blistering, the pus arriving
 like sleepwalking snow—what is it
we declare for small things,
 the sheer weight of something
being looked at, deliberately, persistently—

Then the durational string-pluck
 of turbulence shearing prayer
from the body's tarmac, the unpacking
 like an era that refuses to come
to an end or begin again.
 Here have more night
the mind says. And as if from nowhere
 Here have more blue,
Are you feeling too simple?
 Are you wanting the glazed
lake of memory to shoot up
 for air and take
more of you away back with it
 when it goes?

Faces with wishes stitched across them
 like large quilts,
and the sunset, even from this high up,
 tips down along the dark
outcome of sky. Immeasurable beauty
 is immeasurable precisely
until it's gone—

A LIFE WHERE
NOTHING HAPPENS

Mazen Maarouf

TRANSLATED FROM THE ARABIC BY THE AUTHOR
WITH LAURA SUSIJN

During the war, my father was not afraid unless we were around him. If he was alone, he didn't care. His fear was that we would die in front of him and so he thought of us all the time, which is not what he wanted. I heard him say this to my mum: I feel like I am one of those people born to stay alive while everyone around them dies. When the frequency of the clashes intensified, he raised the volume of the radio to disguise the sound of the bombing. This meant we always knew when he was afraid. He had a skill for finding a song we hadn't heard before: pop, rock, folk, jazz or classical. We would ask him to explain the song lyrics, and he would say that it was about a person who lived a life where nothing happens. He told us it was the same song we listened to last time.

It was amazing to us kids how my dad managed to find the same song every time but set to a different tune. We also thought that his insistence we go down to the shelter without him was so that he could fight with the armed men. With all the armed parties that had spread around us, we did not understand which of them were the 'heroes' and who were the 'thieves', but we were certain that my father was on the side of the 'heroes'. The truth was quite the opposite. As soon as we went down to the shelter my father would lie on the floor of our sitting room with his sketchbook, covered in the five heavy, fireproof

blankets we received from our subsistence aid. He wanted to be a comic book artist. His imagination did not help him to write stories, but he persisted, drawing characters that didn't speak, like children's drawings. Mostly drawings of gunmen and children. But with no text. He was saying that he could not write because nothing happened in his life with us.

One day, while the boys at school were talking about the armed men who go into battle, how no one knows their faces, and about the unarmed men who roam the streets, I said that my father goes to fight when we go down to the shelter. One of the boys asked me to describe his uniform, so I borrowed from a gunman's uniform my father had drawn in his notebook. Days later, we arrived home from school and learned from the neighbours that armed men had taken my father from our house and that they were looking for a military uniform – the same uniform I had described to my classmate. Apparently, my father had smiled, saying that something was going to happen at last. I told my schoolmates that my father had been kidnapped by gunmen, but that the heroes would save him. Weeks passed, then months and years, yet there was never any sign of my father.

Later, we were forced to leave the building along with the rest of the other residents. We were displaced and told we had no right to stay in our apartment after the war ended. My mother hung a note with the address of our new home on the door for my father to read when he returned. The piece of paper stayed there for months, until the owner of the building removed it, as part of the internal and external restoration work. My mother knew this and asked me to write something in the newspaper urging my father to return. I told her my father was missing. She insisted that he was alive, but that he was a fool and might assume we were among the dead, and so he might not make enough of an effort to search for us. My mother asked me to write to him, something to let him know that our life was not as he always said: that nothing happens in it. She told me to make sure the letter was in a different format every time. She said your father is an artist above all else and if he sees that we write the same

note every time he'll think that we don't appreciate him enough, and that he was right to leave us.

So I did.

That was my first attempt at writing. A simple notice of three or four lines that I published monthly in the newspaper. My mother never read what I wrote or asked any questions about its content. She was busy working and just gave me the money to cover the cost of publication. She said that if she read it, she would feel pain. A strange intuition told her so. But she was convinced that my writing would bring my father home. Thus, I remained with those few lines, describing one subject, the same subject, but in different forms over and over. Exactly like the songs my father used to describe on the radio during the bombing. Until what my mother expected to happen finally happened, and my father came back to us one day. He was in dire straits, with signs of anxiety, exhaustion and sadness visible on his face. However, within half an hour of his return, his expression changed to one of anger and we quarrelled. He told me that if I decided to become a writer, I should avoid personal writing, because I was not good at it. If I ever tried it, he was sure I would misuse it.

Despite his defiant tone of voice, I sensed that he was actually asking for something else: help. But I didn't do anything. I even stopped writing.

Now, after all these years, recalling my past self is like following a holographic shadow that might mimic the shape of another person at any moment. For this reason, I usually end up writing about other people I once wished to be. My father is of course not one of them. Yet I am more than willing to write about him, realising that my failure to capture his character gives me the opportunity to appear as if I really am misusing the writing, just as he said I would. So I write about someone else. Someone my dad wished he could be.

If you were wondering what I published in the newspaper, what I felt could attract my father's attention, in only a few lines so it would not cost much – it was a notice on the obituary page. Almost every month, I would post an obituary commemorating the death

of one of my three brothers, who had initially been upset before it became a joke. When are you going to write your own obituary? they joked, describing me as an obsessive. In their view, it was useful that I wanted to be a writer. My dad never returned to comics. Today, he rarely listens to music. He also thinks that I only write to remind him of when he left us. Often, the moment he starts fighting with me, I open a playlist on my phone and turn up the volume. He approaches me and says: You're afraid! Ha? Afraid. Say it! Say it! ∎

TONYINTERRUPTOR

Nicola Barker

'When I was eighteen, the vision was to make music that didn't exist, because everything else was so unsatisfactory.'

'Blue cheese contains natural amphetamines. Why are students not informed about this?'

– Mark E. Smith

1

One day, he just stood up in the middle of a live music performance and said, 'Is this honest? Are we all being honest here?'

He pointed at Sasha Keyes who had just begun what he (Sasha Keyes) felt to be a particularly devastating improvised trumpet solo, and added, almost pityingly, 'You, especially.'

The interruptor had a good voice, a strong voice. It was fundamentally classless but with the slightest suggestion of northern grit. It had a pleasing timbre: low, grave, sincere. And the line was delivered in such a way that it seemed at once spontaneous but considered, indignant but measured. It was heartfelt. There was . . . somehow or other, there was *soul*.

Many people couldn't (or didn't) hear what the interruptor was saying because they were so intent on the performance. His words were just so much *sound* to them. They had – for the most part – paid for their tickets, and while the tickets weren't expensive (as befits an improvisational jazz show in a moderately affluent southern English cathedral town), nor were they cheap. Insofar as value for money is relevant to art, that audience – an attentive audience, a great audience – were determined to get it. They were focused (there may even have been a degree of breath-holding) and the overriding consensus was that they were all definitely getting a bang for their buck:

Effortless flair –
Deep concentration –
Implacable scowling –
Occasional nonchalance –
Undeniable finesse –
Subterranean grunting –
Utter humourlessness –
Visible sweat –
Patent commitment –

Honest, though?
Honest?

Sasha Keyes was/is both a fantastically complex individual, and an extraordinarily talented trumpet player. A virtuoso. That much, at least, is not up for debate. It's *known*.

Sasha Keyes was/is reputed to have made Prince Charles cry after he slaughtered 'My Funny Valentine' (fearlessly, magnificently) while sailing down the Thames on a London barge. The (then) future monarch was held physically and aurally captive by this one-man last-minute booking and his legendarily uncompromising trumpet (Jamie Cullum had cancelled because of flu. The events organiser

was summarily fired. This story may possibly be an urban myth, but it certainly rings true).

It also goes without saying (almost) that the gig wasn't much *fun*, but then who buys tickets for an improvised jazz set by Sasha Keyes and his Ensemble (the Ensemble didn't consider themselves to be 'his' or 'an ensemble', so much as a group of individuals who just happened to be playing together, several of whom actively despised each other) in the spurious belief that 'fun' would be involved? To expect (or require) 'fun' would be like going to a railway station (any railway station) and trying to book yourself onto a direct flight to Acapulco. This was an altogether different mode of transport. Fun was neither a point of departure nor arrival.

Over time, this moment – which we are now calling, for the sake of clarity, The First Interruption – would acquire a kind of mythical status. It became a little piece of Performance Lore; a source of ferocious interest/contention/amusement/debate across at least three creative disciplines, the subject of four books – this being the third – and the root of approximately 2.5 million tweets and memes. Even Sasha Keyes himself would eventually come to see his involvement in The First Interruption as a marker of status (never a source of pride), although this uncomfortable accommodation was still a very long way off.

Very.

A very, very long way off.

And yet . . .

Even while we are calling it The First Interruption, can we be absolutely certain that this is indeed so? Was The First Interruption really the first interruption? Surely it must be highly likely that TonyInterruptor (John Lincoln Braithwaite to his mum and all the teachers who repeatedly threw him out of class) would have interrupted countless other live music performances, but these interruptions had inexplicably (but also explicably) escaped public record? It *is* absolutely certain that he would've left many live music events in complete disgust, as such was his nature, and to vote with

your feet he considered a small yet revolutionary act of defiance (especially if the venue was seated and he was positioned, as he invariably was, dead centre, three rows from the front).

To stand, at a critical moment, during a live music performance – or a play, or a reading, or a maths class, or a poetry recital – and to leave (with all the adjacent kerfuffle . . . where's my anorak got to? Oops, I forgot my gloves), must surely be to surreptitiously disrupt and undermine a generalised feeling of consensus around what is 'good'?

For the record, The First Interruption wasn't especially notable or even outrageous (although some were outraged – Sasha Keyes in particular), but for a selection of obscure reasons it *became* significant. It represented a perfect storm. For a storm to be perfect there will always be a rare combination of meteorological factors (a serving of warm air from a low-pressure system hitting a portion of cool, dry air from a high-pressure system, with a dash of tropical moisture thrown in like a condiment), which, just as in jazz improvisation, facilitate the creation of something potentially mind-boggling. Perhaps perfection is always a subtle and random combination of disparate factors? Perhaps perfection is simply the unplanned conjoining (and unifying) of the unlikely? So brief! So fragile! (Sasha Keyes once keenly disputed this idea, out of sheer perversity, during a heated post-performance exchange with Fi Kinebuchi. We can imagine Kinebuchi making this perfectly sensible and uncontentious point in breathy undertones with her trademark, flowery, birdlike gestures and Sasha Keyes gazing at her with an icy dismissiveness before saying something withering like: 'Have you thought about this a lot, Fi?')

In just this way (i.e. the perfect storm way) there was the timing of the Interruption, the content of the Interruption, the general tone of the Interruption, the personality of TonyInterruptor himself (could we rightly call it charisma? This is a chapter in itself), the reaction of his interlocutor (Sasha Keyes), the presence of a disgruntled zoomer, India Shore, who had been compelled to attend the performance by her architecture professor father (Lambert Shore) in the belief that it would be, at some level, improving and educational for her.

Some people *thought* they heard what he was saying. Larry Frome (kicking butt on his ARP Pro Soloist 1975) was actually staring straight at TonyInterruptor, somewhat dazedly (and wondering how long Sasha Keyes would solo this time around) when *he* heard the words,

'Sasha Keyes is a dick. A blowhard and a dick.'

This bears no resemblance to what TonyInterruptor actually uttered, but Larry Frome *to this very day* insists that it was so, even in the face of prodigious documentary evidence to the contrary (recorded on a mobile phone: #firstinterruption). This has opened up an entirely different area of enquiry #fromediffers around ideas connected to meaning and intent, and whether the human ear hears only what it *wants* to up to (approximately) 87 per cent of the time.

It's interesting to wonder whether TonyInterruptor would even exist (as a meme, a metaphor, a celebrity, a concept) without Sasha Keyes – the very person whose sincerity he had pointedly and spontaneously called into question that particular night. Did Sasha Keyes actually *create* TonyInterruptor by sarcastically christening him, post-gig, with an idle, throwaway comment? Do we *all* inadvertently create our own mortal enemies by imagining them into being (and naming them) then spending inordinate – even heroic – amounts of energy fiercely battling with them through this crazy, mind-boggling delusion we call 'time'?

2

'A *dick*? Are you *sure*?'
Sasha Keyes is perched, uncomfortably, right on the edge, the lip, of the only comfortable chair provided in the small but nicely appointed artists' changing room. Larry Frome is keenly aware of this fact because he has lower-back issues and had assessed which chair might be best suited to his needs on first entering the changing room prior to soundcheck. Once this assessment had been made, he

had allowed himself to believe that any other band member (they weren't a band, they were just random individuals 'performing') who sat in that particular chair and deprived him of it was a complete arsehole. Almost the entire band were arseholes, apparently; especially Sasha Keyes (who, in Larry Frome's view, behaved like an arsehole approximately 90 per cent of the time).

Larry Frome is six foot three and incredibly thin. He is forty-seven years old and looks a little bit like Gil Scott-Heron. He enjoys wearing motorbike goggles even when he isn't on a motorbike (he once hired a dirt bike during a weekend on the Canary Islands in the early 2000s and stole the goggles – happily losing his deposit of €175 – because he liked the feeling of pressure around his eyes).

Larry Frome is celebrated for being extraordinarily frank and literal (he still remains disappointed that he didn't see an actual canary on the Canary Islands, for example) but is generally liked among his peer group of musicians because he only ever speaks at a low whisper, which takes the edge off his caustic proclamations. Over time his trademark goggles (which have two tiny holes bored into the reinforced plastic on either side to preclude excessive quantities of condensation) have rubbed a kind of permanent parting onto the back of his head. His Afro hair has formed into two distinct bubbles. It is a strange but a good look.

Larry Frome suffers from ADHD and is incapable of sitting still for more than three minutes at a time unless he happens to be deeply engrossed in something. Generally the two things that engross him most deeply are vintage synths and arguments. He rarely eats and finds swallowing difficult because he sometimes completely forgets how to do it properly unless he isn't concentrating.

'That's not even remotely close to what I heard,' Saul Timpson shrugs, distractedly removing one of Fi Kinebuchi's dark hairs from the arm of his new, bright yellow Crew jumper.

Saul Timpson always acts with a measure of grandiosity – as if he were the rightful heir to the key-cutting, shoe-mending business, Timpson. But he isn't. He's just a 63-year-old geography professor

from Reading with a talent for the cello who sometimes gets gigs with Sasha Keyes (whenever Cecil Home is busy) because his sister was Sasha Keyes's first ex-wife and he is a fat-headed but fundamentally amiable sycophant. He also holds an especially important place in Sasha Keyes's heart for introducing him (as a raw, unschooled nineteen year old) to Pharoah Sanders and the whole concept of 'sheets of sound'. Other ensemble members sometimes refer to Timpson, pityingly, as 'The Whipping Boy'.

'What did you hear, Tims?' Sasha Keyes demands.

'I heard "Is this *honest*? Are we being *honest* here? *You* especially." Tims points at Sasha Keyes. He holds out his pointing arm with a measure of Gothic aplomb, like the Grim Reaper.

'What the fuck? Some random, fucking nobody,' Sasha snarls, 'some dickweed, small-town TonyInterruptor . . .' He temporarily runs out of invective because his levels of upsetness are too profound to be fully encapsulated by mere words (or 'worms' as Larry Frome likes to refer to them – semi-seriously).

'TonyInterruptor,' Larry Frome echoes. 'One worm? Heh!'

'Surely the title of an early Fall single?' Simo Treen chuckles, also impressed, in spite of himself.

Simo Treen plays piano.

Simo Treen has been fascinated by the tonal peculiarities/sonic and compositional variations of birdsong *forever* – long before anyone else was even vaguely interested in the subject (although, to be frank, everyone has *always* been interested in the sonic and compositional variations of birdsong). Treen deftly follows up his Fall comment with the apparently unrelated observation that 'Sasha has never really had the capacity to fully galvanise a group of people.'

'What the hell?!' Sasha turns on him, outraged.

Never had the capacity to fully . . . ?

This is precisely the kind of unnecessary sideswipe for which Simo Treen is legendary. He is a small but very muscular and hairy man with immense hands. He insists on always wearing shoes with impossibly pointed toes even though they must, inevitably,

compromise his use of piano pedals. For this reason he has perfected a style of pedal-free piano playing. Nobody knows which came first: the pedals or the shoes. In-the-know contemporaries like to call this 'the Simo Treen shoe/pedal conundrum'.

'TonyInterruptor,' Fi Kinebuchi notes, thoughtfully, 'I expect you are familiar with the Krishnamurti quote that "when you teach a child that a bird is named 'bird' that child will never see a bird again"?'

'What the . . . ? How the . . . ? Shut the fuck up, Fi,' Sasha snaps. Fi's possession of a vagina makes her interjections, if possible, even more irritating to Sasha Keyes than Simo Treen's (and this is a proven, scientific fact).

'*You* shut up you *fucking dick*,' Larry Frome whispers, almost inaudibly, while fishing around inside his mouth for one of Fi Kinebuchi's hairs, which he appears to have partially swallowed.

(Larry Frome and Fi Kinebuchi are currently an item although they live in different cities.)

'Krishna . . . ?' Simo Treen echoes. 'What exactly has TonyInterruptor to do with birdsong again?'

Nobody can ever really tell whether Fi Kinebuchi is actually the profoundly mystical and otherworldly intellectual that she appears to be. She plays the autoharp and the lyre but also the guitar. She lectures in music at Christ Church University (several of her students were in attendance at the gig – Lambert Shore regularly corners her in the staffroom) and is generally known (by herself – on her social media – and therefore by the world at large) as 'The Queen of Strings'.

Some people (notably Sasha Keyes) think that a) she is the 'queen of strings' but the mistress of none and b) that she just googles things and then randomly inserts them into conversations no matter how pertinent or relevant they may be. This means that she is invariably surrounded by a perplexing nimbus of question marks. She wears these like her queenly ermine. Sasha Keyes thinks she plays a devilish and cunning peek-a-boo within the voluptuous folds of this furry cloak.

Sasha Keyes was married to Fi Kinebuchi for seven years. For six of those years Fi Kinebuchi was living abroad and studying medicine

in Oslo. One month before taking her finals, Fi Kinebuchi abandoned her degree. Sasha Keyes found this impossible to comprehend at the time. He still hasn't forgiven her.

While we are on the subject of fur: if Fi Kinebuchi were to be said to resemble anything then it would be an Alaskan Klee Kai. This is a relatively new toy breed of dog that (in turn) slightly resembles the Alaskan malamute and the Siberian husky and was recently popularised by the dog Nico in American reality TV show *Couples Therapy*. The Klee Kai is adorable and dynamic and sheds its hair all year round. Fi Kinebuchi is tiny with a pointed face and bright blue eyes. She is adorable and dynamic and possesses a fabulous frizz of curly hair which *she* sheds all year round.

Saul Timpson (who is greatly enjoying his current role in the conversation as 'interpreter' / He Who Brings Clarity) says, 'When you name a thing you at once create *and* destroy it.'

Fi Kinebuchi turns to look at Tims with a measure of astonishment. *Did I really just say that? How wonderful!*

'Oh thanks for helping us all out there, Tims.' Sasha Keyes rolls his eyes (while simultaneously deciding if he agrees with this helpful precis or not. He doesn't, because he refuses, on point of principle, to ever agree with any of Fi Kinebuchi's gnomic utterances).

As Sasha speaks, Simo Treen is inspecting the venue's hashtag on his iPhone and noting that there is already a post on the stream in which TonyInterruptor can be seen (at a slightly unusual/unflattering angle) asking whether everyone is being honest. He immediately likes it and inserts the comment '#TonyInterruptor' to the feed then copies the post onto his Snapchat, adding the comment: '#TonyInterruptor . . . heh heh WTF?!'

He then starts a poll to the bottom of the post: 'Agree? Disagree? LET'S VOTE PEOPLE!'

There is a gentle tapping on the small refreshments table, which currently holds a selection of empty water bottles and crisp packets. It is Tod Knowles. Tod Knowles is a percussionist. He is tapping on the table with a plastic straw. Tod Knowles likes to announce every

utterance he produces (he doesn't say much, otherwise this tendency might be extremely wearing) with a small, preliminary drum roll: *Ppprrrrrum-pum-pum pum!*

'I dunno. Did I get this wrong or did this interruptor guy actually say that our music-making lacks integrity? Did I get this wrong? Because . . . yeah . . . that kinda *hurts* man. That stings.'

A short silence follows. It's almost as if nobody has considered this idea previously, aside from Sasha Keyes who took the whole thing as a personal (rather than a communal) insult. But yeah . . . now he comes to think of it . . . Sasha starts to smirk then stops smirking. *Does this improve things for him, personally, though? Isn't it always better to just be slap-bang at the centre of attention (negative or positive)?*

'I like to think that I'm an honest person,' Fi Kinebuchi muses, 'but in terms of performance . . . ? Hmm.'

'Hmm?!' Sasha Keyes parrots, satirising her, enragedly.

(An 'honest' person?! Really?! Off being a mature student in Oslo for six years and then, Oh sorry, I just don't think I actually want to do this after all . . . ? *Total bollocks.*)

Fi gently expands on her position: 'This was an improvised set, yes, absolutely, but surely we are all subject to various group dynamics which subconsciously – or consciously – underpin . . . Would you stop filming me, please, Simo? I actually find it a little bit disconcerting.'

'What I think Fi is attempting to say,' Saul Timpson delightedly returns to his 'interpreter role', 'is that we all operate within a certain unstated understanding of who does what, when and for how long. A kind of unspoken contract, I suppose . . .'

'Does he have an "off" button?' Larry Frome whispers.

'Does he have an "on" button?' Sasha Keyes counters (also at a whisper).

'I'm not entirely sure if that makes any sense,' Larry Frome responds.

Sasha Keyes rolls his eyes. These people are fools. A bunch of fools. He takes a quick swig of his beer.

'Did you brush your unruly fucking *mane* over this table earlier, Fi?'

Sasha asks, pulling a long strand of said mane out of his beer glass. 'I thought we agreed you'd always tie it back in our communal spaces?'
'Oh fuck my head is going to explode,' Larry Frome sighs.

3

L ambert Shore is excitedly telling his wife, Mallory, about a brief conversation with TonyInterruptor, which took place while queueing for their coats after the gig.

TonyInterruptor did not deign to introduce himself even though Lambert Shore had gently tapped his arm, held out his hand and said, 'Hi. I'm Lambert Shore. I'm an architecture professor at Christ Church University. My daughter . . .' He indicated, vaguely, over his shoulder towards India, who was casually knocking back the advances of a boy in the year above her at school, while also surreptitiously trying to persuade him to sell her his old vape (which happened to be an unregulated parallel handmade box mod from True Mods. This vape was made in 2015, which to India – who was made in 2007 – rendered it impossibly desirable and antique).

'Um . . . yes . . . that's my daughter. She actually filmed the comments you made earlier – entirely by accident – on her iPhone, and posted them onto her social media . . .'

TonyInterruptor gazed at Lambert Shore, then peered over at India Shore, then glanced back at Lambert Shore, blankly, as if he had entirely forgotten about said 'comments'.

'Okay,' he murmured, after a couple of beats.

'Are you local?' Lambert Shore wondered, still holding out his hand.

'Uh, you'd probably need to define your terms . . .' TonyInterruptor frowned (as if agreeing to the requirements of a concept as broad as 'local' would involve more fudging and compromise than he could comfortably tolerate during a brief conversational exchange). After what felt like an inordinately long interval, TonyInterruptor took

Lambert Shore's hand and shook it, wearing an expression of gentle bemusement (to *shake someone's hand*? Seriously?! I mean what better demonstration of white supremacy/capitalist grind than this smallest of formal gestures?).

'I object to handshaking on ideological grounds,' he confessed, 'but you seem well-meaning so I'm happy to respond in the vernacular you're most comfortable with.'

'I object to handshakes on *ideological* . . . ?!' Mallory parrots, astonished. 'Are you serious?'

'His exact words,' Lambert nods, gravely.

'Why would you object to a *handshake* of all things?' Mallory demands (although Mallory habitually approves of – and objects to – pretty much everything in her life with equivalently rigorous levels of vigour).

'I know literally nothing about the history of handshaking,' Lambert confesses, somewhat forlornly. 'Perhaps there's more subliminal political meaning embedded in this everyday gesture than we realise – I dunno – like an unconscious allusion to something intrinsically fascistic . . . ?'

'You have such an embarrassing *man crush* on this lunatic!' Mallory guffaws. 'What did you say his name was again?'

'He didn't actually introduce himself.'

Lambert Shore is tight-lipped. He is wounded. Does Mallory *always* need to be so . . . so relentlessly sassy and unapologetically tart and . . . and so insufferably ebullient?

(The answer to this question – on purely empirical grounds – is a resounding YES. At one stage in their relationship these had been precisely the characteristics that had rendered her irresistible to him. She was just so . . . so marvellously *impossible*.)

'Huh? Why not?' Mallory persists (she always persists, like a seagull up to its knees in sea-swell, determinedly dissecting a crustacean as it rolls ceaselessly back and forth).

'I don't know. Careful? Private? Highly secretive? I don't know.'

'*Cuss*-ed. Just plain *cuss*-ed!' Mallory snorts.

'I was a total stranger approaching him at a gig . . .' Lambert shrugs.

'Paranoid. Obsessive. A complete egomaniac.'

'Um.'

Lambert Shore scratches his head.

'What does he look like?'

Lambert considers this question for a moment. 'Quite tall. Lean. A mix of Anders Danielsen Lie – the Norwegian actor – and . . .'

'I *know* who Anders Danielsen Lie is, Lambert!' Mallory exclaims. She is unloading the dishwasher and almost drops a mug in her irritation. 'Please don't treat me like one of your idiotic students!'

Lambert Shore opens and then closes his mouth.

(At one stage Mallory *was* one of his idiotic students.)

'The handshake?' Mallory demands. 'Weak? Flaccid?'

'Long.'

'Sorry?'

Mallory straightens up.

Lambert suspected TonyInterruptor might actually be an alien from another planet, but he nodded his head, obligingly (the nod representing the registering of something essentially inexplicable yet nonetheless marvellously profound), before doggedly ploughing on: 'I was just fascinated to understand what you *meant* exactly when you called Sasha Keyes "dishonest", earlier . . .'

'Hmm . . .' TonyInterruptor simulated a slight surprise at Lambert Shore's 'angle'.

'Might you release my hand now, perhaps?' Lambert Shore asked.

'Oh . . . Okay. Yeah . . .' TonyInterruptor let go of Lambert Shore's hand (his excessive shaking had brought an almost farcical element to what was previously – in Lambert's mind, at least – a perfectly straightforward and amiable gesture of greeting).

TonyInterruptor inspected Lambert Shore intently. Lambert Shore was/is a small, slim, perfectly formed late-middle-aged man with a boyishly handsome face and a greying blond quiff. He always

combines expensively tailored suit jackets with beautifully faded jeans and impeccably crafted trainers.

'I don't think I *did* call Sasha Keyes "dishonest",' TonyInterruptor reasoned. 'It wasn't an attack. I'm not in the business of attacking things – or people. I think I simply asked whether we were *all* being honest. It was a completely spontaneous enquiry into the true nature of improvisational performance, which I suppose became, in turn, almost *a part* of the performance, and so – at some level – the most authentic thing about it.'

TonyInterruptor started to pull on his jacket. He was plainly intent on leaving.

Lambert Shore (a man of considerable ego himself) silently pondered whether TonyInterruptor might be an egomaniac.

'Wow,' Mallory Shore interjects. 'The vanity of the man! Those are precisely the kind of pretentious comments *you* might be expected to make after a couple of drinks. Was he rat-arsed?'

Lambert ignores this. 'So then *I* said, "Is authenticity intrinsically more important or interesting than musicianship in performance? Do the two things always necessarily need to coexist?" '

'Haha. Oh you *were* pissed,' Mallory chuckles, drolly. 'How did he respond?'

'He said, "Yes," then immediately added, "Radiohead *slash* Muse . . . although I don't have much time for either, as it happens . . . The Beatles *slash* The Monkees. Truth is beauty." Then he laughed. Then he ruminated for a moment and said, "I feel like I aged approximately five years during the course of this conversation." Then he walked off.'

Before he walked off, TonyInterruptor smiled. When TonyInterruptor smiles the sun comes out. He rarely smiles, except in triumph. Lambert Shore mentioned the laugh to Mallory but he didn't mention the smile (he was still smarting from the 'man crush' comment), although he was completely dazzled by the openness of the smile and gazed up at TonyInterruptor in that moment with something amounting to awe.

This man *was* truth. This man *was* beauty.
I dunno. Kind of. Somehow.

'*Daydream Believer!*' Mallory squeaks, outraged (she is an ardent fan of The Monkees). 'How *dare* he?!'

'Yes.'

Lambert Shore shrugs. He knows (and indulges) Mallory's intense feelings about Michael Nesmith.

'An existential question about the nature of . . .' Mallory Shore continues unloading the dishwasher. 'What does he mean by that, exactly?'

Mallory Shore is a trained barrister.

'I suspect he's calling into question whether most "improvisation" is truly spontaneous,' Lambert responds. 'He probably feels like it's generally just the rolling out of a series of familiar musical tropes – recurrent themes and motifs – all dependent on various traditional ideas about *non*-traditional musical composition, as well as established power relationships in the group etc. But he was also saying that what *he* did – his interjection – *was* improvised, or truly spontaneous, and therefore honest.'

'And he couldn't just wait until *after* the performance to make that point, maybe quietly, to a friend?'

Mallory pauses. 'If he *has* any friends. *Was* he there with a friend?'

'He became a part of the performance. If improvisation actually means that a thing is truly unplanned and spontaneous then surely . . . ? Um. No. So far as I could tell he was attending the gig alone.'

'He's taking everything back to first principles when in actual fact there *are* no first principles . . .'

'Um. Very possibly.'

(Lambert Shore doesn't really know what Mallory Shore means.)

'I mean there's a *contract*,' she persists. 'An informal contract that if I pay money and buy a ticket to go and see a live music performance then I should expect to be able to watch that performance without another audience member unduly compromising it. You know,

clambering onto the stage with a penny whistle and tooting along, singing loudly, clapping out of time at inappropriate moments . . . That's the agreement. That's the contract. The venue promises to deliver the performance to me – whatever it may be, improvised or no – without interruption. I must also fulfil *my* part of the contract because otherwise I will get turfed out for compromising the performance for the rest of the audience who are *also* informally contracted to behave in a way that is conducive to the well-being of the whole . . .'

Mallory Shore is not a practising barrister because she spends much of her time looking after her eight-year-old daughter, Gunn, who has special needs, and is also (like her mother) magnificently quarrelsome. When she gets the opportunity to work, Mallory is a superb legal copy editor (on travel insurance documents, mortgages etc.). She loves to submerge her ferocious intellect into astonishingly mundane levels of detail. There's almost a kind of mischief in it. To be so unrelentingly *precise* in the creation of something cast iron and unassailable.

Lambert Shore PhD stopped paying attention after 'that's the agreement'.

'Show me the thing on your phone,' Mallory demands, while simultaneously grabbing her own phone from the kitchen table and going to India's Snapchat herself. India is not her biological daughter. Mallory would never have christened a child of hers with the name 'India'. The very thought is inconceivable to Mallory, who feels strongly about everything (including names).

Lambert Shore takes out his phone nonetheless, finds the link to India's post on it, and then blinks at the number of likes. He notices Simo Treen's comment/hashtag.

'TonyInterruptor,' he marvels. 'Simo Treen *himself* has hashtagged him! That's hilarious.'

'TonyInterruptor? Sounds like the title to a Fall song,' Mallory muses. 'Good heavens! She's received over three *thousand* likes! Who even knew that Sasha Keyes – or Simo what's-his-name – had that level of pulling power?'

Lambert has now crossed over to Simo Treen's Instagram and sees *his* post.

'This thing is going viral!' he exclaims. 'There are already 418 comments. People are really engaging!'

'Talk about a storm in a fucking teacup,' Mallory clucks.

'I dunno. Is this good or bad?' Lambert wonders out loud. 'I can't decide.'

Is this good or bad?

Lambert Shore can't decide. He looks to Mallory for guidance. Mallory always knows what to think, thank God.

He suddenly notices India standing in the doorway, listening intently to their conversation. Her expression is inscrutable.

'Did you see this thing?' he asks, holding out his phone. 'It's blowing up, kiddo!'

' "Blowing up"?!' Mallory snorts.

'Is this *seriously* how normal people talk to each other in their kitchens?' India demands, aghast. 'Because if it is, I swear to God I may as well just end it all now. It feels like . . . I dunno . . . like being dead already. Like having your brain gradually syringed through your ear. Like . . . *urgh* . . . like being roasted alive in a firepit of stupid *blah blah blah*. Do the two of you ever say anything *real* to each other? Is anything ever actually *real* in this house?'

She pauses. 'Honest?' she rejigs, effortlessly. 'To be *honest*? With each other? With yourselves?! Do you even have any idea what that *means*?' ■

A kapok tree, Cambodia

MUTE TREE

Y-Dang Troeung

Cambodians have a phrase to describe the loss of language in what is known as 'Pol Pot time'. It is *dam-doeum-kor,* which translates to *planting the kapok tree* or *mute tree.* The emphasis on *planting* and *rooting* suggests that when language abandoned us, when words were no longer capable of making meaning of our world, Cambodians still nurtured the seed of rebirth and regeneration, believing that, from the void within, the kapok tree would one day re-emerge. Silence during Pol Pot time carried an intentionality, a planting of something for an imagined future that was not yet visible.

In the case of many Cambodian women like my mother, this seed was human life itself, nurtured in the womb and long afterwards. The kapok tree, the refugee child who would one day speak for herself, is like the lotus flower that grows out of the mud. It symbolizes the capacity for the renewal of life, for rebirth of spirit and *pralung (soul)* in the darkest places.

When I was growing up, my father often told me about the kapok tree. As a child, he loved the dry season in Cambodia when the kapok tree pods would ripen, turning from bright green to brown and growing to the size of corn husks. He remembers the large piles of harvested brown pods at his father's trading business in Kampong

Thom, where workers removed the white cotton fibres from these pods. To him, the tree was like magic, its fluffy cotton the material of all the pillows and cushions that lined his household. The kapok tree grew everywhere, belonged to no one, and provided for everyone.

In Khmer, the word *kor* means both *kapok* and *mute*. It is said that when the wind blows in Cambodia, the leaves of *doeum-kor*, the kapok tree, make no sound; therefore, the kapok tree is like a person who is mute, or, rather, a person who is mute is like the ancient kapok tree.

During Pol Pot time, Cambodian people recited the proverb *to plant a kapok tree* (*dam-doeum-kor*) to each other as a word of wisdom from one Cambodian person to another about how to survive the genocide. To plant a kapok tree, then, exists as a way of knowing, being and surviving.

The kapok tree is a source of livelihood for Cambodian people: its silky fibres are used for textile production and cushion stuffing; its plants and seed pods are eaten as snacks; and its bark can be used medicinally to treat illnesses.

The *Floral Hole* ink drawing by Visoth Kakvei draws us into a space of paradox that confounds and unsettles so much of what we know or think we know about trauma, loss and survival. When we enter into that space, we delve into a spiral of infinite darkness, but we also swirl into a field of life: a lifeworld, a meditative, repetitious space of beauty, creativity and regeneration.

The aftermaths of war and displacement are a lifelong process of finding the shape of living and healing. Knowledge of sources of living, and the means to stay silent, make life in blocked passages habitable, viable and sometimes even beautiful.

One day, when my father is away on assignment with a men's work brigade, he comes across a field of kapok trees.

He knows that the Khmer Rouge regime has now forbidden Cambodian people to forage for food or to plant vegetables of their own. All the resources of the land that provided for Cambodian

people for centuries – the trees, the water, the plants – are now the sole property of the state. People are given only two bowls of rice gruel each day. 'Stealing' food is punishable by death. And so, many people starve, and watch their loved ones starve, even as the natural abundance of the land flourishes all around them.

On this day, in front of the kapok tree, my father weighs the risks and benefits of defying the regime to feed himself and his family, as he will do hundreds of times over the course of the next four years. This time, he takes the risk. He picks a few pods from the tree, cracks them open and savours their black delicious seeds under the cool shade of the quiet branches. For this brief moment, the kapok tree quells his hunger and reminds him of the old days, the happy times, before the war.

Sometimes, like the silent branches of the kapok tree, life makes no sound. At other times, life finds a way of speaking through silence, speechlessness and laboured speaking.

In my family's stories I have searched for ways to listen to and read this difficult ground, to hear its accounts of worlds destroyed and remade. My search has led to my own silence, my own yearning not to see myself – my refugee image – but only to hear myself speak. Why is it so hard for me to speak?

I have yet to meet a Cambodian survivor from my mother and father's generation who is not familiar with the proverb of the kapok tree. Perhaps it is one of the darkest ironies of the Cambodian genocide that those who *did* survive had to learn to tell their story, and to do so often, for whoever wanted to know. Perhaps that is why we have had to become, to some extent, *like the kapok tree.*

> It was called 'Planting a Kapok Tree' in Cambodia . . . It was more than just keeping one's mouth shut, seeing and hearing nothing; it also meant 'don't stand out.' Avoid the Khmer Rouge soldiers as interaction breeds emotion and gets one noticed, taken away and never seen again.

This logic was used to survive in Pol Pot's new world, his
return to year zero, where everything, including emotion
and feeling, was extinguished as wrong.

– Karl Levy, *Sinarth: A Dedication to Life*

The word *sanction* once gave honour, permission, authority. But
when Cambodian people were given a sanction, it only imposed a
cruel penalty on its people.

Like many countries today that disintegrate under the weight of
disease and starvation, Cambodia in the 1980s was relinquished to a
devastating famine. During Pol Pot time, Cambodian people like my
family lived off two bowls of watery rice gruel a day for almost four
years, stunting their capacity for resistance. After the Vietnamese army
(America's greatest enemy during this era) invaded Cambodia and
deposed the Khmer Rouge in 1979, the West imposed a sanction on
foreign aid to Cambodia. No food arrived in Cambodia. No medicine.
Nothing.

We didn't have enough of anything, my mother once told me about
this time of total insufficiency. The sanctions of war propelled a
spiralling exodus of refugees. Some wanted to leave Cambodia
forever; others just walked toward the borders in search of food.

What emerged from sanctions was the Cambodian land bridge – a
human flow of Cambodian people over land from the north-western
regions of Cambodia to the refugee camps at the Thai border. The
term *land bridge* comes from the field of biogeography and refers
to a strip of land that forms across an expanse of water, linking two
previously unconnected land masses. The formation of a land bridge
allows for a new circuit of migration to take shape.

From 1979 to 1980, Cambodian men, women and children
walked for days to pick up rice, seeds and tools that had been
stockpiled at the border camps. They carried heavy bags of rations
on their heads, traversing dangerous paths of land mines, warring
militias, checkpoints, dehydration and the hazards of the jungle. How

many women, like my mother, were carrying food on their backs and new life in their wombs as they walked?

In the image of the land bridge, the ingenuity of refugee survival is laid bare alongside the scourge of permanent war. Backward from Cambodia to Laos, Vietnam and Korea, and forward to Afghanistan, Syria and Yemen – how far can this bridge wind on?

One of the most common injuries suffered by people in war zones is called a concussive wave. When a bomb hits the earth, it sends a shock wave through the air that radiates outward. The effects of these waves on the body and mind are not well studied, but doctors speak of *blast-associated traumatic brain injuries*. Blast traumas, tear connections, shock waves. This is the vocabulary of invisible wounding.

In 1974, concussive waves rippled across Cambodia's capital city of Phnom Penh during a deadly battle at the end of the dry season. With fury in their hearts after years of living under aerial bombardments, the Khmer Rouge guerrillas blasted the city using American 105mm Howitzers, guns they had acquired on the black market. In retaliation, the US-backed Lon Nol army fought back with their American-made T-28 bomber jets. In the wake of the fighting, the fires came. They blazed through every street, every school and every home in the city's north-eastern residential district, not far from where my parents and two older brothers lived.

I think of Phnom Penh today, in 2021, as another era of war is being called to an end. In 2001, Afghanistan became a new battleground of conflict that burned under the fires of 'Operation Enduring Freedom', an occupation that continued for twenty years and is said to have now ended. As in Cambodia, the war in Afghanistan has left a legacy of invisible wounds and unspeakable grief: one of the largest amputee populations in the world, a collapsed infrastructure, an ongoing refugee exodus.

From 1863 to 1953, Cambodia was a colony of France. War came in 1946, and besides some brief moments of stillness, did not end until the early 1990s, when the Vietnamese armies finally left the country.

By then, war had been present for over forty years. In Afghanistan, too, war has been unceasing, besides a moment of stillness here and there, since 1978, over forty years. Forty years of wave upon wave of bombs and battles and death. Entire generations, submerged.

The long wars wear down a population, slowly, like water corroding a cracked surface. The long wars engulf the lives of soldiers who return home in states of depression, memory loss, PTSD and shell shock. But these soldiers only spend months, or perhaps a few years in these waves, and they are always far from home. What can we say about the brain health of people whose sense of war is one of permanence, whose home is war itself?

In Cambodia, my parents called bombs *kro bike,* which literally meant *broken seed.*

Bombs break nature apart. They pound and pummel the earth far outside the natural cycles of life. Ending lives and maiming bodies, bombs are the antithesis to what the seed embodies – life, growth and regeneration. Bombs crater and deform the land. They bend and truncate trees. They make the water, air and homes of human and non-human life uninhabitable for generations to come.

From 1970 to 1973, Cambodia, once known as an *Island of Peace,* wanted no part in the Vietnam War. But the bombs kept arriving, all 2.7 million tons of them, dropped by US airplanes. These broken seeds transformed Cambodia's lush, tropical landscape into a scarred surface, freckled with hollowed-out spots.

Not all the bombs would detonate right away. Some would lay dormant for years, some for decades, just beneath the earth's skin. They would begin to fragment, one by one, triggered by feet foraging for food, or small hands searching for toys.

Today, fifty years later, broken seeds still sprout from the ground. They add to the ticker of body counts and maimings. In the watery craters that Cambodian people today call 'bomb ponds', fragile little ecosystems grow.

Courtesy of Colin Grafton

Courtesy of Vandy Rattana

A photograph of a scorched landscape outside of Phnom Penh captures the early destruction wrought by US bombs. With its monochrome palette of a lone survivor, ruined landscape and darkened skies, the photo evokes the tones and composition of an apocalyptic death-world.

These reflections call attention to the sonic violence of concussive waves and its tormenting effect. The waves would create madness out of anger, desolation and despair, which would harden into a militarized collectivity of rebellion that would relentlessly seek its revenge on the *imperialists and landowners* in the years to come.

Madness is featured in the photo's landscape, a surreal and awe-inspiring combination of beauty and terror. The broken seeds create broken infertility. The lone person walking through it does not stand tall against a scarred and sublime landscape, but is, as are all refugees, conjoined with it.

The atrocities that have rippled across Cambodia to our shores evade calculation. We speak of the deaths as countless, the violence as inconceivable, the event itself as outside of our beliefs in reality, in mankind.

Yet as I write this in 2021, the US is still demanding that the debt from the early 1970s – money spent on war munitions and to keep alive the army fighting the Khmer Rouge – must be repaid. It was $278 million in the 1970s; today the debt to the US stands at more than US $700 million.

In February 2017, US Ambassador to Cambodia William Heidt insisted at a press conference in Phnom Penh that 'it's in Cambodia's interest not to look at the past, but to look at how to solve this [debt] because it's important to Cambodia's future'.

What does it mean to be asked to pay this debt? How do we understand our own pain caused by US bombs as incalculable, yet the deaths caused by those bombs as payable debts?

The US bombing of Cambodia devastated the country's civilian and agricultural infrastructure and contributed to a massive

food shortage that paved the way for the United States to step in with a loan to Cambodia in the form of agricultural commodities. The loan was made to the Lon Nol government, a regime seen by many as coming to power illegitimately through a US-backed coup in 1970.

The lender rarely needs the money they lent. What they need is the debt to be permanent, to be, in many senses of the word, *outstanding* – to stand out so much that it covers up any question of reparations, of covert intervention and secret war. Debt masks culpability.

Many Cambodians view debt not as an evasive tool, but as a moral obligation to each other. Our debt means we must redress the harms of the past. Debt connects us to the US, who bombed us, because our shared moral debt creates a relation, a future of working together, a means of healing and repair (thus the word *reparations*).

On Qingming, the annual festival to honour the dead, Cambodian streets fill with small fires that burn fake money or gold in remembrance of our ancestors, transferring commodities that are of the most value to the afterlife. Today, the Cambodian riel remains devalued as a national currency. Instead, piles of fake US dollars are set alight.

Idyllic and tranquil, Vandy Rattana's *Bomb Ponds* photo series (2009) shows the former bomb craters overgrown with fecund foliage in Cambodia's eastern provinces.

I feel an articulation of collective wounds in Rattana's photos, an illegibility turned deeply material. I feel the threat that lurks just beneath nature's tranquil surface, those grotesque broken seeds, brought here by a crusade of vested interests.

In one photo, the landscape traces human interaction, both in the bomb that created the crevice, and in the agricultural grid of the rice field that grows around it. The bomb pond remakes land, creates the conditions for new growth. This growth is neither tragic nor optimistic. The muddiness of the pond is reflected in the muddy sky, and trees stand far off, like onlookers. I feel the photo's silence, arriving long after concussive waves have rippled out. It is my own

loss of speech that comes from telling one's story of war and trauma again and again and again.

Though silent, the ripples never end. They come in the belated arrival of toxicity and early deaths. They travel to far-reaching rural spaces, the offshored, off-the-grid coordinates where they can never be traced back to a particular source. When we dare do the tracing ourselves, denial meets us at every turn.

When our testimonies are repeatedly invalidated, we must turn to the earth itself as evidence. The ponds that resemble war's continual presence.

When and where does the crisis of war begin and end?

Decades of war in Cambodia, we are told, belong to the dark history of a dark nation. War, then or now, can never belong to a single place, time, or people. War is a concussive wave whose ripples never end, though they might go silent. War is the broken seeds that recreate the land, and in turn, those who live and travel upon the land, for as long as that land exists. War is the land bridge that connects us to the faraway places, where war is repeatedly sanctioned anew. ∎

LOVE BOOKS, LOVE FOLIO

Exclusively available from

The Folio Society

FOLIOSOCIETY.COM

CONTRIBUTORS

Nicola Barker is the author of twelve novels – including *Wide Open, Darkmans, The Yips* and *In the Approaches* – and two short story collections. She has been twice longlisted and once shortlisted for the Booker Prize, and was named one of *Granta*'s Best of Young British Novelists in 2003. Her novel *H(A)PPY* won the 2017 Goldsmiths Prize. Her most recent novel is titled *I Am Sovereign*.

James Berrington is a visual artist living and working in London. He has exhibited widely in the UK and beyond, and was selected for Bloomberg New Contemporaries in 2016. His work has recently been acquired by the University College London East Public Art Collection.

Sama Beydoun is a multi-disciplinary artist, currently based in Paris and born and raised in Beirut. Her project 'Beirut Street Museum' won the 2019 Areen Prize of Excellence in Graphic Design in Beirut and 2021 Emerging Graphic Designer of the Year by DNA Paris Design Awards. Her photography has been shown in Paris, Marseille, Barcelona, New York and Beirut.

A.K. Blakemore is a poet and novelist from London. Her first novel, *The Manningtree Witches*, won the Desmond Elliott Prize for Best First Novel and was shortlisted for the Costa and RSL Ondaatje prizes. Her second novel, *The Glutton*, is forthcoming from Granta Books.

Lydia Davis is the author of seven collections of stories, one novel and two books of non-fiction, *Essays One* and *Essays Two*. She is also the translator of a number of works from French and other languages, including Proust's *Swann's Way* and Flaubert's *Madame Bovary*. A new collection of short fiction, *Our Strangers*, will be appearing this autumn from Bookshop Editions and Canongate.

Brian Dillon's books include *Affinities, Suppose a Sentence* and *Essayism*. He is working on a book about Kate Bush's 1985 album *Hounds of Love*, and another about aesthetic education.

Wiam El-Tamami is a writer, translator and editor. Her work has been published or is forthcoming in *Granta, Freeman's, Social Movement Studies, Jadaliyya, Banipal, Ploughshares Solos* and *Craft*. She won the 2011 Harvill Secker Translation Prize and was a finalist for the 2023 Disquiet Prize.

Peter Englund, a historian and writer, is a member of the Swedish Academy, which chooses the winners of the Nobel Prize. He is the recipient of a number of literary awards, including the August Prize, for the best Swedish book of the year, and the Selma Lagerlöf Prize.

Maartje Scheltens grew up in Leiden, the Netherlands, studied English at Cambridge and lives in the Fens. After twelve years in the literature department at Cambridge University Press, she now works as a freelance editor and copywriter. She is working on her first book.

Martha Sprackland is an editor, writer and translator. Founder and editor of independent publisher Offord Road Books, she is also poetry editor for Cheerio Publishing. Her collection *Citadel* was shortlisted for both the Forward Prize for Best First Collection and the Costa Poetry Award.

Anjan Sundaram's new memoir, *Breakup: A Reporter's Marriage amid a Central African War*, was published in the UK in May 2023.

Laura Susijn is a literary agent and owner of The Susijn Agency.

Y-Dang Troeung was a researcher, writer and assistant professor of English at the University of British Columbia. She was the author of *Refugee Lifeworlds: The Afterlife of the Cold War in Cambodia*, and she co-directed the short film *Easter Epic* and organised the exhibition *Remembering Cambodian Border Camps, 40 Years Later* at Phnom Penh's Bophana Center. She died of pancreatic cancer at the age of forty-two. 'Mute Tree' is an excerpt from her memoir *Landbridge*, forthcoming from Allen Lane in the UK and Knopf in Canada.

Ed Vulliamy is a journalist and writer. He has won numerous British journalism awards for his work in the Balkans, Iraq and Mexico, including the James Cameron Memorial Award, and in Poland, the Ryszard Kapuściński Award for literary reportage. His latest book is *When Words Fail: A Life With Music, War and Peace*. He is currently working on a book about music and musicians at war in Ukraine.

Bryan Washington is a National Book Award 5 Under 35 honoree and winner of the Dylan Thomas Prize. He received the New York Public Library Young Lions Fiction Award for his first book, *Lot*. 'Family Meal' is an excerpt from his novel of the same title, forthcoming from Atlantic Books in the UK and Riverhead in the US.

Ada Wordsworth is a master's student in Slavonic studies at the University of Oxford. She is also the co-founder of KHARPP, a grassroots project repairing homes in Eastern Ukraine.

Jeffrey Zuckerman is a translator of French, including books by the artists Jean-Michel Basquiat and the Dardenne brothers, the queer writers Jean Genet and Hervé Guibert, and the Mauritian novelists Ananda Devi, Shenaz Patel and Carl de Souza. In 2020 he was named a Chevalier de l'Ordre des Arts et des Lettres by the French government.

Diana Evans is the author of four novels, including *The Wonder*, *A House for Alice* and *Ordinary People*, which won the South Bank Sky Arts Award for Literature and was shortlisted for the Women's Prize for Fiction.

Suzie Howell was born in Bristol and is a photographic artist living in London. Howell's work has been exhibited in London and New York and has been featured in various photographic publications. Recent commissions include work for the *New York Times*, *Granta*, *Document Journal*, *Bound Magazine*, the BBC, the *Financial Times* and the *New Statesman*.

Tabitha Lasley was a journalist for ten years. Her work has appeared in *Esquire*, the *Guardian*, the *London Review of Books* and the *Paris Review*. Her memoir *Sea State* was longlisted for the Rathbones Folio Prize, and shortlisted for the Portico Prize and the Gordon Burn Prize.

Mazen Maarouf is a writer, poet, translator and journalist. His story collection *Jokes for the Gunmen* was translated into English by Jonathan Wright, and longlisted for the Man Booker International Prize. Since then, he has published (in Arabic) a second collection called *Rats That Licked the Karate Champion's Ear* and recently the interlinked stories *Sunshine on the Substitute Bench*. He is working on a novel.

Adam Mars-Jones is a writer and critic living in London. He was named one of *Granta*'s Best of Young British Novelists in 1983 and 1993. His fiction includes *Box Hill* and *Batlava Lake*, which are short, and *Pilcrow* and *Cedilla*, the expansive first parts of a semi-infinite novel. The third instalment, *Caret*, will be published in August 2023.

Oluwaseun Olayiwola is a poet, critic and choreographer living in London. His poems have been published in the *Guardian*, the *Poetry Review*, *Oxford Poetry*, *fourteen poems* and elsewhere. A Ledbury Poetry Critic, his criticism has been published in the *Telegraph*, the *TLS*, the *Poetry School* and *Magma*. His debut collection *Strange Beach* is forthcoming from Granta Books.

Sigrid Rausing is the author of four books, including an academic monograph, the memoirs *Everything is Wonderful* (shortlisted for the RSL Ondaatje Prize) and *Mayhem* (shortlisted for the Wellcome Prize). She is the publisher of *Granta* magazine, and of Granta Books.

Adèle Rosenfeld was born in Paris in 1986. 'The Tide' is an excerpt from her debut novel, *Jellyfish Have No Ears*, which was a finalist for the Prix Goncourt du Premier Roman and is forthcoming in English from Graywolf Press in 2024.